RADICAL LIGHT

ITALY'S DIVISIONIST PAINTERS
1891–1910

SIMONETTA FRAQUELLI
GIOVANNA GINEX
VIVIEN GREENE
AURORA SCOTTI TOSINI

WITH CONTRIBUTIONS BY
LARA PUCCI AND LINDA SCHÄDLER

NATIONAL GALLERY COMPANY LIMITED, LONDON
DISTRIBUTED BY YALE UNIVERSITY PRESS

Published to accompany the exhibition
Radical Light: Italy's Divisionist Painters 1891–1910
The National Gallery, London, 18 June–7 September 2008,
Kunsthaus Zürich, 26 September 2008–11 January 2009

The exhibition has been curated by Simonetta Fraquelli, Christopher Riopelle and Tobia Bezzola

Exhibition sponsored at the National Gallery by Credit Suisse

Partner of the National Gallery

First published in Great Britain in 2008 by
National Gallery Company Limited
St Vincent House
30 Orange Street
London WC2H 7HH
www.nationalgallery.co.uk

ISBN 978 1 85709 408 4 paperback 525504
ISBN 978 1 85709 409 1 hardback 525505

British Library Cataloguing-in-Publication Data
A catalogue record is available from the British Library
Library of Congress Control Number: 2008923232

Project manager Jan Green
Editor Lise Connellan
Designer Piccia Neri
Picture researcher Suzanne Bosman
Production Jane Hyne and Penny Le Tissier
Editorial assistance Claire Young and Davida Saunders

Printed and bound in Italy by Conti Tipocolor

Cover Angelo Morbelli, *In the Rice Fields*, 1889–1901 (cat. 38, detail)
Frontispiece Vittore Grubicy de Dragon, *Morning*, 1894–7 (cat. 18, detail)
Pages 8–9 Giuseppe Pellizza da Volpedo, *The Living Torrent*, 1895–6 (cat. 47, detail)
Page 10 Giovanni Segantini, *Afternoon in the Alps*, 1892 (cat. 1, detail)
Pages 60–1 Gaetano Previati, *Motherhood*, 1891 (cat. 25, detail)
Page 127 Carlo Carrà, *Piazza del Duomo*, 1910 (cat. 56, detail)
Pages 128–9 Umberto Boccioni, *The City Rises*, 1910–11; (cat. 63, detail)

CONTENTS

SPONSOR'S FOREWORD

Credit Suisse has a long tradition of supporting the arts and we are delighted to sponsor *Radical Light: Italy's Divisionist Painters 1891–1910*. This is one of the first exhibitions outside Italy to focus on this important movement. As Partner of the National Gallery, we are proud to play a role in bringing this landmark exhibition to a new audience.

The Divisionists used the principles of optical science to combine colour and light in a new style that explored Italy's evolving national consciousness as the twentieth century dawned. Chief among these principles was the notion that unmixed threads of 'divided' colour would fuse for the viewer at a distance, bringing maximum luminosity to the paintings.

This groundbreaking exhibition comprises more than 50 works by the most influential Divisionists, including rare loans from private collections and the public collections of Europe and North America. Congratulations to the National Gallery for successfully bringing this exhibition to the United Kingdom.

We hope you enjoy your visit to this original and thought-provoking event.

Russell Chambers CEO, United Kingdom and Ireland – Credit Suisse

Partner of the National Gallery

DIRECTORS' FOREWORD

Radical Light: Italy's Divisionist Painters 1891–1910 is the first exhibition outside Italy to provide a comprehensive survey of the most significant group of avant-garde artists in nineteenth-century Italy. Few examples of their work will be familiar to visitors of public collections in Britain or North America, with the notable exceptions of Giovanni Segantini's *Punishment of Lust* (fig. 7), his *Spring in the Alps* (cat. 4) and Angelo Morbelli's *In the Rice Fields* (cat. 38), all now or formerly on public display.

What the Divisionists owed to preceding episodes in Italian art, to the dash and scratch of the apparently confused surfaces of *Scapigliatura*, to the separate touches of paint of the *Macchiaioli*, and to the uncomfortable scrutiny of misery and labour which was characteristic of realist painters in the middle of the century, is not easy to understand. Yet both the metropolitan and the pastoral aspects of the subject matter – the gaslit pavements and moonlit glaciers, also the slightly spooky domesticity, the long-suffering solitary tree, the aged outcast, the lonely, emaciated female – are found elsewhere in European art around 1900. And of course the technique of applying separate brushstrokes of pure colour to the canvas was a feature of French painting in the 1890s.

Italian Divisionism has generally been understood as an extension of, or at best as parallel to, French neo-Impressionism. The relationship is a real one, first explored in this country in the Royal Academy's 1979 exhibition *Post-Impressionism*, and the theme of the exhibition mounted by the Guggenheim Museum in Berlin and New York in 2007. What the Italians owed to France is in fact surprising, for the debt to Jean-François Millet is clearer than the influence of Georges Seurat. But this is not to deny their modernity. The dynamic concept of light, and the experiments with representing it, as a form of energy, as pattern and as impastoed relief, leads directly to Italian Futurism, a movement launched with much noise in 1909.

The autonomy and originality of Italian Divisionism was first acknowledged in Italy in an exhibition of 1970 at Palazzo della Permanente in Milan. To this and the larger synoptic exhibition of 1990 in Trento the present exhibition is deeply indebted. The planning of this exhibition first began as a response to the fascinating and provocative small show on the subject at the Estorick Collection, London in 2003. Among the many individuals who have contributed to its making, we thank Dr Maria Vittoria Marini Clarelli, Dr Luisa Arrigoni, Dr Sandro Schiffini and Professor Giandomenico Romanelli in Italy, Glenn D. Lowry in New York and Serge Lemoine in Paris; above all, we thank Simonetta Fraquelli, for her vision and her dedication.

We are delighted that the National Gallery, London and the Kunsthaus Zürich have jointly organised this exhibition in a collaboration that has brought these institutions together for the first time. For the National Gallery, *Radical Light: Italy's Divisionist Painters* is part of its policy of exploring aspects of nineteenth-century European art which are little known in this country, both by adding to the permanent collection and by temporary exhibitions. For the Kunsthaus Zürich this follows their hugely successful exhibition of 1990–1 on Segantini, the most famous of the Divisionists, and is the first time that the public has the opportunity to see an exhibition in Switzerland dedicated to Italian Divisionism.

Together, the National Gallery and the Kunsthaus Zürich extend their particular gratitude to the museums and private collectors who have made this exhibition possible by agreeing most generously to lend their treasured possessions. Finally, we in London are indebted to Credit Suisse, whose generosity has permitted us to realise such a rich display of Divisionist art. We hope that it will be enjoyed by our many visitors.

NICHOLAS PENNY, DIRECTOR, THE NATIONAL GALLERY, LONDON
CHRISTOPH BECKER, DIRECTOR, KUNSTHAUS ZÜRICH

ACKNOWLEDGEMENTS

The organisation of this exhibition and the creation of its catalogue have engaged the energies of many colleagues and individuals both inside and outside the National Gallery and the Kunsthaus Zürich; without their help and commitment none of this would have been possible. I would particularly like to express my gratitude to Christopher Riopelle. His enthusiasm for and knowledge of lesser-known movements of nineteenth-century European art provided the impetus for this exhibition. As co-curators of the exhibition, he and Tobia Bezzola, have shared their expertise and experience throughout. Karine Hocking, Jane Knowles, Linda Schädler and Miranda Stacey have tackled a variety of tasks with great efficiency and good humour. The distinguished art historian Laura Mattioli has extended her kindness, hospitality and support, for which I am deeply grateful. I also owe a particular debt of gratitude to Giovanna Ginex, Vivien Greene and Aurora Scotti Tosini, each noted Divisionist scholars, for their invaluable advice and assistance with important loans and the ground-breaking essays they have contributed to this catalogue. I thank Lara Pucci for her dedication to the project, her invaluable research and for her elucidating texts in this volume. Jo Kirby has provided her expertise with precision and generosity, and I thank Jan Green for her unwavering support throughout this enterprise. I am also most grateful to Lise Connellan for her skilful editing and to Piccia Neri, who created the elegant design for this volume. Finally, I would like to thank Susan Davidson for her constant encouragement.

Special acknowledgement is also due to the following, whose crucial support has enabled the National Gallery and the Kunsthaus Zürich to bring the project to fruition: Chris Adams, Luisa Arrigoni, Maria Baiocchi, Paolo Baldacci, Kate Bell, Suzanne Bosman, Emily Braun, Esther Braun-Kalberer, James Burland, Andrea Buzzoni, Roberta Caramaschi, Pier Andrea Chevallard, Maria Vittoria Marini Clarelli, Ester Coen, Roberta Cremoncini, Beatrice da Ponte, Jeffrey Deitch, Ann Dumas, John Elderfield, Maria Teresa Fiorio, Maria Fratelli, Matthew Gale, Fiorenzo Galli, Audrey Gay-Mazuel, Claudia Gian Ferrari, Claudio Giorgione, Giancarlo Gonizzi, Christopher Green, Mary Hersov, Ellen and Paul Josefowitz, Isabella Kullman, Laura Laureati, Silvia Lefebvre D'Ovidio, Franziska Lentzsch, Lucia Matino, Paul Nicholls, Maria Luisa Pacelli, Ottavio Rigodanza, Giovanni Rossi, James Roundell, Sandro Schiffini, Cristina Sonderegger, Fatima Terzo, Bruno Trezza, Livia Velani.

SIMONETTA FRAQUELLI

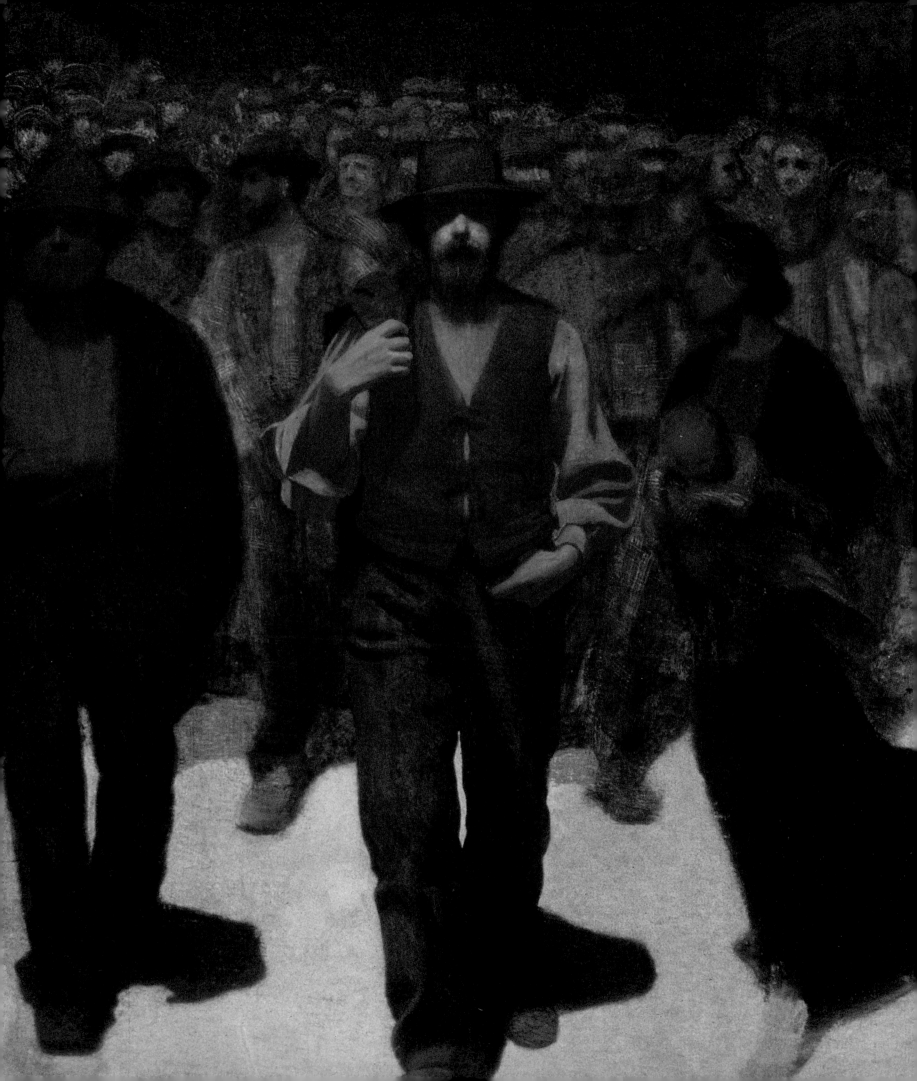

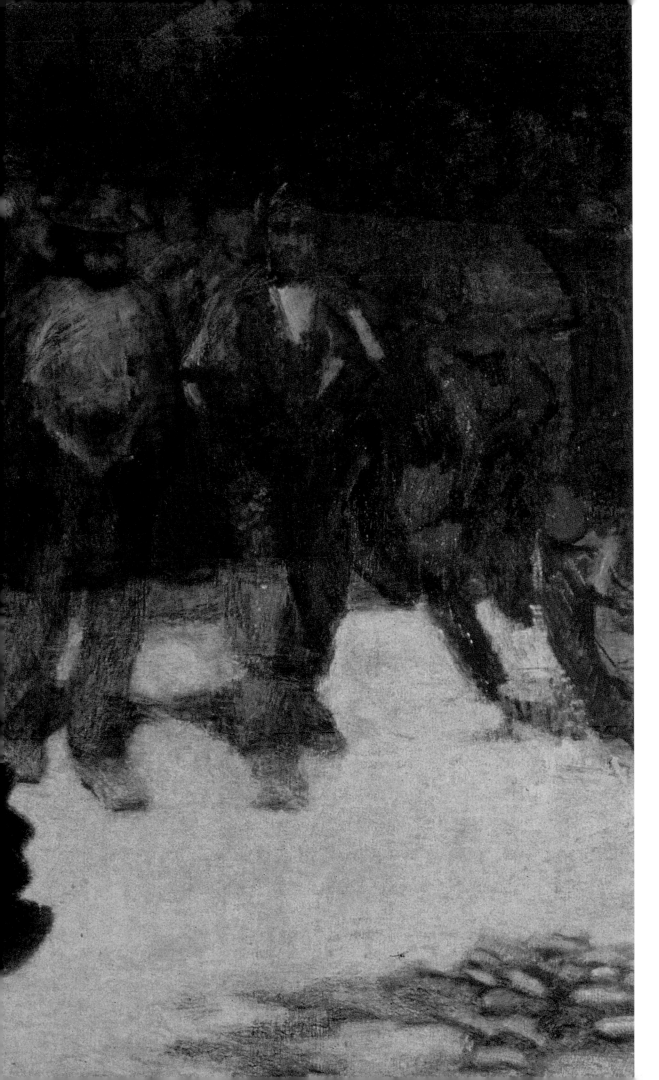

ESSAYS

SIMONETTA FRAQUELLI
AURORA SCOTTI TOSINI
GIOVANNA GINEX
VIVIEN GREENE

ITALIAN DIVISIONISM AND ITS LEGACY

SIMONETTA FRAQUELLI

> If modern art is to have a character, it will be that of the investigation of colour in light.
>
> Giovanni Segantini[1]

Italian art at the end of the nineteenth century had reached a turning point. The *Risorgimento*[2] had unified the disparate sovereign states of the Italian peninsula and accelerated the forces of modernisation that would forever alter the face not only of Italy but of Europe as a whole. However, it was these same forces – most notably industrial development and technological advancement – that were, in the ensuing decades, to give rise to social and political tensions among the Italian people. These conflicts called into question the stability of the fledgling nation and caused many Italians to become disillusioned, as the idealised democratic state they had envisaged did not materialise.[3] By the 1890s, when the avant-garde Divisionist style took hold, political uncertainty, social unrest and an economic recession forced the country's intellectuals and artists to analyse and question the critical divisions – of class, religion and region – that existed within their society. The importance of developing an identifiable Italian artistic style, as opposed to one steeped in regional cultural practices, became increasingly apparent.[4]

Divisionism, so called by virtue of the artists' use of a 'divided' application – that is, individual strokes – of pure colour in order to produce greater luminosity in their paintings, was a pictorial means of expression practised by a loosely knit group of artists from the late 1880s onwards. With its distinctly Italian flavour, it revolutionised the medium of painting at a time when Italian art had lost the pre-eminence it held in earlier centuries. Its genesis is associated with the artists' dissatisfaction with the paradoxes of the modern world. For many, this new style replaced tired academicism (fig. 1) with a forward-looking and modernist approach, which, infused with the celebrated art of Italy's past, aspired to social reform. The Divisionists' innovative approach to technique, together with their espousal of socialism and Symbolism, laid the ground for the formation of Futurism, the radical artistic movement that was launched with the poet and ideologue Filippo Tommaso Marinetti's first *Futurist Manifesto* in 1909.

The first generation of Italian Divisionist artists included the painters Vittore Grubicy de Dragon, Giovanni Segantini, Gaetano Previati, Giuseppe Pellizza da Volpedo, Plinio Nomellini, Angelo Morbelli, Emilio Longoni and Giovanni Sottocornola.[5] They were not a homogeneous group; on the contrary, it was the plurality of their visions that made Italian

FIG. 1
GIUSEPPE BERTINI (1825–1898)
The Painter Francesco Guardi selling his Paintings in Saint Mark's Square, Venice, 1892
Oil on canvas, 140 × 223 cm
Galleria d'Arte Moderna, Milan

Divisionism so distinctive and remarkable. With its inherent contradictions, Divisionism developed more from philosophical attitudes than simply as a pictorial system. Milan's commercial dominance in northern Italy had been bolstered by the country's unification and, with a population of some half a million people by the 1890s, the city had become Italy's wealthiest and most modern metropolis, generating a lively cultural milieu. For the pioneer Divisionist artists, the Lombard capital would become the artistic centre;[6] but not exclusively so, as many of the painters chose to maintain studios elsewhere. Grubicy and Segantini spent long periods in the Italian and Swiss Alps, Pellizza lived in the small town of Volpedo near Alessandria in Piedmont, Morbelli spent his summers in Casale Monferrato, also in Piedmont, and Nomellini was based in the Ligurian town of Genoa.

The depiction of light, which the Divisionists embraced as an intrinsically modern subject, was fundamental to their aesthetic. However, the level of interest in optical science and perceptual psychology varied noticeably from artist to artist. They were particularly attracted to the treatises of the French chemist Michel-Eugène Chevreul, *De la loi du contraste simultané des couleurs* (1839), and the American physicist Ogden N. Rood, *Modern Chromatics* (1879), which had also influenced the contemporary developments of the French *Pointillistes*, and which were introduced into Italy by Vittore Grubicy in the mid-1880s after his visits to Paris, Belgium and Holland.[7] The Italian Divisionists were aware of artistic trends beyond their national boundaries, but they had little or no firsthand experience of the Pointillist paintings of Georges Seurat (1859–1891, fig. 2) and Paul Signac (1863–1935) or contemporary Belgian artists such as Théo Van Rysselberghe (1862–1926).[8] While they shared an enthusiasm for nineteenth-century research into optics, it must be emphasised that Italian Divisionism was not a simple derivative of French Neo-Impressionism and that their aims and results diverged markedly.[9] The Italian artists resisted Pointillism's regimentation of dots or dabs of paint, preferring longer dash or comma-like brushstrokes, more freely applied. In addition, whereas the contemporary French artists, grounded in Impressionism, were focused on urban life and secular themes and often painted compositions of a smaller scale, the Italian Divisionists were responding to social issues of a specifically Italian nature and their paintings, often large in scale, were clearly indebted to long-established native artistic traditions.[10] Christian iconography such as the Madonna and Child (Segantini and Previati) and the use of devotional formats favoured by the Italian Old Masters – for example, tondi (Pellizza; Morbelli, cat. 11), triptychs (Previati, cat. 33) and even polyptychs (Grubicy, cat. 16; Nomellini, cat. 30) – recur in their work. More contemporary influences can be found in the realism of the Tuscany-based *Macchiaioli* artists (1840s–60s), especially Giovanni Fattori (1825–1908), with whom Nomellini and Pellizza studied. The name *Macchiaioli* refers to their distinctive technique of applying blotches of dark pigment (*macchia* meaning 'mark') to areas of the canvas to emphasise the play of light and shadow, and in particular to give objects three-dimensional weight. In their preference for landscapes and scenes of peasants and everyday life, the *Macchiaioli* consciously broke with Italian academic painting and its attendant grand historical subjects to express more egalitarian views.

The paintings of the Lombard *Scapigliatura* (literally translated as 'dishevelment') also exerted a persuasive influence on the young Divisionists. Primarily a literary and artistic movement active in Milan in the decade around 1860 to 1870, its name was taken from the novel *Scapigliatura* (1862) by Cletto Arrighi (the pseudonym of Carlo Righetti). The term *scapigliati* described young

FIG. 2
GEORGES SEURAT (1859–1891)
Sunday Afternoon on La Grande Jatte, 1884–6
Oil on canvas, 207.6 × 308 cm
The Art Institute of Chicago
Helen Birch Bartlett Memorial Collection, 1926.224

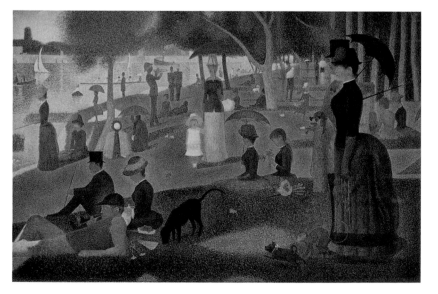

people of a bohemian, independent spirit and the word quickly gained currency in literary and artistic circles. The artists associated with the movement included, among others, the painters Tranquillo Cremona (1837–1878, fig. 3) and Daniele Ranzoni (1843–1889) and the sculptor Giuseppe Grandi (1843–1894). The *Scapigliati* believed in the fusion of all the arts. Typically, they produced images made up of tonal colours and softened contours that characterised their interest in the effects of light. Their work, a prelude to the decadent Symbolism that emerged in the last decade of the nineteenth century, provided a unique stimulus for the atmospheric landscapes of Grubicy (cat. 13) and the moody and sublime fantasies of Previati (cat. 34).

In broad terms, the Divisionist technique can be described as an investigation of visual representation. Following Rood's theories, the Divisionist artists thought that unmixed dabs or threads of colour juxtaposed – or 'divided' – would fuse optically at a distance, resulting in the maximum brilliance and fidelity to actual light conditions.[11] For the Divisionists these conditions encompassed all forms of light, from pure sunlight, to reflected light, to rays of light and later, in the work of Giacomo Balla (cat. 64), to artificial light. They believed that when the eye records an image, it does so, not merely as a camera does, but also by involving the complexities of human psychology. By creating an intense luminous effect and engaging the eye, they believed that their images aroused an emotional response in the observer. Given the variety of human emotions one experiences, the perceived impressions would vary from one individual to another.[12] On the one hand, this method of applying paint allowed the Divisionists to charge complex social issues with additional psychological and emotive overtones, as seen in the frequent depiction of workers, peasants and other members of the underclasses in paintings by Morbelli (*In the Rice Fields*, 1898–1901, cat. 38, and *Holiday at the Pio Albergo Trivulzio*, 1892, cat. 35) or Longoni (*Reflections of a Hungry Man* or *Social Contrasts*, 1894, cat. 40) or, indeed, in Pellizza's iconic image for the Italian proletariat, *The Fourth Estate*, 1898–1901 (fig. 4). In these works, the scientific basis of the Divisionist technique was closely identified with a Positivist-inspired belief in the inescapable progress of the working classes; on the other hand, the Divisionist technique also made it possible for the practitioners to go beyond figurative truth to create images that appear to be enveloped in an aura, emphasising the 'ideal', or timeless values, of the subjects they represented. The rural idylls of Segantini and the Symbolist imagery that Previati depicted are prime examples (cats 3 and 34). These two seemingly opposed aspects of Divisionism – factual observation and the invention of anti-realist, quasi-mythic scenes – were not necessarily mutually exclusive. Both strands were often intertwined, with artists such as Segantini, Previati and Pellizza producing paintings that were both socially inspired and spiritually uplifting.[13]

Vittore Grubicy was the first promoter of Divisionism, although he never assumed the mantle of a true leader for the movement. With his brother, Alberto, with whom he later argued irrevocably, he ran the Galleria Fratelli Grubicy in Milan from the mid-1870s to 1889; together they organised important exhibitions of the *Scapigliati*[14] and were the first to exhibit the paintings of Segantini, Longoni and Morbelli. Grubicy travelled regularly throughout this period, assimilating the new ideas that were

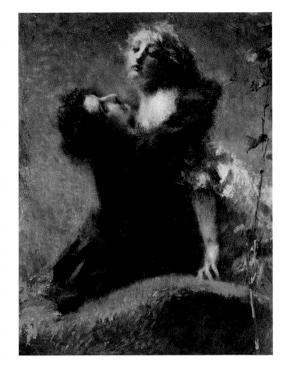

FIG. 3
TRANQUILLO CREMONA (1837–1878)
The Ivy, 1878
Oil on canvas, 99.5 × 133 cm
Galleria Civica d'Arte Moderna e
Contemporanea, Turin

FIG. 4
GIUSEPPE PELLIZZA DA VOLPEDO
(1868–1907)
The Fourth Estate, 1898–1901
Oil on canvas, 293 × 545 cm
Galleria d'Arte Moderna, Milan

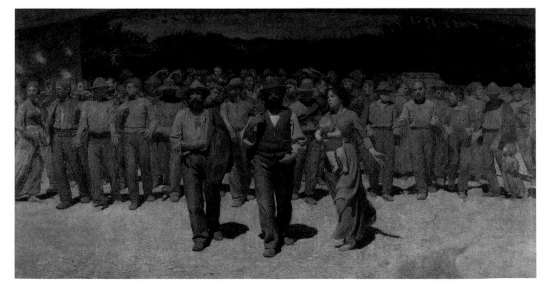

FIG. 5
GIOVANNI SEGANTINI (1858–1899)
Portrait of Vittore Grubicy, 1887
Oil on canvas, 151 × 91 cm
Museum der Bildenden Künste, Leipzig

FIG. 6
GIOVANNI SEGANTINI (1858–1899)
Ave Maria crossing the Lake, 1886
Oil on canvas, 120 × 93 cm
Segantini Museum, St Moritz.
On permanent loan from the Otto
Fischbacher Giovanni Segantini
Foundation

circulating in the capital cities of northern Europe, and disseminating them to his fellow Italian artists. Grubicy's knowledge of Félix Fénéon's authoritative accounts of Neo-Impressionism, that first appeared in the Belgian periodical *L'Art Moderne* in 1886 and 1887, are evident from his extensive writings – principally art criticism published in the Milanese journal *Cronaca d'arte* and the Roman daily *La Riforma*. Having developed a critical eye for contemporary painting, Grubicy himself began to paint in his thirties, during his sojourn in Belgium and Holland from 1882 to 1886, where he studied under the Dutch artist Anton Mauve (1838–1888). On his return to Italy in 1886 he began to elaborate his aesthetic theories and eventually advocated a form of art that he referred to as *ideismo*, or '*idéiste*' art[15] – that is, an art where ideas were no longer dependent on reality, but were expressed by means of a special, identifiable symbolic language. Grubicy interpreted the Divisionist technique as an instrument of a new modern aesthetic: a language that introduced greater social consciousness to art through the depiction of light, which he believed was a manifestation of life. He wrote that 'the Divisionist technique, which tends to increase the expression [of light] on the canvas compared with the past, can be the cradle of the aesthetic horizons of tomorrow'.[16]

Grubicy was a constant support – intellectually and in friendship – to Segantini, who enjoyed the greatest renown of all the Divisionist artists (fig. 5). He is credited with encouraging the young Segantini to separate colours in order to increase the brilliance in his paintings, although works by the French Barbizon painter Jean-François Millet (1814–1875), which Grubicy had also introduced to the artist, may have provided a stimulus for Segantini's new approach as well. In 1886 Grubicy reputedly convinced Segantini to paint a second version of his *Ave Maria crossing the Lake* of 1882 in the new Divisionist style (fig. 6).[17] Having supported and promoted him from 1880, by 1889 Grubicy's financial relationship with Segantini was severed, as Segantini abandoned the Millet-like realism of his earlier work and chose to combine a naturalist landscape of the Swiss Alps with Symbolist subject matter.[18] Segantini's pantheist Symbolist landscapes of the early 1890s are invested with a profound spirituality: among them, the grand masterpiece *The Punishment of Lust* (1891, fig. 7) is both a moral allegory and an exaltation of nature.[19]

In 1888 the Grubicy brothers were responsible for organising the section of Lombard artists included in *The Italian Exhibition* held in London.[20] This was quite an achievement for a private gallery. Vittore consciously used the opportunity as a forum not only to boost sales but chiefly to champion the innovative technique as signalling the new direction in Italian art, one that Grubicy specifically aligned with the attempt to develop a new national consciousness. In the preface to the painting section in the catalogue,[21] Grubicy expounded the idea, for the first time, that these new trends in Italian art – and by this he meant the recent works of Segantini, Morbelli and Attilio

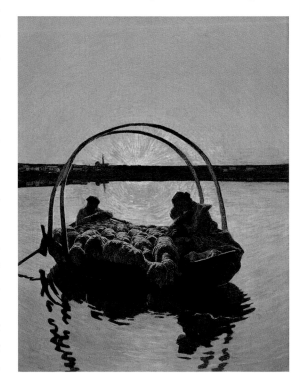

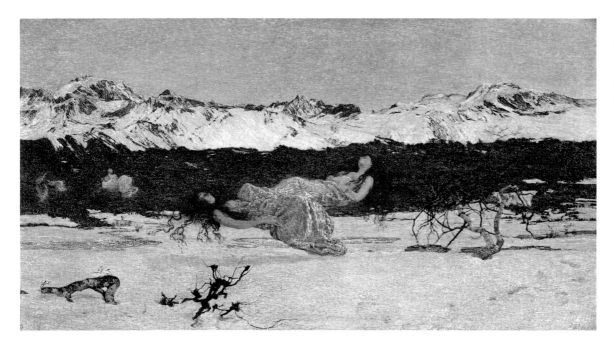

FIG. 7
GIOVANNI SEGANTINI (1858–1899)
The Punishment of Lust, 1891
Oil on canvas, 99 × 172.8 cm
Walker Art Gallery, National Museums
Liverpool

Pusterla (1862–1941)[22] – were indebted to their *Scapigliati* predecessors.[23] The connection to *Scapigliatura* reinforced the Italian credentials for Divisionism as opposed to linking it to French art, which several critics of succeeding generations were to do.[24] One cannot ignore the fact, too, that the Grubicys represented several artists working in both these styles and so it was to their commercial advantage to promote the association between the two. Despite Vittore's efforts, the exhibition failed to convert foreign audiences and the negative financial outcome was to be one of the main reasons for the brothers' break-up.[25]

Vittore left the gallery in the hands of his brother and re-established himself as an independent talent scout, a role in which he had enjoyed some success in the early 1880s. By 1891 he had become an avid supporter of Previati, staunchly defending his much criticised *Motherhood* (cat. 25), which had been included in the 1891 Brera Triennale.[26] Grubicy admired Previati's visionary Symbolism; the undulating forms of his paintings, created using thread-like strokes of colour, corresponded perfectly to the new aesthetic that Grubicy advocated. For four years beginning in 1892, Vittore acted as the unofficial consultant to the artists practising the Divisionist technique, especially Previati and Morbelli, and possibly also Nomellini and Pellizza, offering advice and placing their works with collectors. He was one of the moving forces behind the organisation of both the first and second Brera Triennale exhibitions in Milan. Perhaps due to ill health – he was slowly going deaf – or more realistically owing to a lack of shared ambitions among the Divisionists he supported, by 1896 Grubicy had virtually abandoned this advisory role and was concentrating on his own art, which consisted for the most part of atmospheric light renditions of the Lombard countryside and lakes (*Sea of Mist*, cat. 14).[27]

Divisionism was first brought to the attention of Italian art viewers when a handful of paintings displaying the new rendition of light was included in the first Brera Triennale in Milan in 1891.[28] In the histories of Italian art, this exhibition has come to mark the establishment of modernism. The Brera Academy organised the Triennale in an attempt to rejuvenate the visual arts in Milan and revive the art market, which had been in decline due to Italy's economic slump.[29] The jury, made up of liberal and conservative artists chosen by the Academic Council of the Brera, selected some 225 painters and 78 sculptors to fill the halls of the Brera *palazzo*. The art critic Gustavo Macchi, writing for the Milanese daily newspaper *La Lombardia*, underlined the composite nature of the exhibition and the variety of subject matter and techniques employed by the artists.[30] He drew attention to the Divisionist works,

techniques that would have been used, as was the norm, for realistically rendered history paintings. After 1883 Morbelli chose to document contemporary social themes. In his family home at La Colma, near Casale Monferrato, he began to experiment with the mixing and application of grounds, varnishes and new pigments.[11] The paintings that he sent to London for *The Italian Exhibition* in 1888 show the results of some of his experiments: we learn from his correspondence with Vittore Grubicy that for *Sold* (*Venduta*, 1884; Galleria d'Arte Moderna, Milan) he prepared the canvas with glues based on casein (made from cheese) and that he may also have used colours containing glycerine, with results that were not entirely satisfactory. In other paintings, such as *Milan Central Station* (*La stazione centrale di Milano*, 1887; Trenitalia Collection, Rome), apparently the use of his own homemade oils and varnishes produced more light in the black tones, and gave the effect of tiny suspended particles of pure colour, which Grubicy, in the preface to the catalogue lauded as authentic attempts at innovation.

This supposedly increased brilliance – an almost enamelled effect – could be linked to Morbelli's interest at the time in the theoretical study of light and colour, which from around 1891 onwards he focused on the perception of colour. Following the advice of the chaplain at the Pio Albergo Trivulzio (the almshouse for the elderly in Milan where he made a series of works), he studied volumes on physics, chemistry and philosophy, including H.F. Magnus's *Histoire de l'évolution de la couleur* and works by Chevreul and Rood, which helped him assess the quality of different pigments.[12] Morbelli had begun examining the effects of applying colours separately, juxtaposing tones to render the vibration of light; his carefully gauged individual brushstrokes could be clearly seen in the paintings exhibited at the 1891 Brera Triennale. In his plein-air painting *Dawn* (cat. 12) – a fine representation of contrasting light values painted at La Colma, constructed from small separate brushstrokes applied in spots and small lines – Morbelli was studying the orange light of the rising sun seen behind the green leaves and brown trunks of two trees, exploiting the dazzling effect of the juxtaposed colours to evoke the natural space around them. An atmosphere of pulsating light gives body to the interior scenes of the Pio Albergo Trivulzio in, for instance, *Holiday at the Pio Albergo Trivulzio* (cat. 35 and fig. 14) and *Inquisitive Old Ladies* (*Vecchine curiose*, 1891; private collection). In *Inquisitive Old Ladies*, a dense web of dots and dashes in contrasting colours enlivens the scene with continuous reflections, seen to best effect on the garments and bodies of the elderly female inmates.[13] As was the case for Segantini, the stability of the pigments was vital to Morbelli and it may be no coincidence that once he had access to varnish and colours commercially available in tubes from the French firm of Lefranc, which listed their chemical compositions, he gave up mixing his own.

The development of Segantini's and Morbelli's painting techniques between 1888 and 1891 was, although not totally similar, parallel in approach. This contrasted with the experiments with colour and light demonstrated by the works of Previati and Longoni shown at the first Brera Triennale in 1891. After early training in Ferrara, Previati was accepted by the art establishment of Milan as one of their most promising young painters, producing large, captivating literary and historical scenes, heavily influenced by the *Scapigliatura* movement. *Women smoking Hashish* (*Le fumatrici di hashish*, 1887, private collection; and another canvas in the Galleria d'Arte Moderna Ricci Oddi, Piacenza) and *Paolo and Francesca* (1888; Accademia Carrara, Bergamo) were large canvases painted in many colours with a thick impasto and using sweeping brushstrokes to render the airy volume of the forms, or interpreting contrasting emotions with gradual changes from one shade to another, heightened with brilliant whites; these won Previati the unequivocal praise of the critics.

By about 1889 Previati had begun fragmenting his brushwork and juxtaposing pure colour in contrasting complementary areas on the canvas to achieve plein-air effects, capturing and reproducing a particular moment, as shown, for instance, in *In the Meadow* (*Sul prato*, 1889–90; Galleria d'Arte Moderna,

FIG. 14
ANGELO MORBELLI (1853–1919)
Holiday at the Pio Albergo Trivulzio, 1892
Detail of cat. 35

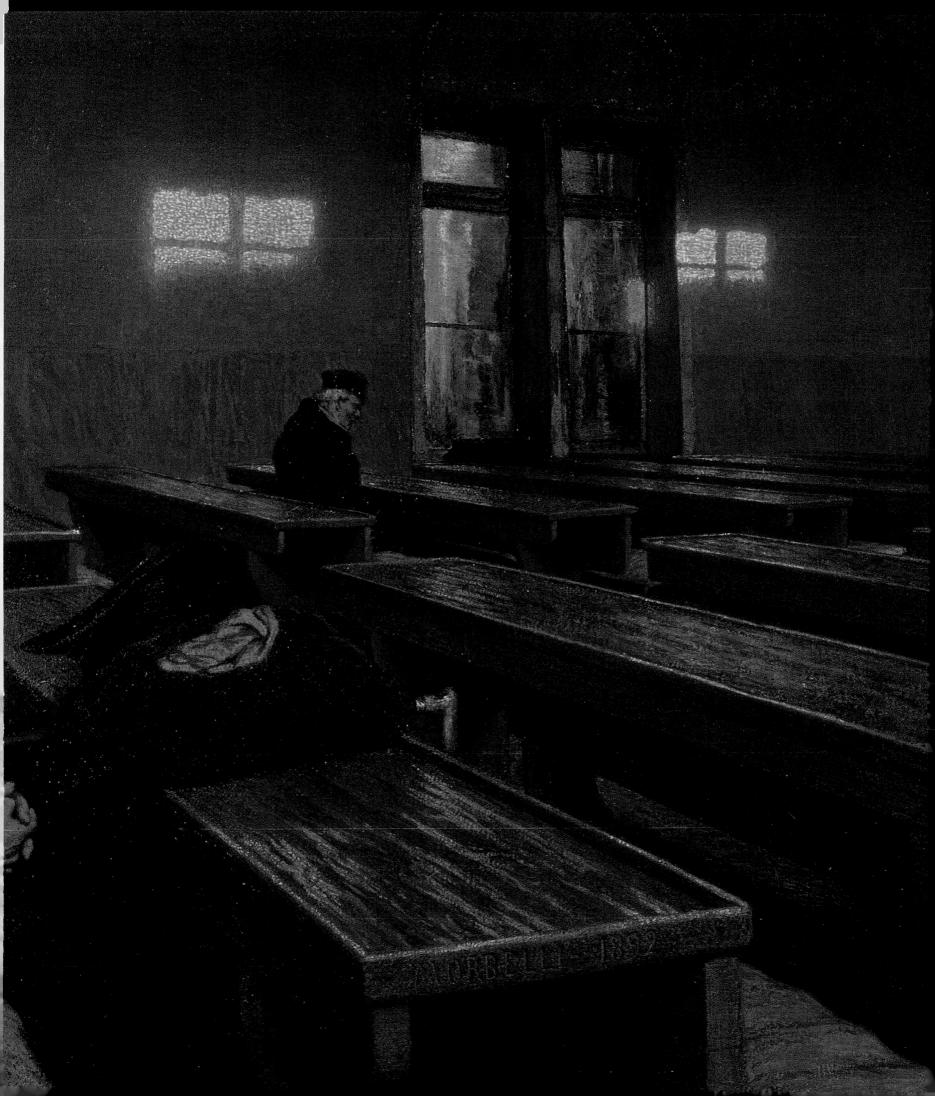

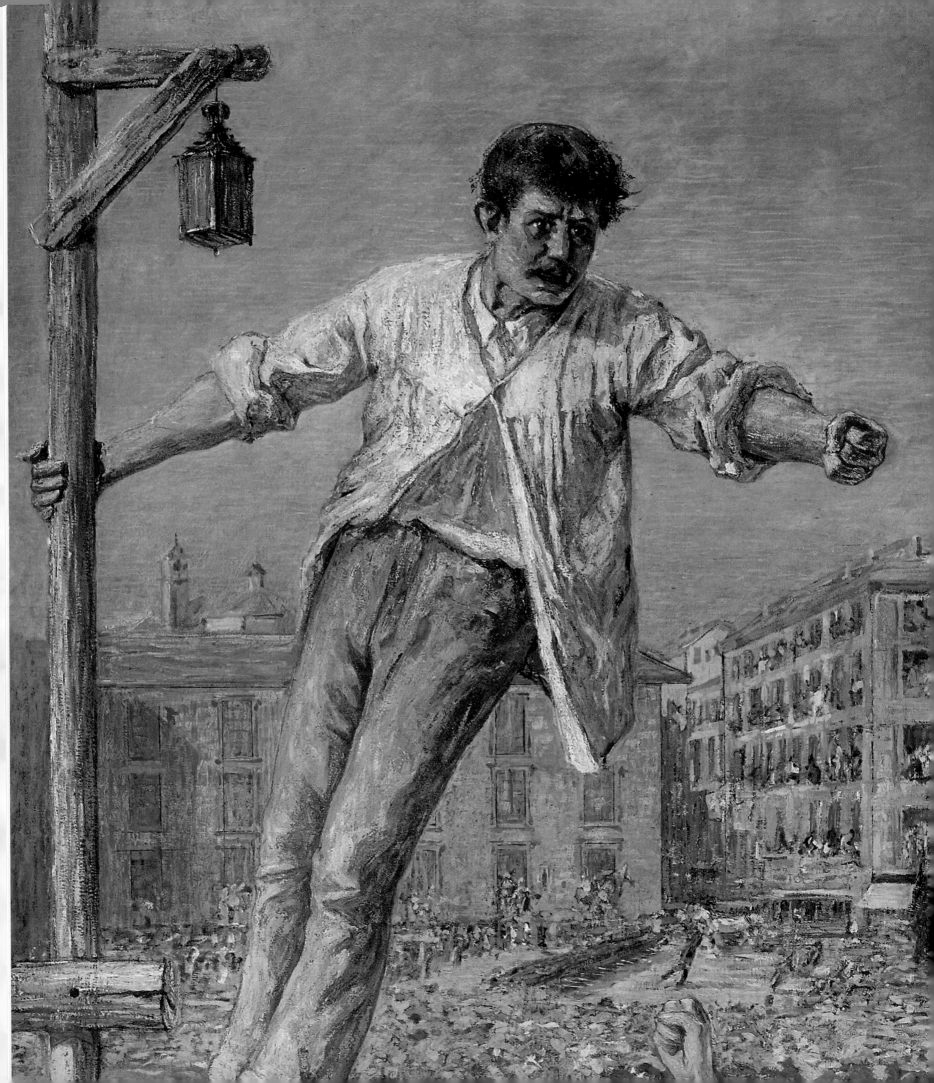

DIVISIONISM TO FUTURISM:
ART AND SOCIAL ENGAGEMENT

GIOVANNA GINEX

During the 1880s and the 1890s, use of the Divisionist technique by an Italian artist was an indication that he consciously supported revolutionary trends in painting. For most of the painters of the first generation of Divisionists, the application of complementary colour theory coincided with the onset of their artistic maturity and recognisable individual styles, applied to favoured subjects. Moreover, the application of the scientific method of dividing the colours was interpreted with absolute individual liberty, which from the start was a defining characteristic of Italian Divisionism.[1] The Divisionist 'revolution' was therefore inherent within the painting technique itself as well as the choice of theme and style. Finally, the debate surrounding Divisionism, its pictorial possibilities and any ideological value connected with it fuelled the exchange of ideas among the artists themselves; this exchange was kept alive by avant-garde critics who were informed about what was happening abroad, and was also particularly championed by Vittore Grubicy de Dragon, who was active as painter, theorist, critic and art dealer.

The technical, scientific phenomenon of Divisionist painting manifested itself against a backdrop of turbulent social and political conditions. The unification of Italy was realised during a protracted period of massive changes in political, social and economic circumstances. Although the kingdom of Italy was proclaimed in 1861 under the Savoy crown, it took some time before the Austrians and the French were ousted. Furthermore, the naming of Rome as the nation's capital did not take place until 1871 and only after Garibaldi had taken military action. By the 1890s, as in the rest of Europe, industrialisation had radically changed the fabric of social and economic life, violent conflict over wealth and politics inevitably emerging. The new democratic voting laws, which replaced those based on property ownership, seemed to encourage more visible socialist and anarchist movements. Workers' associations violently called for land redistribution in 1892, and King Umberto I had already survived assassination attempts in 1878 and 1897 before another succeeded in 1900. This widespread instability had grave economic consequences, making even more apparent the wide divisions between rich and poor, owners and workers, and north and south.

These circumstances led a number of artists deliberately to combine a technically innovative phase in their artistic careers with profound social and political involvement – although this duality did not constrain their choice of subjects.[2] In 1891 in Milan, at the groundbreaking first Brera Triennale, an exhibition organised by the Reale Accademia di Belle Arti di Brera to promote art from all over Italy, many paintings and sculptures addressed social themes. Among these, four pictures can be considered innovative, both for their painterly qualities and their original subject matter: *The Two Mothers* (*Le due madri*) (1889, fig. 8) by Giovanni Segantini, *Parlour of the Luogo Pio Trivulzio* (*Parlatorio del Luogo Pio Trivulzio*, 1891; Fondazione Cassa di Risparmio di Alessandria) by Angelo Morbelli, *Piazza Caricamento, Genoa* (1891, cat. 51) by Plinio

FIG. 19
EMILIO LONGONI (1859–1932)
The Orator of the Strike, 1890–1
Detail of cat. 49

37

Nomellini and *The Orator of the Strike* (1890–1; cat. 49 and fig. 19) by Emilio Longoni. Only the latter displayed an uncompromisingly urban character and made explicit the political nature of its subject.

When he exhibited his *Orator* in the Brera in 1891, Longoni – who had only recently, with painstaking effort, achieved a certain notoriety for his portraits and still lifes – was undoubtedly aware that the painting he was presenting would cause debate among the public and the critics, whether for its experimental technique or for its outspokenly political content: 'With stoical disdain for the accepted norms, Longoni painted his *Orator of the Strike*; in it he wanted to pick out, against the sky and the crowd of people, the vigorous figure of a rebellious working man. This painting, testimony to an unshakeable artistic honesty, jarred many nerves on the judging panel. It gives serious hope for even stronger works in the future. The arguments it has already provoked are an indication of its worth.'[3]

The mason, hoisted on to the scaffolding, is a symbolic image that presents an extraordinary visual synthesis, becoming a metaphor for the radical urban development and burgeoning building work taking place in the city, and the social tension that hit Milan as the new decade began; this tension was characterised by well-supported strike action, particularly in the building industry, one of the largest employers of manpower at the time. Within one scene Longoni conveys his own personal emotional tension, the social unrest of the period and the daily life of the city, in a dramatic composition that underlines the spectacle of the occasion. The scene is depicted from above, from the point of view of the striking mason; the foreground is occupied by the heads of the protestors, painted in an impasto with a proto-Expressionist touch that adds a great sense of modernity to the painting, and colours modulated on greys and blues; the orator is placed in the centre of the canvas, standing out against the background in his chalk-white jacket, his face agitated and his whole form emphasised by an orange outline. Spots of colour, pure and mixed, indicate the crowd and the city beyond. The sky is furrowed by touches of pure indigo, crossed by horizontal lines; the lamp on the scaffolding adheres rigidly to the Divisionist technique, with its threads of red and green.

The artist depicts the strike that was called on 1 May 1890, a year earlier, to celebrate the first international Labour Day, an event in which he himself took part. In 1891 the second celebration of Labour Day, which like the first was outlawed by the authorities, coincided with the opening date of the Triennale; thus the background of the painting – the army charging the demonstrators with bayonets levelled, the red flags and the tram barricading the square – assumes the significance of a provocative visual record of one of Milan's most turbulent days.

Reproductions of socially engaged paintings began appearing during the 1890s in the pages of periodicals aimed at workers and socialists: some of the paintings reproduced were executed using the Divisionist technique. In the 1893 issue of *Lotta di Classe del Primo Maggio*, the official organ of the Socialist Party, a heartfelt passage by Gustavo Macchi gives Longoni's 'orator' a voice: he has 'climbed up there, found himself a prominent place among the crowd'. The article bears witness indisputably to the political impact of the painting.[4] In 1894 the same periodical published Longoni's *Reflections of a Hungry Man* (1894, cat. 40), and the cover of the *Almanacco Socialista* for 1895 featured his drawing *Allegory of Socialism* (*Allegoria del socialismo*, 1894–5).

Reflections of a Hungry Man, a lifesized painting that hovers between an urban view and a protest, marks the peak of social engagement expressed

FIG. 20
ACHILLE BELTRAME
The uprising in Milan, at Palazzo Saporiti on Corso Venezia
Cover of *L'Illustrazione Italiana*, no. XX, 15 May 1898, engraving
Private collection

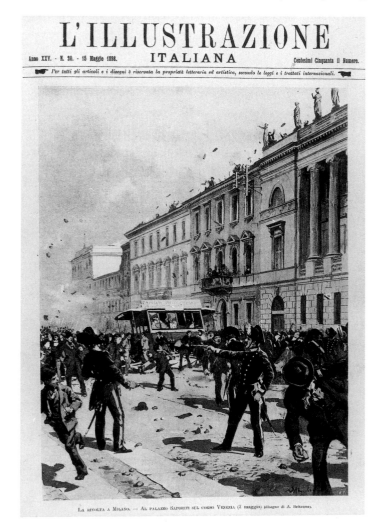

in Longoni's painting. As we shall see, this example of urban poverty was no isolated episode in the Brera Triennale of 1894 where it was exhibited: never did social realism display such expressive potential as it did on this occasion, in all different artistic media. What made Longoni's canvas more visible than the others that were also based on the 'social question' was its publication in *Lotta di Classe*, of which more than 100,000 copies were handed out during the celebrations of 1 May, once again the day on which the Triennale opened. In the text alongside the reproduction, an interpretation of the protagonists was given, the dialogue between the bourgeois couple lunching in the restaurant contrasting with the monologue of the starving man gazing at them through the window.[5]

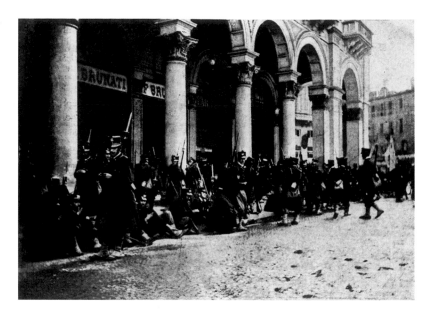

The juxtaposition of text and image elicited a reaction from the censor, who imposed an embargo on the newspaper; this was followed throughout the decade by several more legal actions on the part of the authorities against Longoni. Attacks on the painting were countered by a Milanese businessman, one of Longoni's patrons, who responded to the controversy by purchasing the canvas, and on behalf of the critics, by Macchi, who viewed technical experiment and social engagement as one manifestation of the same idea, and was among the first to oppose the sequestration of the painting: 'The artist's intellectual development placed him face to face with the great collective emotions that are sweeping mankind today [...] *The Orator of the Strike*, the first outcome of this new development, seems sombre, harsh and coarse, in thought as well as in technique [...] The purist aesthetes have also accused *Reflections of a Hungry Man* of being a "pamphlet" of social politics [...] But nothing could be less accurate. The painting cannot be confused with a newspaper illustration, since the first impression it makes is purely pictorial, and only sentiment and emotion well up from within it [...] Maybe one hundred painters, including the most mediocre, would have been able to depict a more typical "*grisette*" and a more elegant "restaurant goer" than those seen through the misted window of Longoni's painting; however, very few artists in my opinion would have been able to depict a figure like the hungry boy, nor to place it within a whole which, as well as being pictorial, also constitutes an intellectual unity.'[6]

Reflections of a Hungry Man still provides an impressive visual impact; the artist has by now mastered the Divisionist technique and can use it at will, with virtuosity in the rendering of the bright steamy atmosphere of the inside, more freely in the depiction of the hollow figure of the hungry young man. The construction of this magisterial work – the use of contrasting areas: exterior and interior, light and shade, figure and landscape, figure and interior – was one that was to be used frequently by Longoni.

Also exhibited at the 1894 Triennale was Giuseppe Pellizza da Volpedo's *The Hay Loft* (*Sul fienile*, 1894; private collection), which depicts a priest accompanied by two clerics bringing the Last Sacrament to a poor peasant, dying in the loft of a barn. The painting is a reflection on solidarity, a pivotal theme in Pellizza's personal life and artistic career. In addition, this was the first canvas in which he attempted meticulous scientific Divisionism, thereby obtaining a particularly airy and compact luminosity. Finally, it is a work born out of direct knowledge of working-class life and a solid social conscience, which was to become overwhelmingly evident in the iconography of *The Fourth Estate (Il Quarto Stato*, 1898–1901; fig. 4).

In the reports of the Triennale jury meetings, Pellizza's work is discussed: 'Pellizza's painstaking work was debated in courteous and lively terms, defended with warmth and opposed with respect. The minority felt that the delicacy of the drawing, the intensity of the colours, although rather forced and monotonous,

FIG. 36
GIACOMO BALLA (1871–1958)
Villa Borghese – The Deer Park, 1910
Oil on canvas
190 × 390 cm
Galleria Nazionale d'Arte Moderna,
Rome

Moreover, the notions of all-consuming experience and multi-sensory responses followed Symbolist constructs regarding sensory stimuli and perceptual phenomena.

These ideas were the touchstones for early Futurist experiments with multi-panel works, such as Giacomo Balla's triptychs and polyptychs (fig. 35). But, while Balla adopted Divisionist brushwork and strategies first, around the turn of the century, Umberto Boccioni was the Futurist artist who most ardently embraced Divisionist theories. He read Previati's writings on the division of colour and visited the painter several times in the hope of receiving approbation (which the older, now conservative artist did not give him). Boccioni theorised about the synthesising possibilities of the painting style itself, as well as the visual fusion of events and experiences in imagery that it allowed, and the psychological effects these images could convey.[50] Until his premature death in 1916, he persisted in using Divisionist brushwork and felt that this integrative painting method best achieved the synthesising goals he sought in his compositions, whether collapsing multiple events into a single image as he does with *The City Rises* (1910–11, cat. 63) or reinterpreting the triptych in his 1911 *States of Mind* (*Stati d'animo,* Museum of Modern Art, New York).[51]

The paradoxical intersection of the modern and the traditional, of science and religion, shaped the creations of artists living in a time fraught with ambiguities. The integration of Christian iconographic elements from religious art of the past and the revival of sacred formats was not only a way to readdress spiritual or ideal subjects, but also provided a means to reactivate a link with Italy's artistic legacy. The Divisionists' combination of this Christian iconography combined with their new painting technique – and often philosophical, if not specifically political, idealism – allowed for the emergence of a visual and narrative model capable of communicating abstract concepts, evoking emotional states, and eliciting sensations congruent with Italian modernist philosophies, opening the way to the 'multicoloured, polyphonic tides of revolution' celebrated by Filippo Tommaso Marinetti in his 1909 Futurist Manifesto.[52]

FIG. 35
VITTORE GRUBICY DE DRAGON
(1851–1920)
Detail of *Snow,* part of *Winter in the Mountains,* 1894–7 (see pp. 143–4)

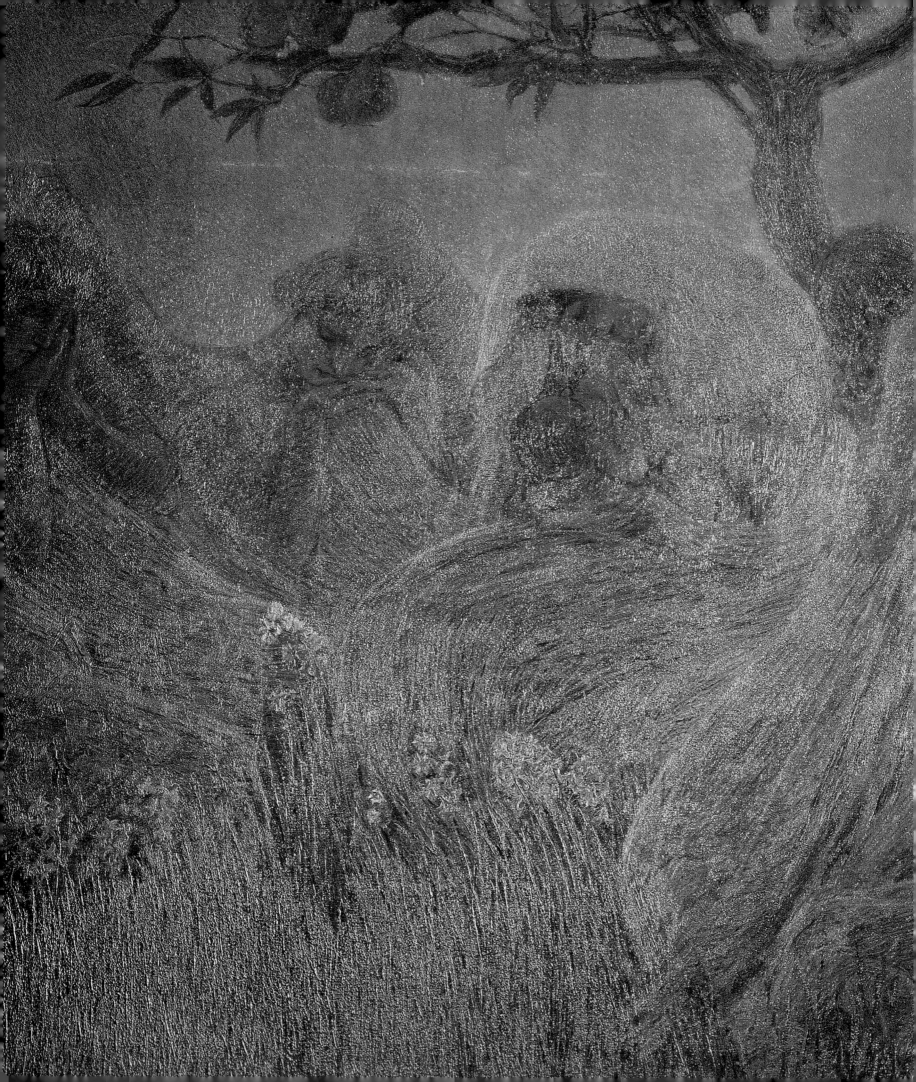

PLATES

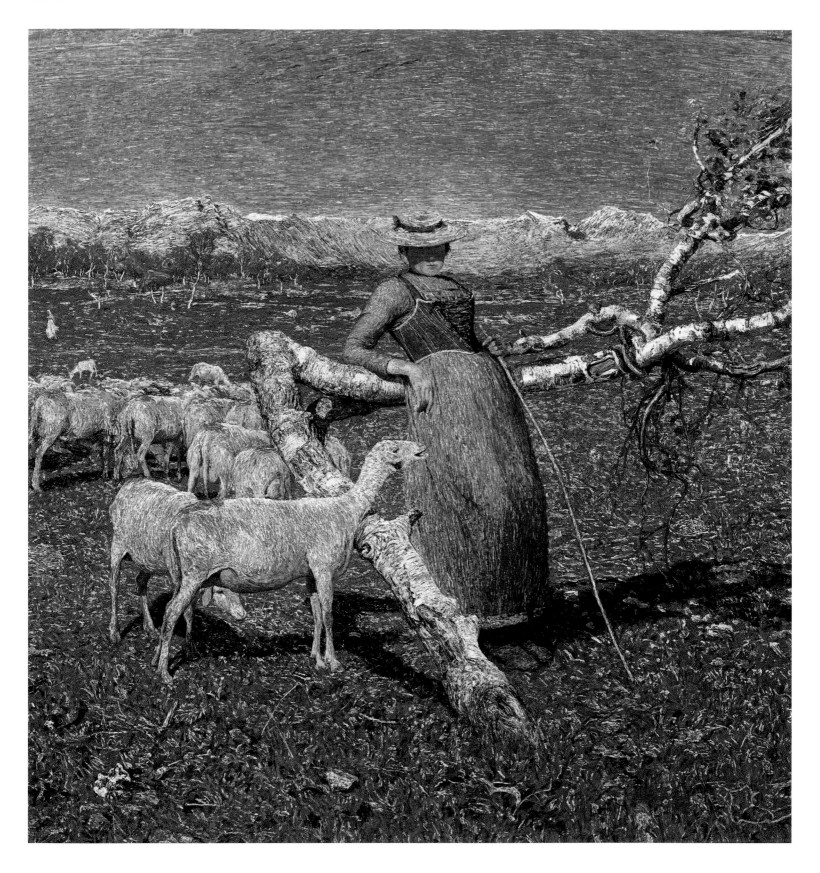

1 GIOVANNI SEGANTINI
Afternoon in the Alps (Pomeriggio sulle Alpi), 1892
Oil on canvas, 85.5 × 79.5 cm
Ohara Museum of Art, Kurashiki (1022)

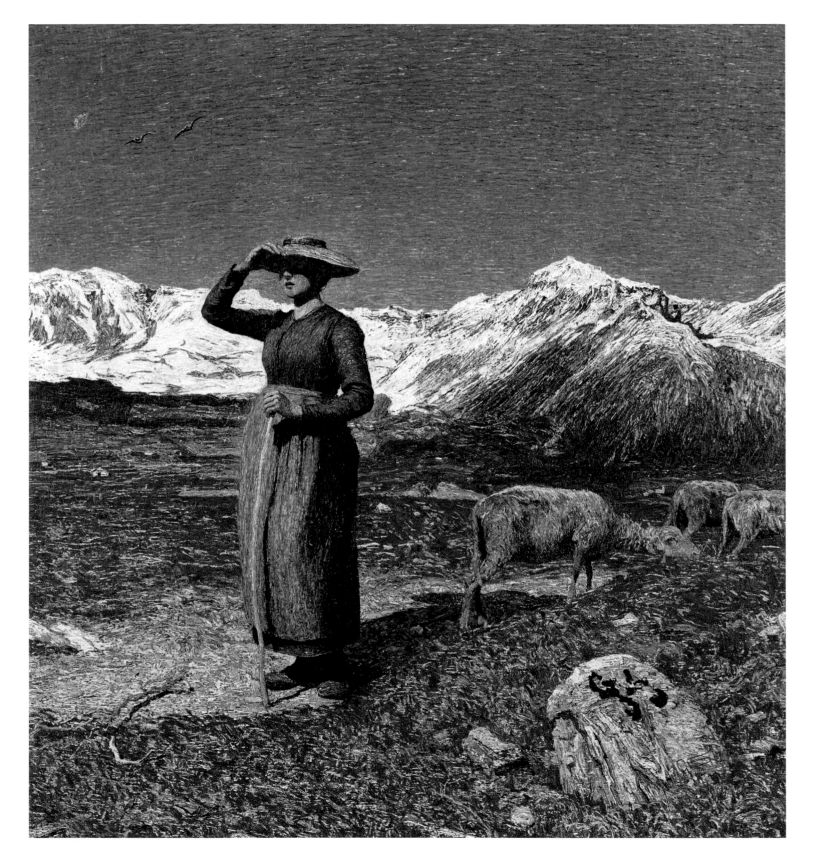

2 GIOVANNI SEGANTINI
Midday in the Alps (Mezzogiorno sulle Alpi), 1891
Oil on canvas, 77.5 × 71.5 cm
Segantini Museum, St Moritz, on loan from the Otto Fischbacher Giovanni Segantini Foundation

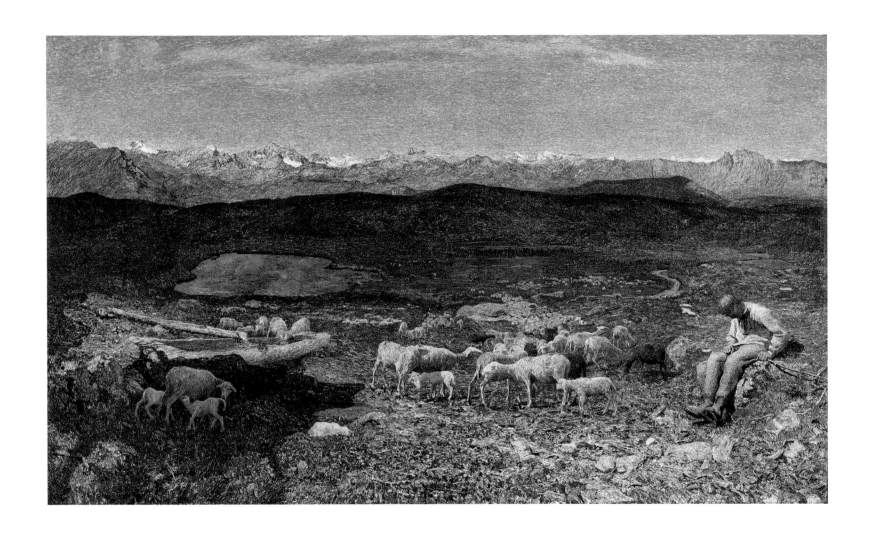

3 GIOVANNI SEGANTINI
Alpine Meadows (Pascoli alpini), 1893–4
Oil on canvas, 169 × 278 cm
Kunsthaus Zürich (1985/28)

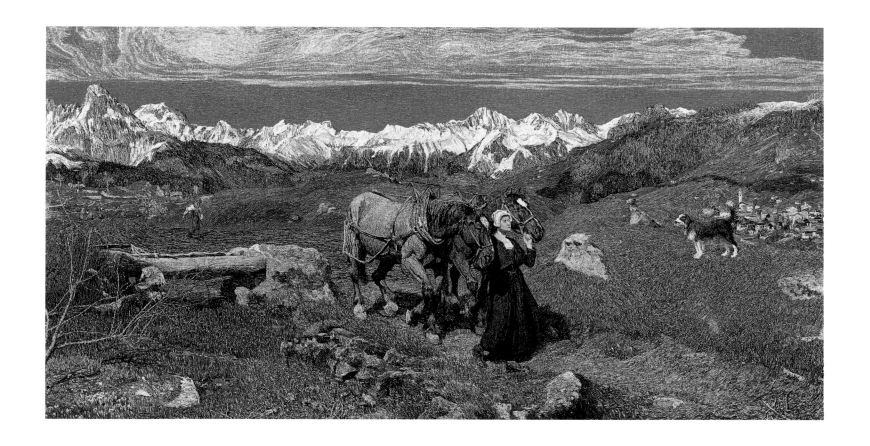

4 GIOVANNI SEGANTINI
Spring in the Alps (Primavera sulle Alpi), 1897
Oil on canvas, 116 × 227 cm
French & Company, New York

5 GIOVANNI SEGANTINI
My Models (I miei modelli), 1888
Oil on canvas, 65.5 × 92.5 cm
Kunsthaus Zürich, Society of Zurich Friends of Art (1975/16)

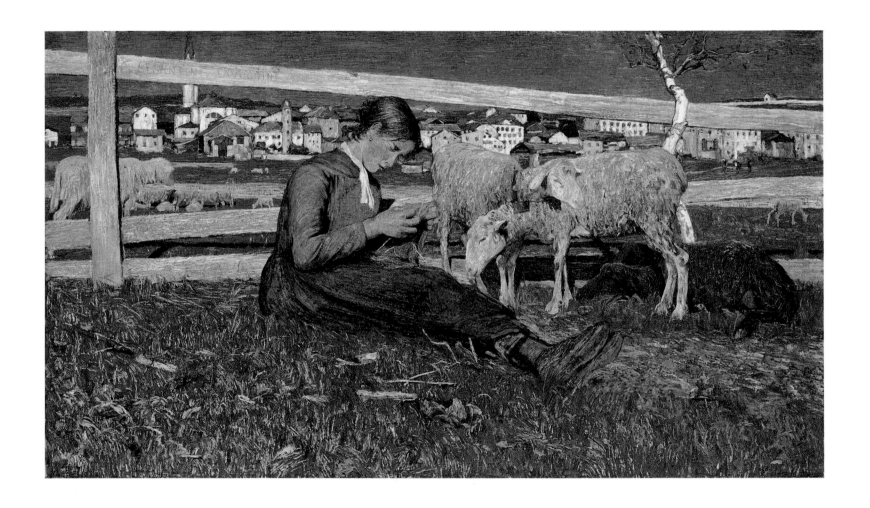

6 GIOVANNI SEGANTINI
Girl Knitting (Ragazza che fa la calza), 1888
Oil on canvas, 53 × 91.5 cm
Kunsthaus Zürich, on loan from Gottfried Keller Foundation (884)

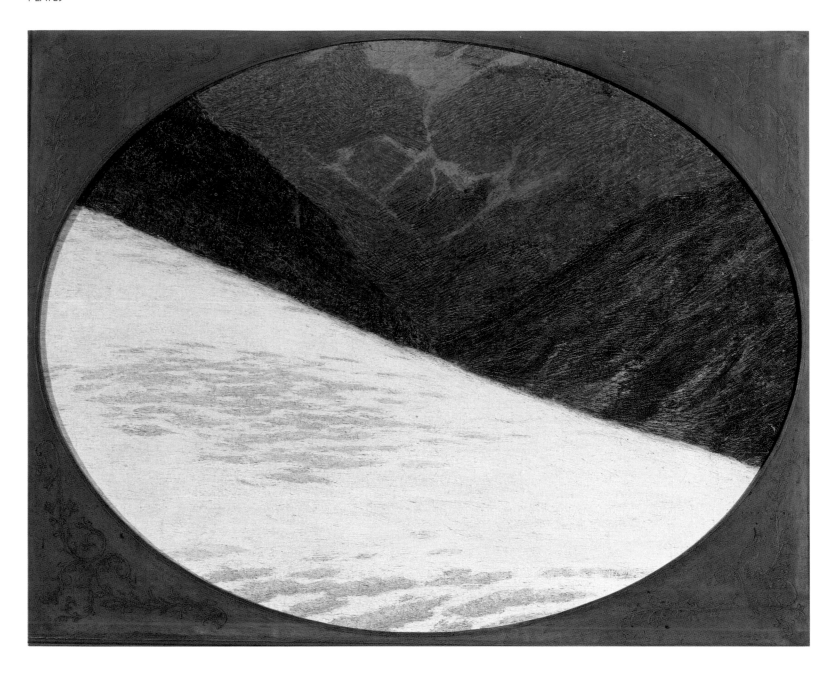

7 ANGELO MORBELLI
The Glacier of Forni (Il ghiacciaio dei Forni), 1910–12
Oil on canvas, 75 × 94 cm
Private collection

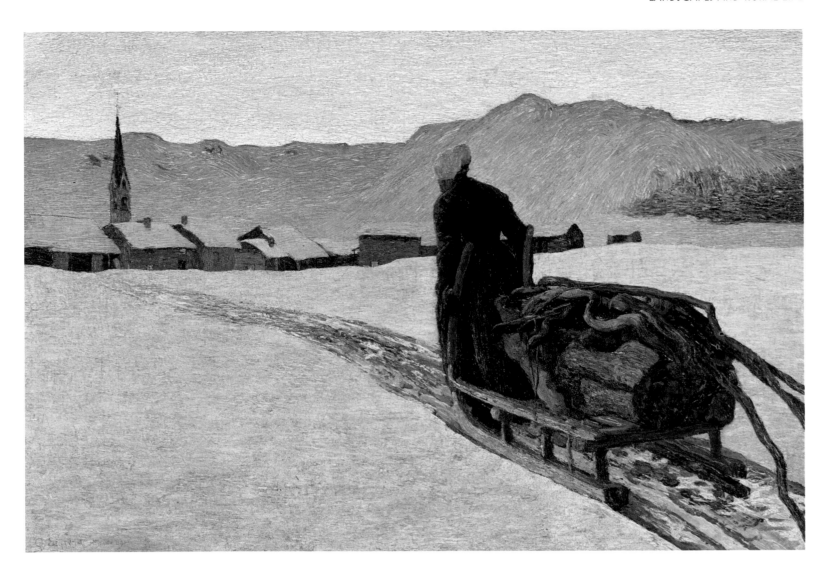

8 GIOVANNI SEGANTINI
Return from the Woods (Ritorno dal bosco), 1890
Oil on canvas, 64 × 95 cm
Segantini Museum, St Moritz, on loan from the Otto Fischbacher Giovanni Segantini Foundation

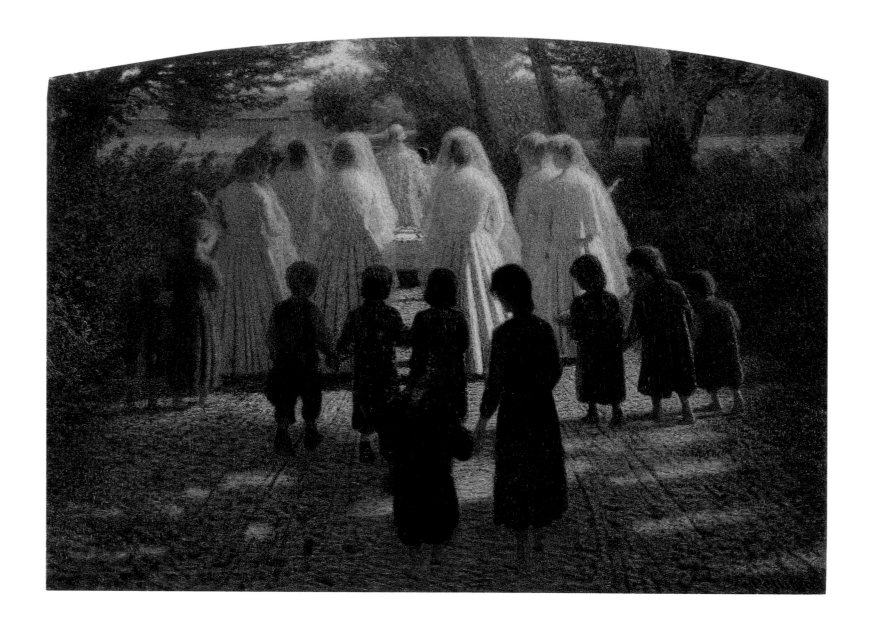

9 GIUSEPPE PELLIZZA DA VOLPEDO
The Dead Child (Il morticino or *Fiore reciso)*, 1896–1902
Oil on canvas, 79 × 105.5 cm
Musée d'Orsay, Paris (RF1977-281)

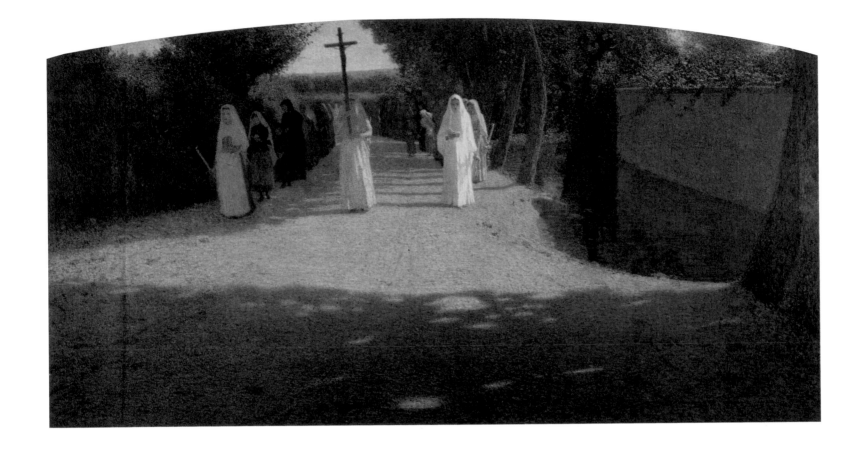

10 GIUSEPPE PELLIZZA DA VOLPEDO
The Procession (Processione), 1892–5
Oil on canvas, 95 × 157 cm
Museo Nazionale della Scienza e della Tecnologia Leonardo da Vinci, Milan (1782)

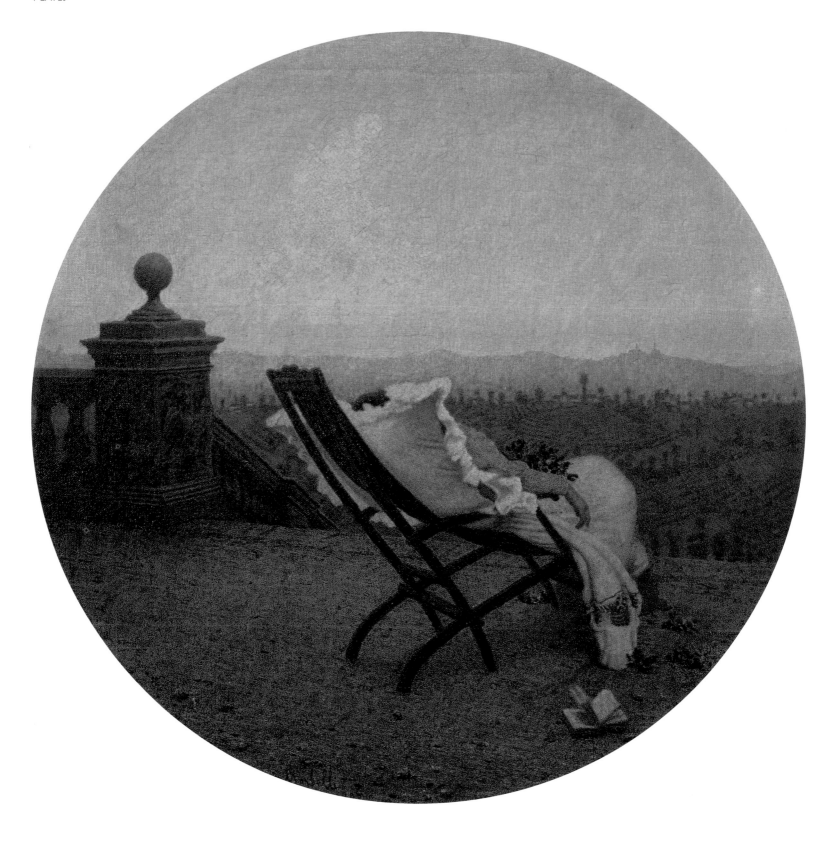

11 ANGELO MORBELLI
Twilight (S'avanza), 1896
Oil on canvas, 85 cm diameter
Galleria d'Arte Moderna, Comune di Verona

12 ANGELO MORBELLI
Dawn (Alba), 1891
Oil on canvas, 77.5 × 55 cm
MNAC. Museu Nacional d'Art de Catalunya, Barcelona (MNAC/MAM 11137)

13 VITTORE GRUBICY DE DRAGON
Morning (Mattino), 1897
Oil on canvas, 47 × 41 cm
Musée d'Orsay, Paris (RF1977-426)

14 VITTORE GRUBICY DE DRAGON
Sea of Mist (Mare di nebbia), 1895
Oil on canvas, 38.5 × 58.5 cm
Private collection

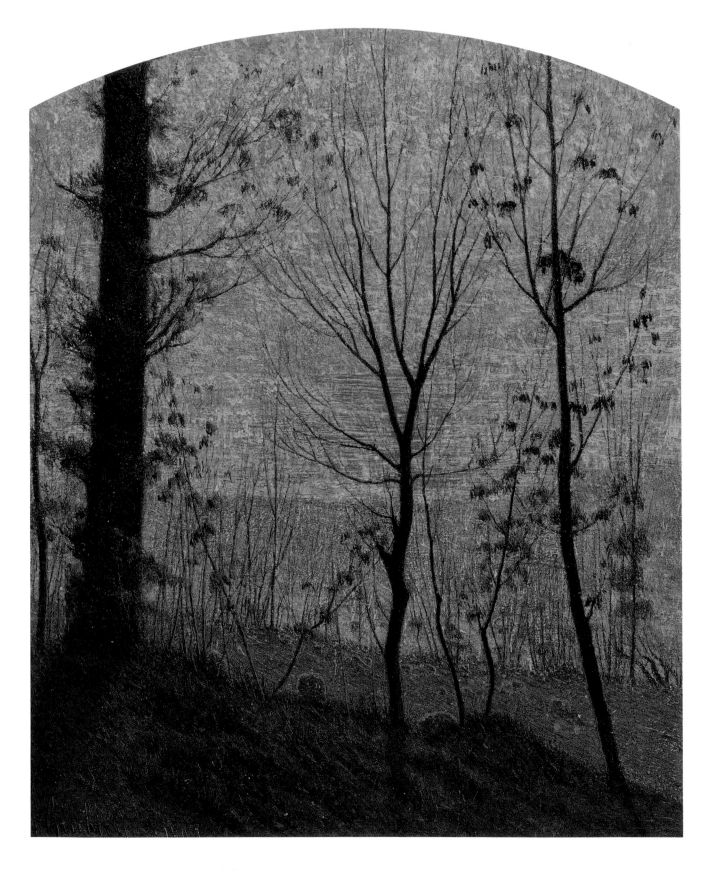

15 VITTORE GRUBICY DE DRAGON
Winter (Inverno), 1898
Oil on canvas, 48 × 40 cm
Musei Civici Veneziani, Galleria Internazionale d'Arte Moderna di Ca' Pesaro, Venice (163)

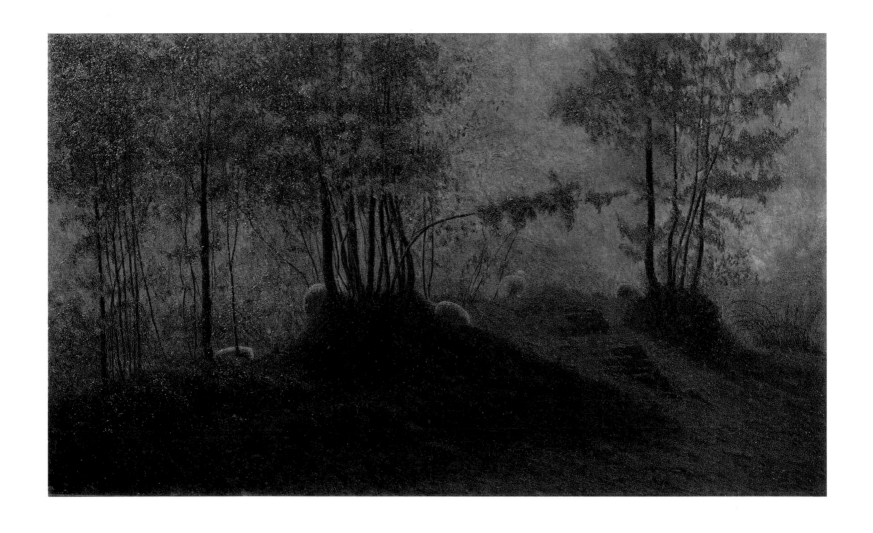

16 VITTORE GRUBICY DE DRAGON
Sheep among the Rocks (El crapp di rogoritt, or *Pecore sullo scoglio).* Oil on canvas, 58 × 98 cm. From the polyptych
Winter in the Mountains (Inverno in montagna. Poema panteista), 1894–7; reworked 1911–17
Civiche Raccolte d'Arte (Galleria d'Arte Moderna, Milan) (GAM 1720)

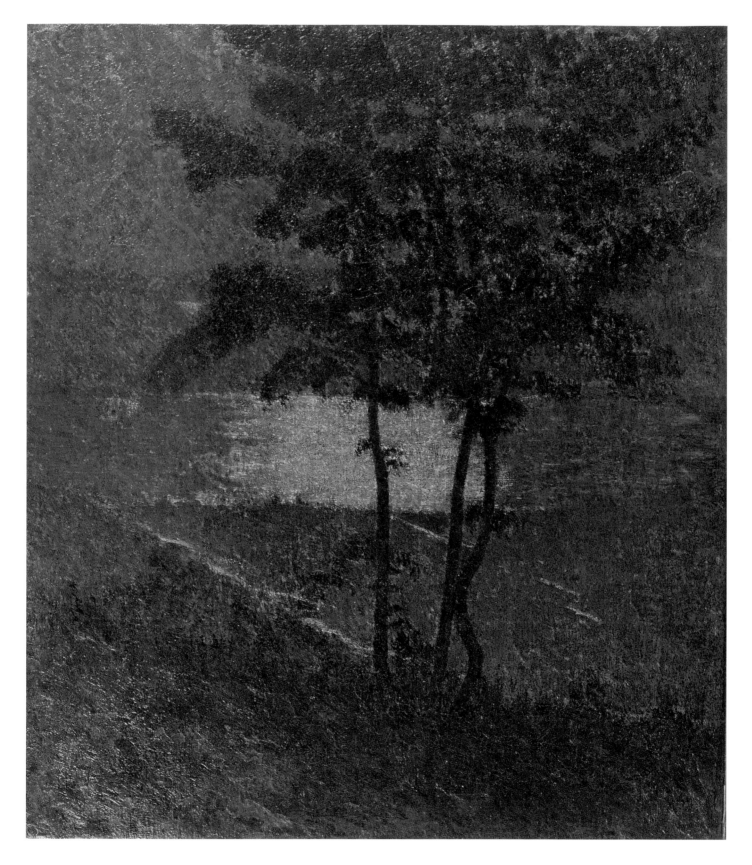

17 VITTORE GRUBICY DE DRAGON
Moonlight (Notte lunare or *Chiaro di luna).* Oil on canvas, 64.5 × 55.5 cm. From the polyptych
Winter in the Mountains (Inverno in montagna. Poema panteista), 1894–7; reworked 1911–17
Civiche Raccolte d'Arte (Galleria d'Arte Moderna, Milan) (GAM 1717)

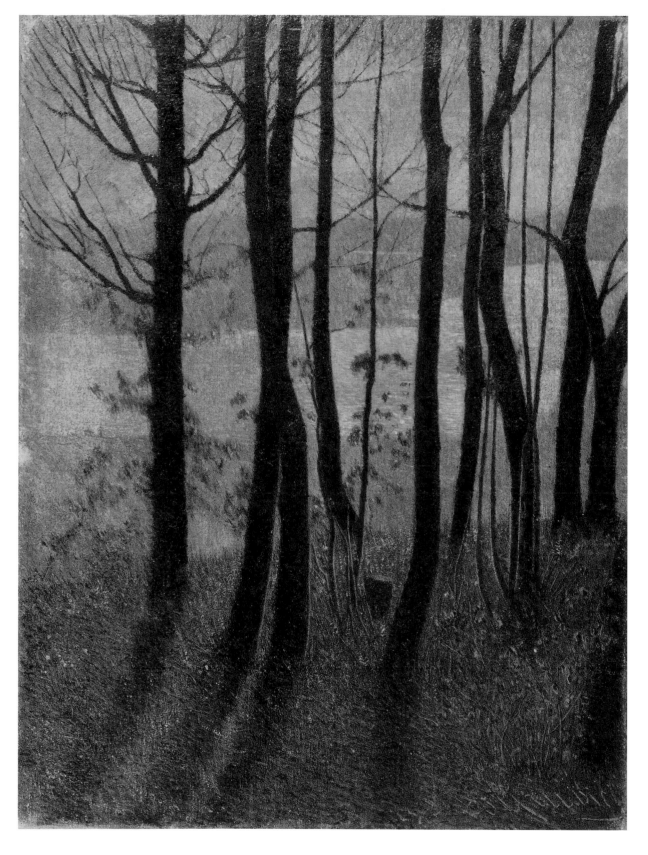

18 VITTORE GRUBICY DE DRAGON
Morning (Mattino or *Mattino gioioso)* Oil on canvas, 75 × 56 cm. From the polyptych
Winter in the Mountains (Inverno in montagna. Poema panteista), 1894–7; reworked 1911–17
Civiche Raccolte d'Arte (Galleria d'Arte Moderna, Milan) (GAM 1718)

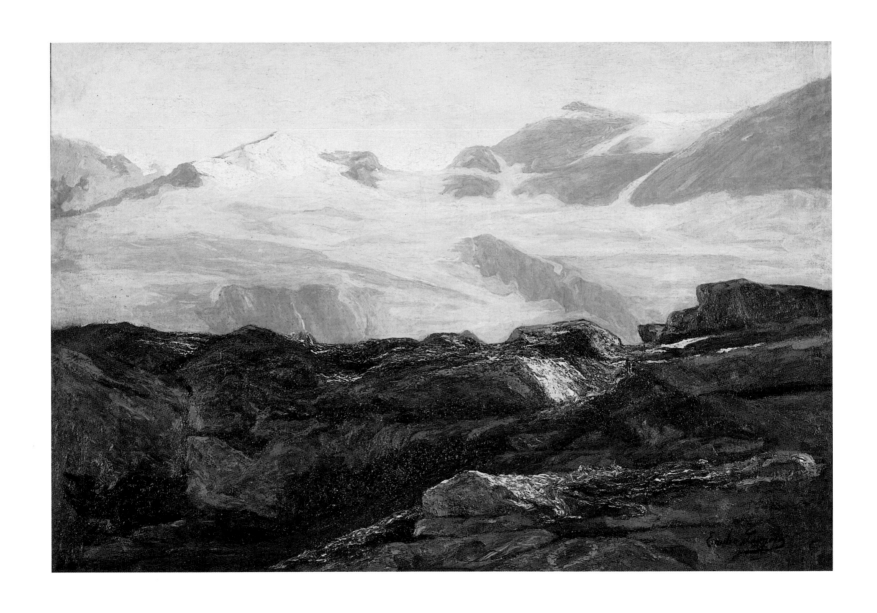

19 EMILIO LONGONI
Glacier, Bernina Pass (Passo del Bernina), 1904–5
Oil on canvas, 103 × 150 cm
Banca di Credito Cooperativo di Barlassina, Milan

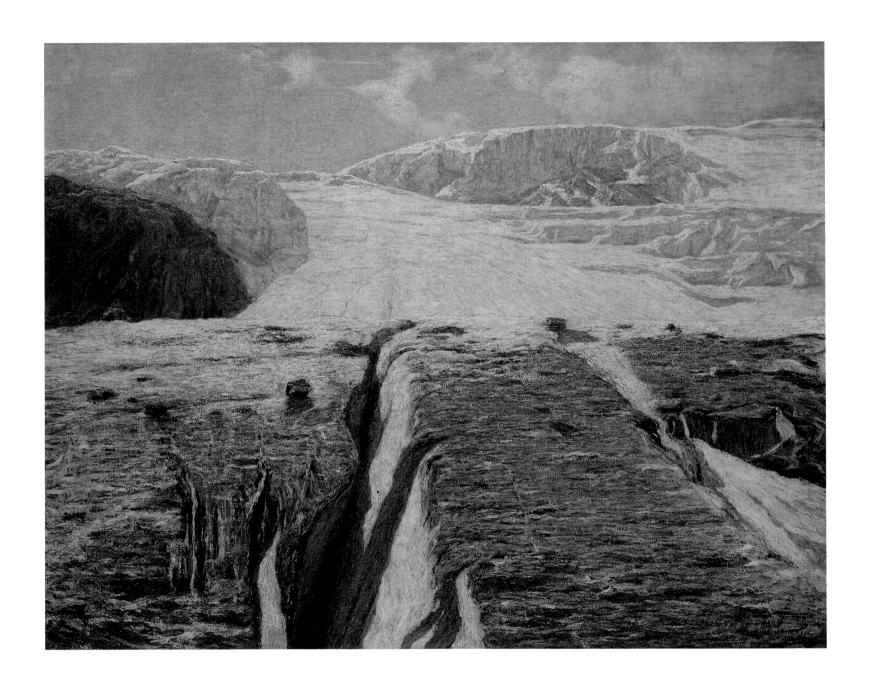

20 EMILIO LONGONI
Glacier (Ghiacciaio), 1905
Oil on canvas, 155 × 200 cm
Private collection

21 UMBERTO BOCCIONI
Roman Landscape or *Midday (Campagna Romana* or *Meriggio)*, 1903
Oil on canvas, 58.8 × 122 cm
Museo Civico di Belle Arti, Lugano (2254)

22 UMBERTO BOCCIONI
Lombard Countryside (Campagna Lombarda), 1908
Oil on canvas, 95 × 142.2 cm
Museo Civico di Belle Arti, Lugano (2258)

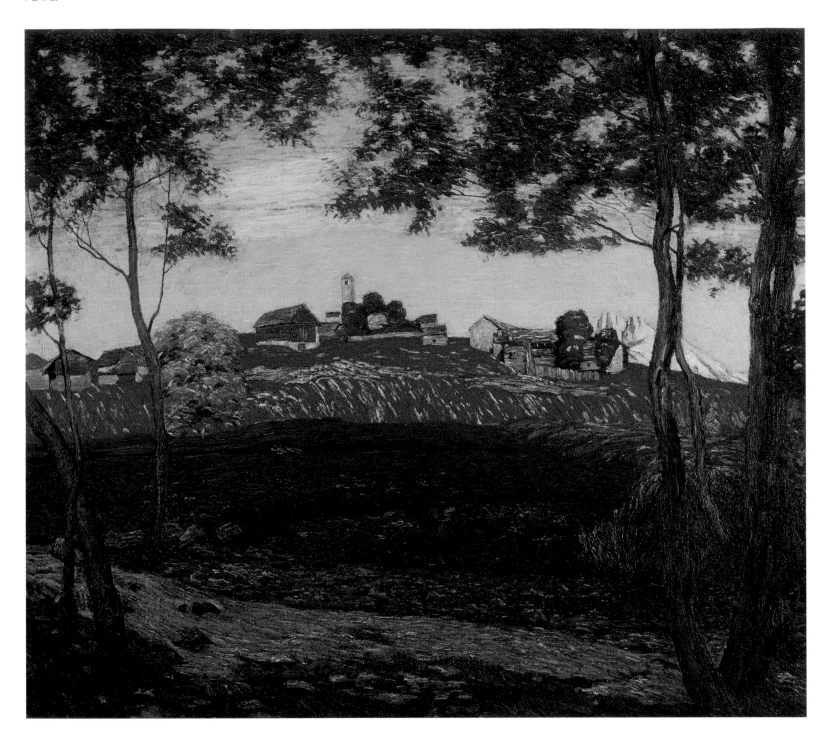

23 CARLO FORNARA
The Lengthening Shadow (L'ombra si stende), 1908
Oil on canvas, 70.5 × 81 cm
Private collection, courtesy James Roundell

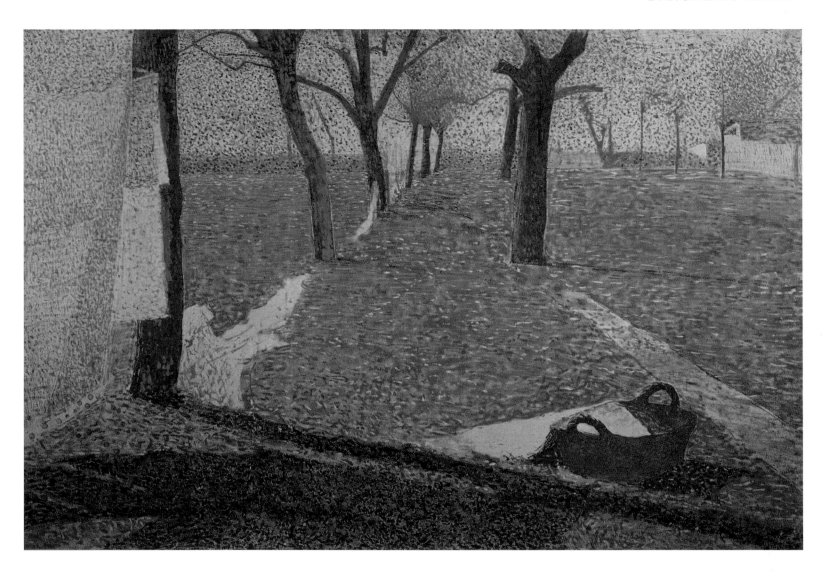

24 GIUSEPPE PELLIZZA DA VOLPEDO
Washing in the Sun (Panni al sole), 1905
Oil on canvas, 87 × 131 cm
Private collection, courtesy James Roundell

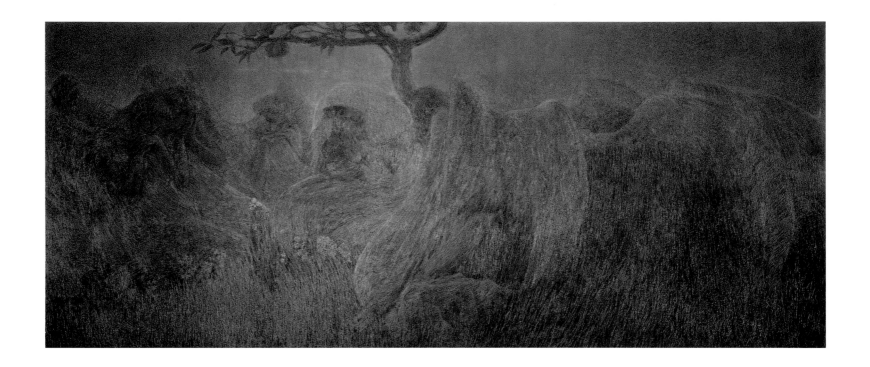

25 GAETANO PREVIATI
Motherhood (Maternità), 1891
Oil on canvas, 174 × 411 cm
Collection of Banca Popolare di Novara (38)

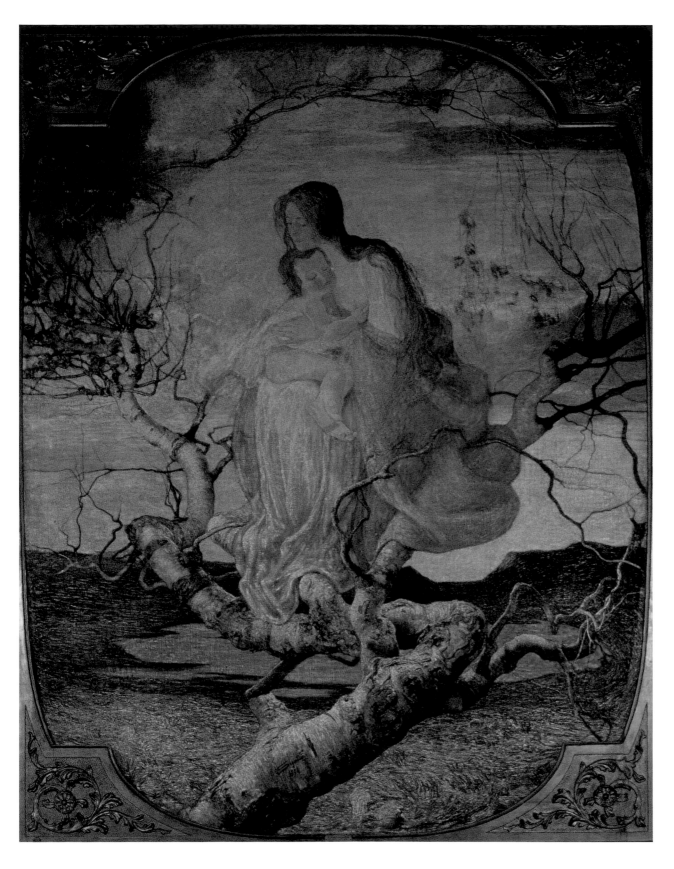

26 GIOVANNI SEGANTINI
The Angel of Life (L'angelo della vita), 1894
Oil on canvas, 276 × 212 cm
Galleria d'Arte Moderna, Milan (GAM 1592)

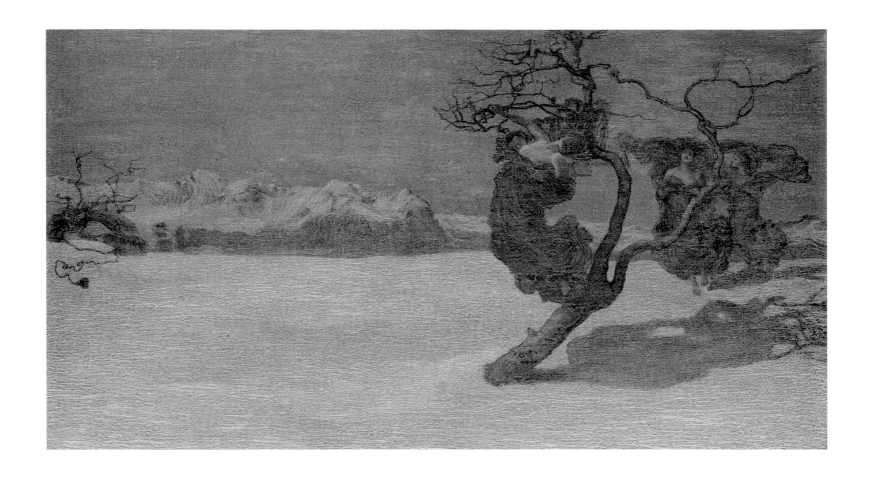

27 GIOVANNI SEGANTINI
The Bad Mothers (Le cattive madri), 1896/7
Oil on card, 40 × 74 cm
Kunsthaus Zürich (1967/66)

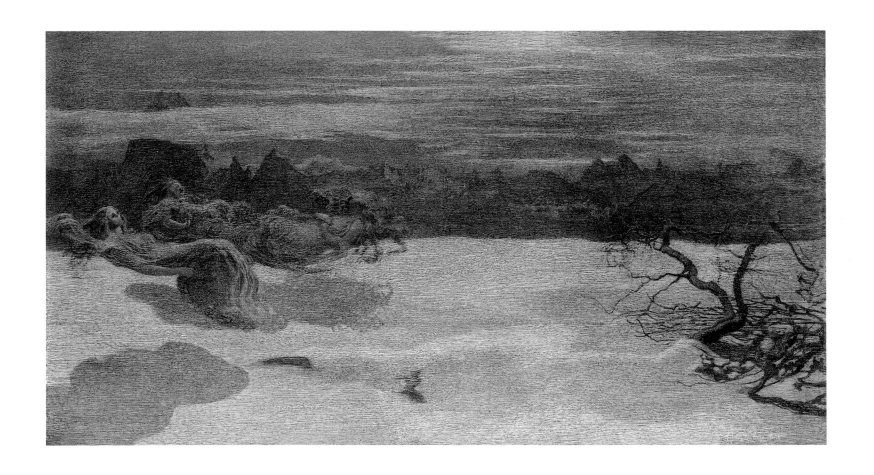

28 GIOVANNI SEGANTINI
The Punishment of Lust (Il castigo delle lussuriose), 1896/7
Oil on card, 40 × 74 cm
Kunsthaus Zürich, purchased with the support of A. Hansmann and Dr Meyer-Mahler (1967/67)

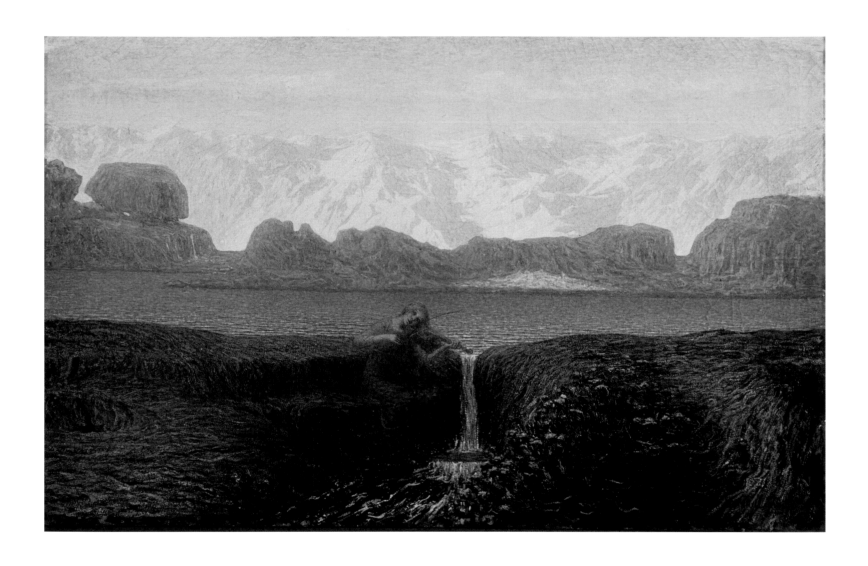

29 EMILIO LONGONI
The Sound of the Stream (Il suono del ruscello), 1902–3
Oil on canvas, 106 × 165 cm
Private collection

30 PLINIO NOMELLINI
Symphony of the Moon (Sinfonia della luna), 1899
Oil on canvas, 174 × 346 cm
Musei Civici Veneziani, Galleria Internazionale d'Arte Moderna di Ca' Pesaro, Venice

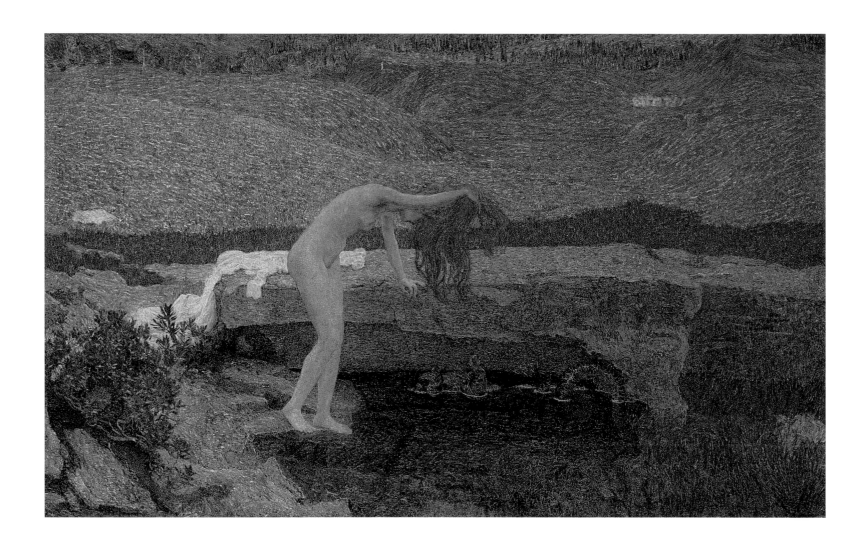

31 GIOVANNI SEGANTINI
Vanitas (La vanità), 1897
Oil on canvas, 77 × 124 cm
Kunsthaus Zürich, purchased with the support of UBS (1996/3)

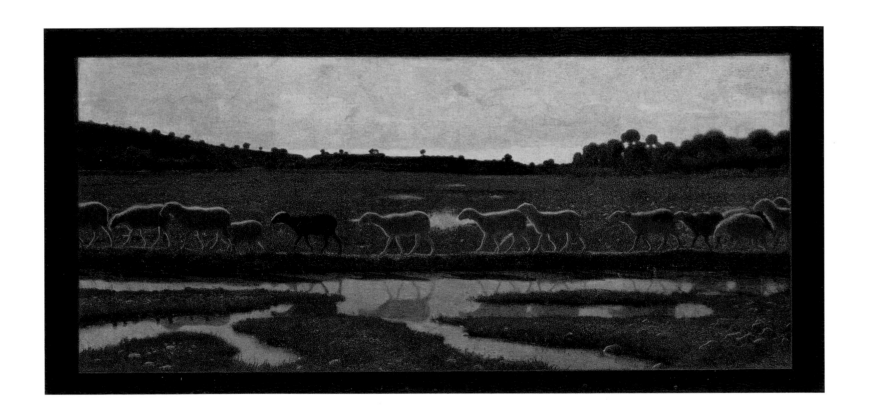

32 GIUSEPPE PELLIZZA DA VOLPEDO
The Mirror of Life: That which the First One does, the Others follow
(Lo specchio della vita: e ciò che l'una fa, e l'altre fanno), 1895–8
Oil on canvas, 132 × 291 cm
GAM – Galleria Civica d'Arte Moderna e Contemporanea, Turin (P 1017)

33 GAETANO PREVIATI
The Chariot of the Sun (Il carro del sole), 1907; central panel of *The Day (Il giorno)*, triptych
Oil on canvas, 127 × 185 cm
Camera di Commercio, Industria, Artigianato e Agricoltura, Milan (1680)

34 GAETANO PREVIATI
The Dream (Il sogno), 1912
Oil on canvas, 226 × 166 cm
Private collection

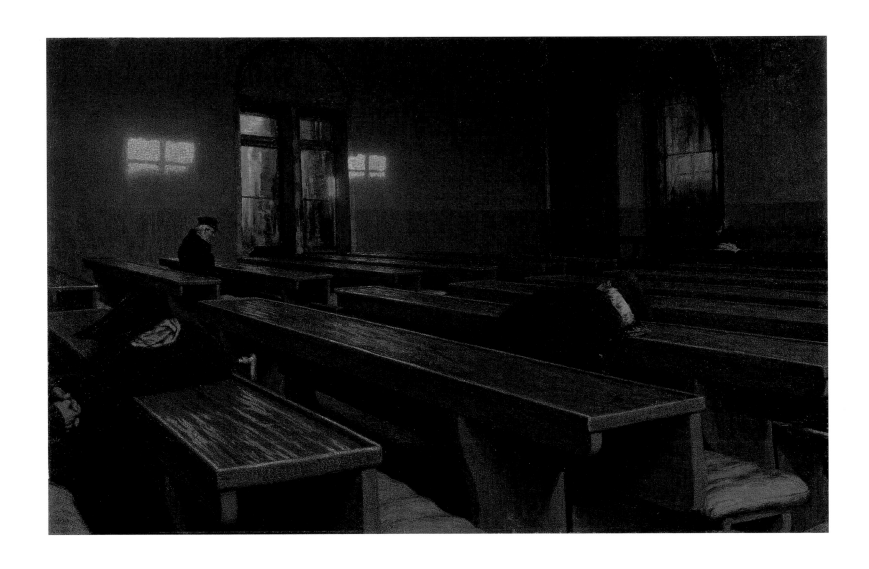

35 ANGELO MORBELLI
Holiday at the Pio Albergo Trivulzio (Giorno di Festa al Pio Albergo Trivulzio), 1892
Oil on canvas, 78 × 122 cm
Musée d'Orsay, Paris (RF1192)

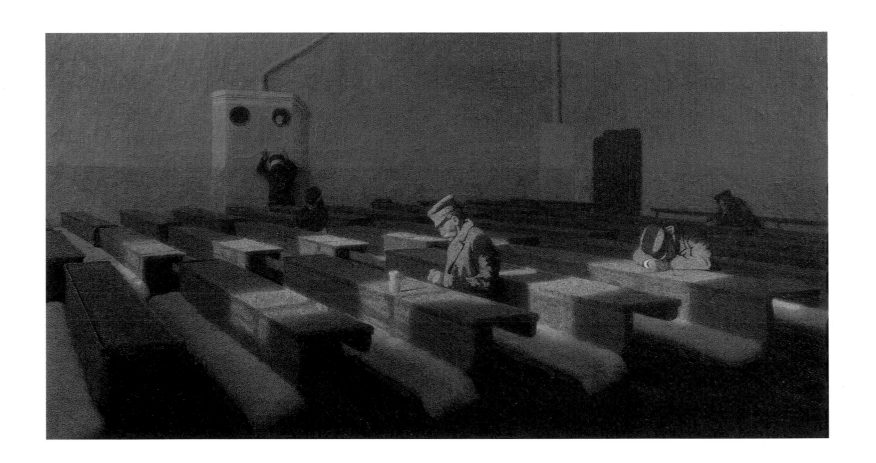

36 ANGELO MORBELLI
The Christmas of Those left behind (Il Natale dei rimasti), 1903
Oil on canvas, 61 × 110 cm
Musei Civici Veneziani, Galleria Internazionale d'Arte Moderna di Ca' Pesaro, Venice

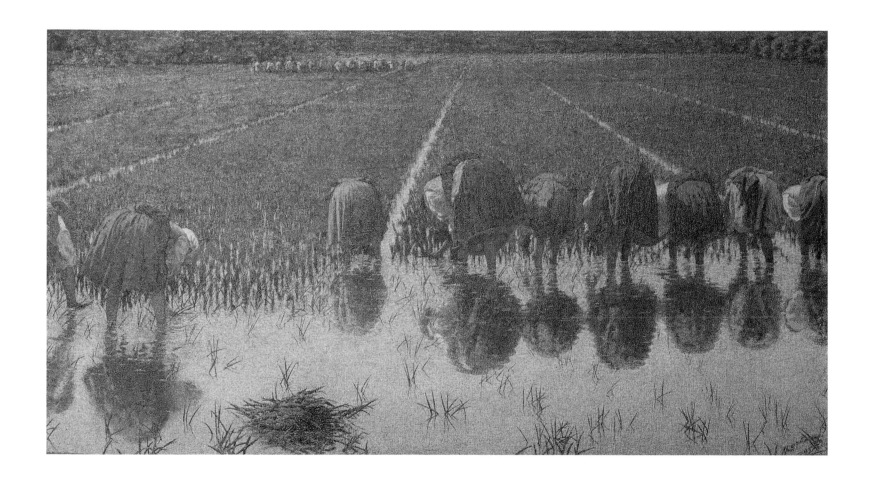

37 ANGELO MORBELLI

For Eighty Cents! (Per ottanta centesimi!), 1893–5
Oil on canvas, 69 × 124.5 cm
Fondazione Museo Francesco Borgogna, Vercelli (no. 196)

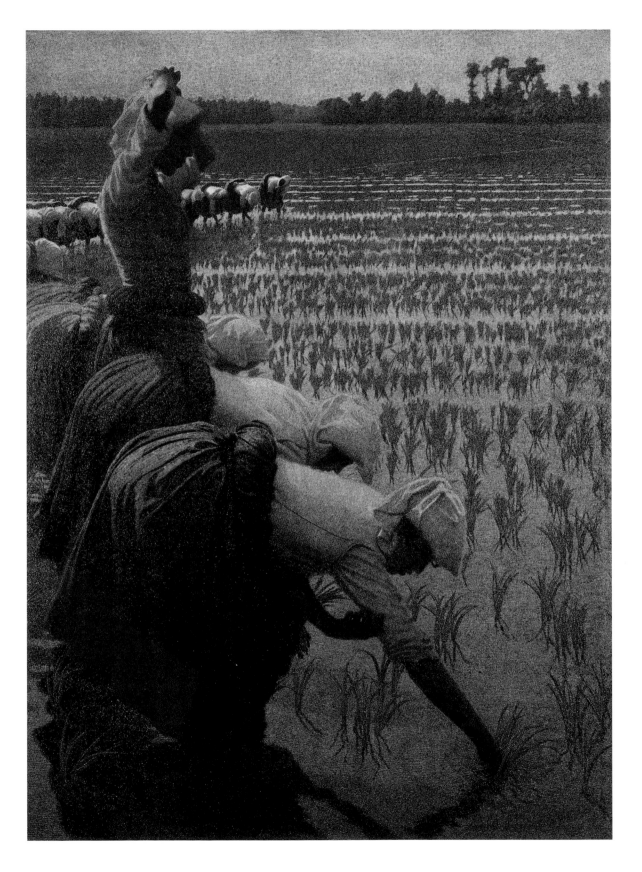

38 ANGELO MORBELLI
In the Rice Fields (In risaia), 1898–1901
Oil on canvas, 183 × 130 cm
Private collection

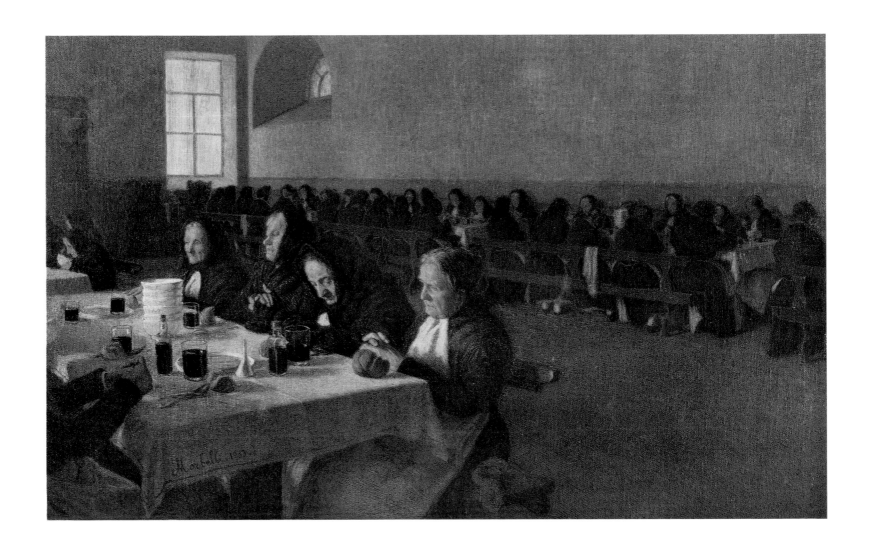

39 ANGELO MORBELLI
I Remember when I was a Girl (Entremets) (Mi ricordo quand'ero fanciulla, Entremets), 1903
Oil on canvas, 74.5 × 114.3 cm
Private collection, on loan to the Fondazione Cassa di Risparmio di Tortona

40 EMILIO LONGONI
Reflections of a Hungry Man or *Social Contrasts (Riflessioni di un affamato* or *Contrasti sociali)*, 1894
Oil on canvas, 190 × 155 cm
Fondazione Museo del Territorio Biellese, Biella (124/1980)

41 CARLO FORNARA
Washerwomen (Le lavandaie), 1898
Oil on canvas, 26.7 × 56.5 cm
Private collection, courtesy James Roundell

42 EMILIO LONGONI
Alone! (Sola!), 1900
Pastel on paper, 74.5 × 125 cm
Casa di Lavoro e Patronato per i Ciechi di Guerra di Lombardia, Milan

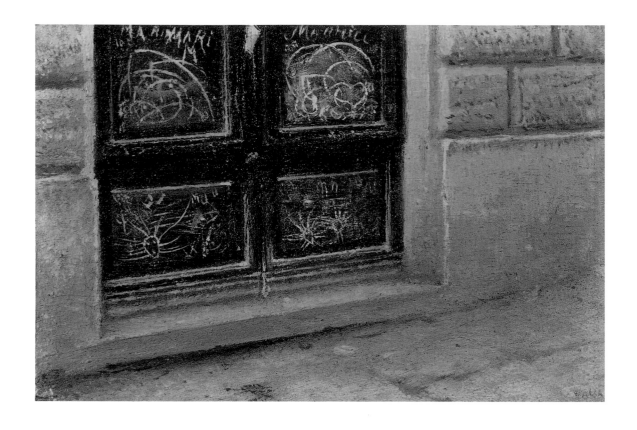

43 GIACOMO BALLA
Study for *Bankruptcy (Fallimento)*, date unknown
Oil on canvas, 11.5 × 17 cm
Private collection

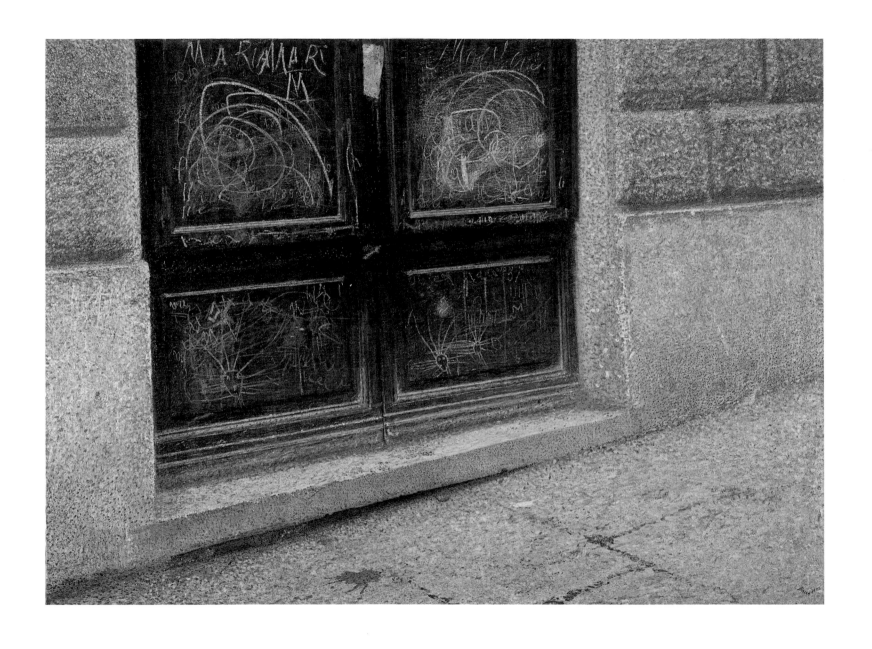

44 GIACOMO BALLA
Bankruptcy (Fallimento), 1902
Oil on canvas, 116 × 160 cm
Private collection

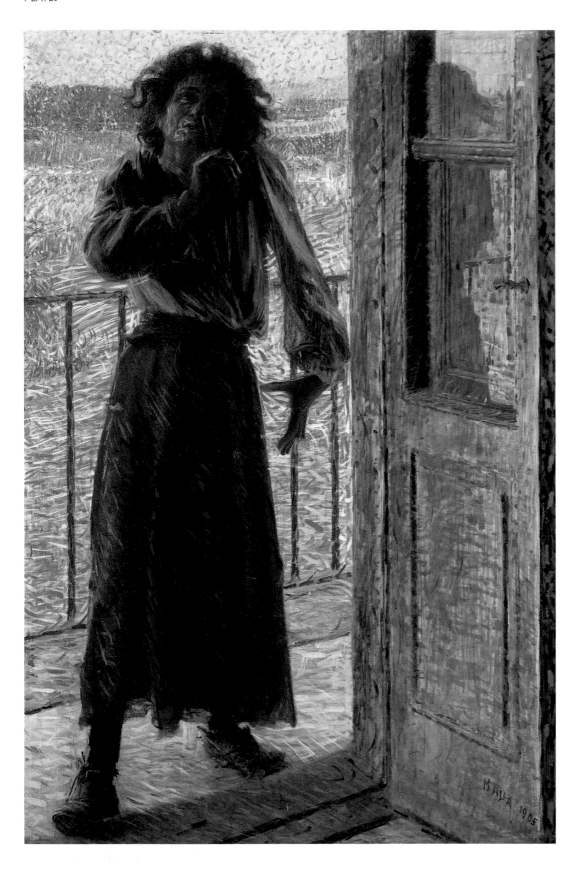

45 GIACOMO BALLA
The Madwoman (La folle), 1905; part of *The Polyptych of the Living (Il polittico dei viventi)*
Oil on canvas, 175 × 115 cm
Galleria Nazionale d'Arte Moderna, Rome (8146)

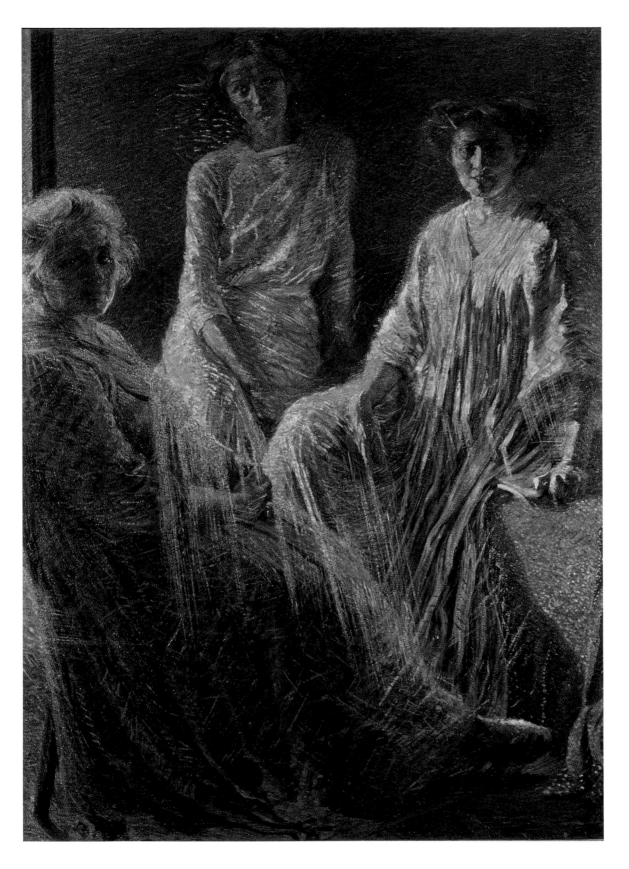

46 UMBERTO BOCCIONI
Three Women (Tre donne), 1909–10
Oil on canvas, 180 × 132 cm
Intesa Sanpaolo Collection, Milan (98)

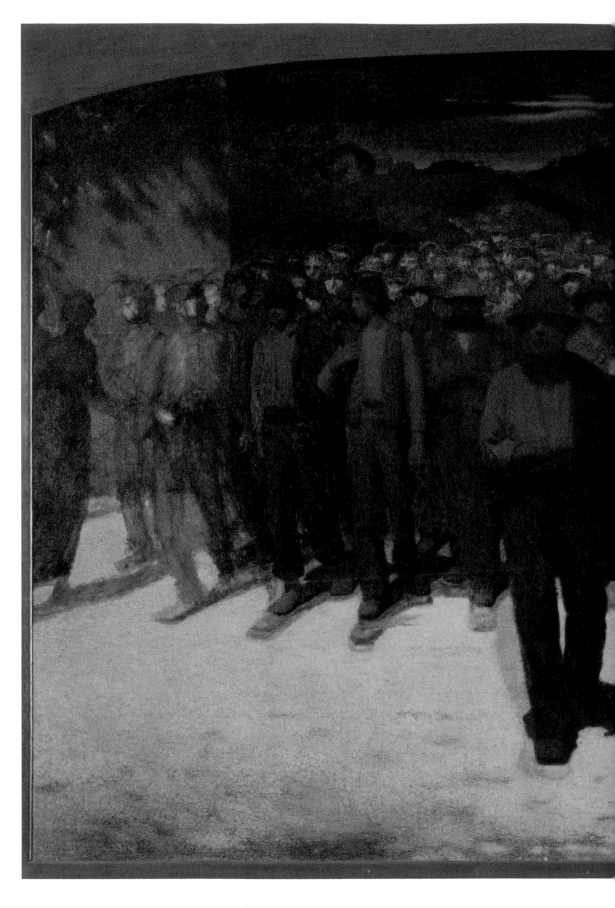

47 GIUSEPPE PELLIZZA DA VOLPEDO *The Living Torrent (Fiumana)*, 1895–6
Oil on canvas, 255 × 438 cm. Pinacoteca di Brera, Milan (Sprind gift, 1986/N.5555)

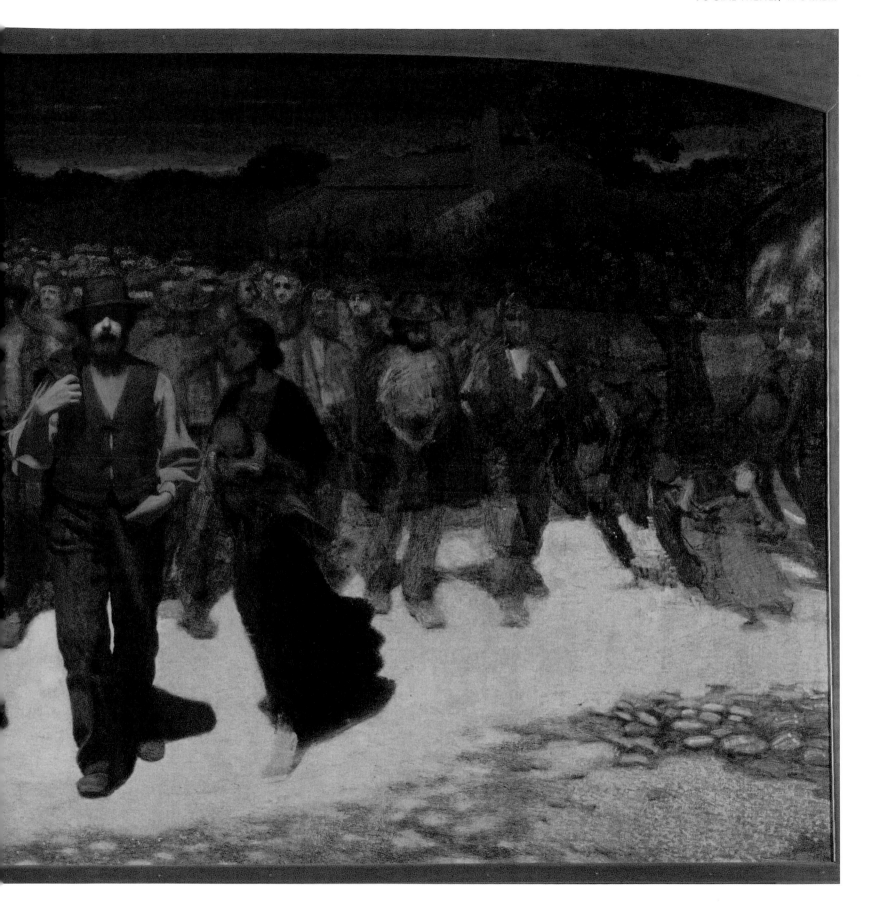

48 GIOVANNI SOTTOCORNOLA
December. The Workers' Dawn (Dicembre. L'alba dell'operaio), 1897
Oil on canvas, 142 × 253 cm
Civiche Raccolte d'Arte (Galleria d'Arte Moderna, Milan) (GAM 1596)

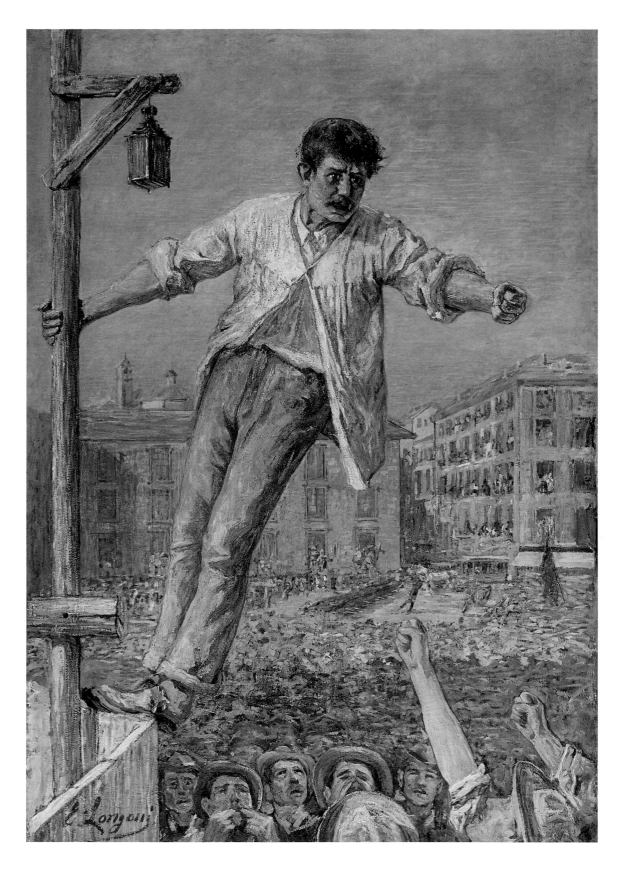

49 EMILIO LONGONI
The Orator of the Strike (L'oratore dello sciopero), 1890–1
Oil on canvas, 193 × 134 cm
Private collection, Pisa

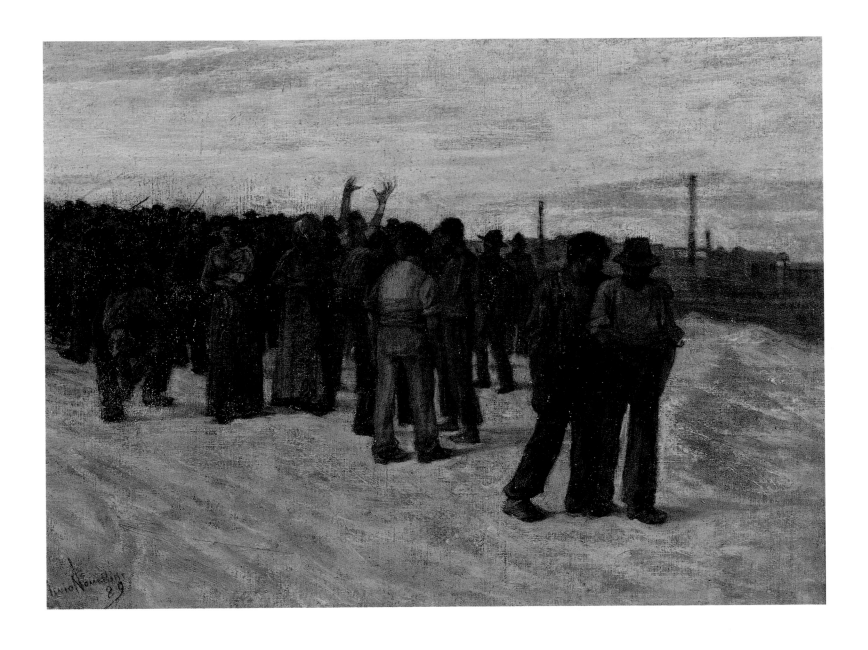

50 PLINIO NOMELLINI
The Strike (Lo sciopero), 1889
Oil on canvas, 29.5 × 40.5 cm
Private collection

51 PLINIO NOMELLINI
Piazza Caricamento, Genoa, 1891
Oil on canvas, 120 × 160 cm
Fondazione Cassa di Risparmio di Tortona

52 GIACOMO BALLA
The Farm Worker (Il contadino), 1903; part of *The Polyptych of the Living (Il polittico dei viventi)*
Oil on canvas, 172 × 112 cm
Accademia Nazionale di San Luca, Rome (697)

53 UMBERTO BOCCIONI
The Story of a Seamstress (Romanzo di una cucitrice), 1908
Oil on canvas, 150 × 170 cm
Barilla Collection of Modern Art, Parma

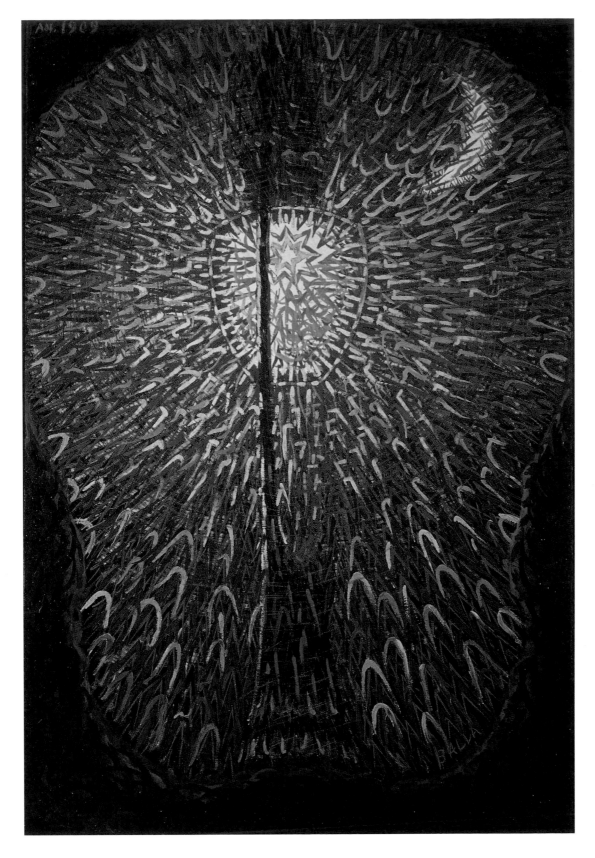

64 GIACOMO BALLA

Street Light (Lampada – studio di luce), dated by the artist 1909 (1910–11)

Oil on canvas, 174.7 × 114.7 cm

The Museum of Modern Art, New York (Hillman Periodicals Fund, 1954) (7.1954)

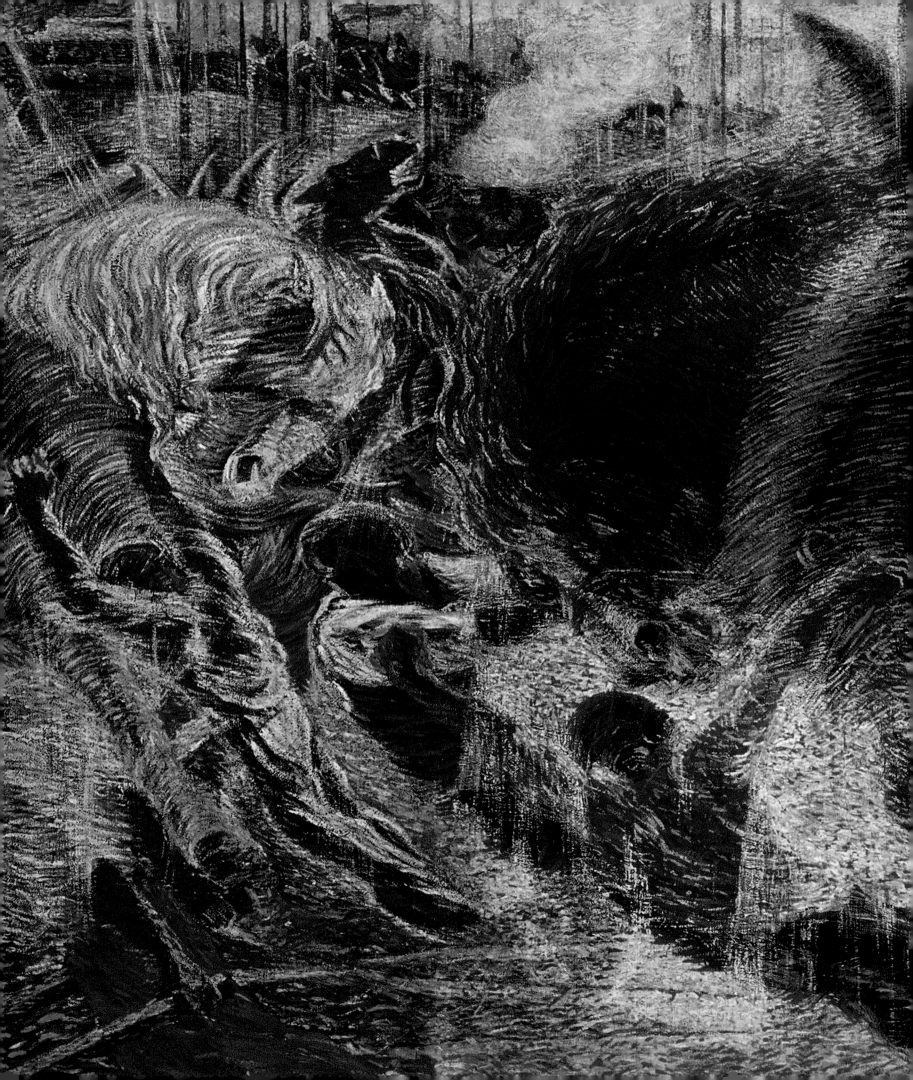

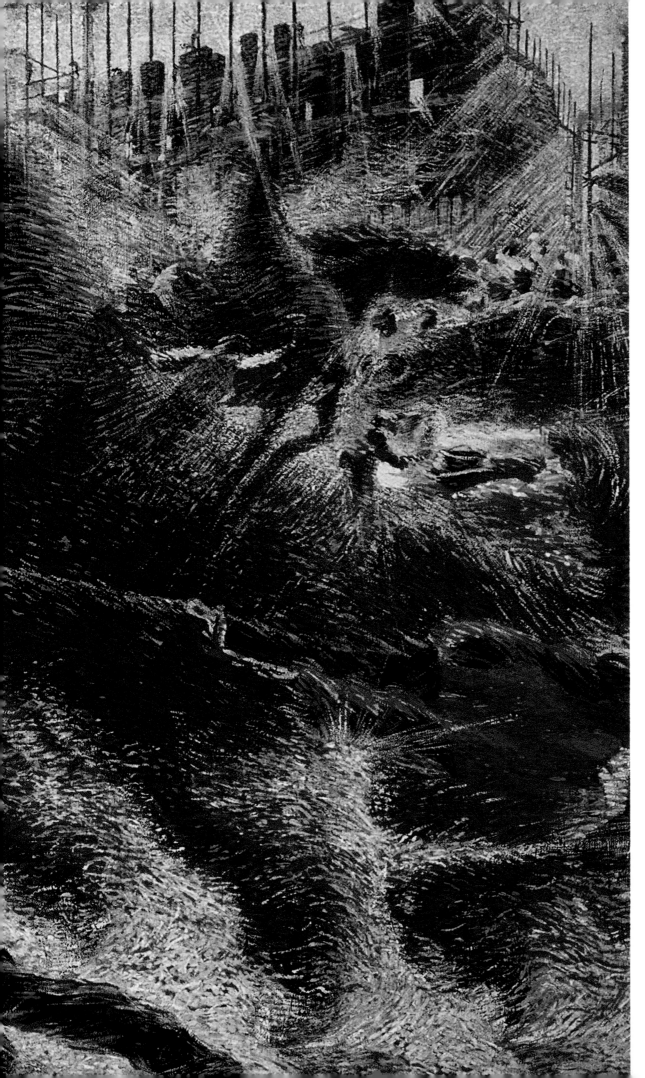

NOTES ON ARTISTS AND PAINTINGS

EDITORIAL NOTE

In the following section the artist biographies are arranged in alphabetical order. For each artist, selected paintings have extended notes which appear immediately after the biography. Subsequent works are broadly chronological in order, although the dates of some of the paintings are still the subject of current debate.
Titles of paintings are preceded by the catalogue numbers.

Simonetta Fraquelli **SF**
Lara Pucci **LP**
Linda Schädler **LS**

GIACOMO BALLA
1871 TURIN–1958 ROME

After the death in 1880 of Balla's father, an industrial chemist and keen amateur photographer, the family's financial position became precarious. Balla worked intermittently in a lithography workshop and, at the age of twenty, he enrolled at the Accademia Albertina in Turin, but left after a few months. He took evening classes in drawing and taught himself to paint, initially in a more traditional academic nineteenth-century style. He also attended lectures by prominent speakers and was deeply impressed by the controversial psychiatrist and founder of the study of criminal anthropology, Cesare Lombroso. Balla's first experience of exhibiting at the Promotrice di Belle Arti in Turin (1891) was so disappointing that he refused to participate for several years afterwards. Nevertheless, he continued working intensively, specialising in landscapes, portraits and caricatures. In 1895 Balla and his mother moved to Rome, where he suffered initially from isolation and nervous strain. There he became acquainted with the educationalist Alessandro Marcucci, the brother of his future wife, Elisa, whom he married in 1904.

In 1900 Balla travelled to Paris to see the Exposition Universelle. He stayed there for seven months, working for the painter and illustrator Sergio Macchiati, a close friend of Vittore Grubicy. Confused and fascinated in equal measure by the city, Balla also saw works by the Impressionists, Post-Impressionists and the Viennese Secessionists, as well as the sequential photographs of Étienne-Jules Marey (1830–1904), which recorded the movements of people and animals. Following his visit to Paris and influenced by the paintings of Pellizza and Morbelli, he turned more emphatically towards Divisionism. Balla was friendly with prominent socialist sympathisers such as the artist Dullio Cambellotti and the poet and publisher Giovanni Cena, and he designed covers for the left-wing weekly paper *Avanti della Domenica*. His work was inspired by an interest in the problems of the working class, the marginalised and the dispossessed, together with a scientific interest in the effects of both natural and artificial light, but he also continued to paint portraits and genre scenes of the middle classes.

Balla soon became a prominent member of the avant-garde in Rome; many artists visited his studio at the Porta Pinciana, and both Boccioni and Severini, who were later members of the Futurist movement, became pupils. Balla exhibited regularly in the annual exhibitions of the Società degli Amatori e Cultori di Belle Arti in Rome. Gradually he abandoned social and humanitarian topics, and in 1910–12 he produced his iconic work *Street Light* (cat. 64), underlining his interest in the representation of electric light. After 1910 Balla was producing Futurist paintings, influenced by his preoccupation with light phenomena as well as with movement and speed. This fascination with modernity was even reflected in the naming of his daughters: Elica (helix, propeller) and Luce (light). For a certain period he also developed an interest in sculpture and applied art. In the 1920s he increasingly dissociated himself from Futurism, finally breaking with the movement in 1937, when he returned to a form of realism that he pursued until his death. **LS**

SELECTED REFERENCES
Lista 1982; Fagiolo dell'Arco 1987; Fagiolo dell'Arco (ed.) 1989

ZURICH ONLY

44 *Bankruptcy* (*Fallimento*), 1902
Oil on canvas, 116 × 160 cm
Private collection

This strikingly original painting depicts a close-up view of a shop doorway, closed due to bankruptcy, on Rome's Via Veneto, close to the artist's studio just beyond the city centre. The bold composition dramatically truncates the doorway, focusing our attention on the material signs of neglect – the childish graffiti on the door, the glob of spit on the pavement – studied in detail informed by photography. This meticulously observed view, reproduced in a dense web of precise marks reminiscent of Morbelli's painted surfaces, combines with the life-size dimensions of the canvas to produce a powerful illusion of a slice of the city having been brought into the gallery.

Balla enhanced this illusion, designing the canvas to rest on the floor, with the oblique perspective implying continuity between pictorial and gallery space, inviting us to step on to the pavement and replicate the artist's original encounter with the bankrupt premises. A 1929 photograph shows Balla posing in front of the painting, as though walking on the pavement in front of the abandoned doorway, having stopped momentarily to pick up his hat from the ground.

In contrast to the expansive views of the burgeoning industrial landscape in Boccioni's pre-Futurist paintings such as *Workshops at Porta Romana* (1909, cat. 55), Balla directs his gaze into the gutter of the city. By bringing this overlooked corner of the urban fabric into the gallery, Balla sought to draw his viewers' attention to the plight of the city's victims. The bankrupt doorway is symbolic of the destroyed lives of the people who had depended on this abandoned business.

The human cost of industrial growth was a recurrent theme in Balla's pre-Futurist oeuvre, which is implicitly critical of the romanticised conception of the city that would be upheld by the Futurists. For example, *The Worker's Day* (*La giornata dell'operaio*, 1904, fig. 22) – also known as *They Work, Eat and Go Home* (*Lavorano, Mangiano, Ritornano*) – does not simply celebrate the emergence of the new city, but describes the

inescapable cycle of labour for those employed to construct it.

Bankruptcy is also related to a series of paintings on the theme of social exclusion on which Balla began work in the same year: *The Polyptych of the Living: The Beggar, The Sick, The Farm Worker* (*Il polittico dei viventi: Il mendicante, I malati, Il contadino*, 1902–5); see *The Madwoman*, 1905, cat. 45, and *The Farm Worker*, 1903, cat. 52. The humanitarian socialism that inspired these paintings was informed by the

work of the socialist writer Giovanni Cena, originally from Turin, who would later establish schools for rural workers in the Roman countryside.

Combining social realism with a Divisionist technique, *Bankruptcy*, like these other pre-Futurist works, was consistent with the political and aesthetic concerns of Morbelli and Pellizza, also a close friend of Giovanni Cena, whom Balla met in his native Turin before settling in Rome in 1895. **LP**

PROVENANCE
Collection of Giuseppe Cosmelli, Rome

SELECTED EXHIBITIONS
1903 Rome, Società degli Amatori e Cultori di Belle Arti, *LXXIII Esposizione*; **1914** Rome, Società degli Amatori e Cultori di Belle Arti, *LXXXIII Esposizione*; **1935** Rome, Galleria Antonina, *Balla*; **1960** Venice, *XXX Biennale Internazionale d'Arte* (*Mostra storica del Futurismo*); **1961–2** New York (Museum of Modern Art), Detroit (Institute of Arts), Los Angeles (County Museum), *Futurism*; **1963** Turin, Civica Galleria d'Arte Moderna, *Giacomo Balla*; **1968** Rome, Galleria l'Obelisco, *Ricostruzione futurista dell'universo*; **1986** Venice, Palazzo Grassi, *Futurismo & Futurismi*; **1989** London, Royal Academy of Arts, *Italian Art in the 20th Century*

SELECTED REFERENCES
Fiori (ed.) 1968, p. 139, cat. X.58; Martin 1968, p. 74; Barnes Robinson 1981, pp. 36–7; Balla 1984, pp. 113–5, 117; Drudi Gambillo and Fiori (eds) 1986, vol. II, p. 152, cat. 9 [incorrect dimensions]; Tisdall and Bozzolla 1996, pp. 62, 122; Caroli and Masoero (eds) 2001, cat. 71 (preparatory study)

43 Study for *Bankruptcy* (*Fallimento*), date unknown

Oil on canvas, 11.5 × 17 cm
Private collection

PROVENANCE
Collection of the artist; Angelo Bajocchi collection, Rome

LONDON ONLY

64 *Street Light (Lampada – studio di luce)*, dated by the artist 1909 (1910–11)

Oil on canvas, 174.7 × 114.7 cm
The Museum of Modern Art, New York (Hillman Periodicals Fund, 1954) (7.1954)

Inspired by one of the first electric street lights in Rome, Balla's first 'Futurist' painting can be read as a visual response to some of the early proclamations of that newly-formed movement. The Technical Manifesto of Futurist Painting, to which Balla put his name in 1910, declared that: 'The suffering of a man is of the same interest to us as the suffering of an electric lamp, which, with spasmodic starts, shrieks out the most heartrending expressions of colour.' And Marinetti's celebration of artificial illumination, 'Let's Kill the Moonlight', published in *Poesia* in 1909, may account for Balla's retrospective dating of the canvas, which was executed in 1910–11.

Unlike Russolo's *Lightning* (*I lampi*, 1909–10, cat. 59), which privileges the explosive display of natural light effects over the gentle glow of the artificial streetlights below, the raging beams of Balla's street lamp engulf the

diminutive crescent moon, as Marinetti's 1909 manifesto had threatened.

Balla had explored artificial light effects before – in *Work* (*Lavoro*, 1902) and *The Worker's Day* (*La giornata dell'operaio*, 1904, fig. 22) – but these had been contextualised by social themes: the deserted place of work observed in reverential contemplation on the condition of the worker; or the illuminated streetlamp indicating the long-awaited end of the worker's day. *Street Light* is striking as a study of light *per se*. This conceptual shift is as relevant an indicator of Balla's nascent Futurism as the stylistic transition from the delicate Divisionist mark-making of those earlier works to the bold, spiky chevrons that dominate this canvas.

However, the continuing influence of the Divisionist methods of Pellizza, whose work had taught Balla the technique of applying pure colour in individual strokes, is

evident from a comparison between *Street Light* and Pellizza's *The Sun (Rising Sun) (Il Sole (Sole nascente)*, 1904, fig. 18). The tonal transition of the sharp rays emanating from Pellizza's sun is replicated in the arc of Balla's street light: from the white-hot centre of the light source, to yellows, merging with reds, into deep greens with hints of blue in lighter areas and flecks of brown-black in areas of shade. This was surely a conscious choice by Balla, acknowledging his debt to Divisionism while, at the same time, announcing the dawn of a new era: the Futurist sun would be electric.

Despite *Street Light* being listed in the catalogue for the 1912 Futurist exhibition at Galerie Bernheim-Jeune in Paris, Balla did not in fact exhibit this or any other work there. His decisive commitment to the Futurist project would emerge later that year with two studies of fragmented movement: *Dynamism of a Dog on a Leash (Dinamismo di un cane al guinzaglio)* and *The Hand of the Violinist (La mano del violinista)*. **LP**

PROVENANCE
Giacomo Balla, Rome (1909–54); The Museum of Modern Art, New York. Purchased in 1954 from the artist at the Sidney Janis Gallery, New York, from the Hillman Periodicals Fund

SELECTED EXHIBITIONS
1913 Rome, Teatro Costanzi, *Mostra Futurista*; **1913** Rotterdam, Rotterdamsche Kunstring, *Les Peintres et les sculpteurs futuristes italiens*; **1914** Rome, Società degli Amatori e Cultori di Belle Arti, *LXXXIII Esposizione*; **1928** Rome, Società degli Amatori e Cultori di Belle Arti, *XCIV Esposizione*; **1961–2** New York (Museum of Modern Art), Detroit (Institute of Arts), Los Angeles (County Museum), *Futurism*; **1971** Rome, Galleria Nazionale d'Arte Moderna, *Giacomo Balla*; **1986** Venice, Palazzo Grassi, *Futurismo & Futurismi*; **1989** London, Royal Academy of Arts, *Italian Art in the 20th Century*; **2001** Paris, Musée d'Orsay, *Italies 1880–1910*

SELECTED REFERENCES
Fiori (ed.) 1968, vol. II, p. 146, cat. X.185 (*Lampada ad arco*); Martin 1968, pp. 173, 175 (*Lampe électrique*); Balla 1984, p. 184; Barnes Robinson 1981, pp. 83-7; Drudi Gambillo and Fiori (eds) 1986, vol. II, p. 152, cat. 16 (*Lampada ad arco*); Hulten (ed.) 1986, p. 425; Tisdall and Bozzolla 1996, pp. 60, 63–4; Humphreys 1999, p. 20; Piantoni and Pingeot (eds) 2000, p. 261

52 *The Farm Worker (Il contadino)*, 1903; part of *The Polyptych of the Living*

Oil on canvas, 172 × 112 cm
Accademia Nazionale di San Luca, Rome (697)

PROVENANCE
Purchased from the 1914 exhibition by the Accademia Nazionale di San Luca, Rome, after being awarded the Gustavo Müller prize

SELECTED EXHIBITIONS
1909 Rome, Palazzo delle Esposizioni, *LXXIX Esposizione Internazionale di Belle Arti della Società Amatori e Cultori di Belle Arti in Roma* [*Dei viventi*]; **1909** Paris, Grand Palais, *Salon d'Automne* (*Section d'Art Italienne*); **1910** Buenos Aires, *Esposizione Internazionale di Belle Arti*; **1914** Rome, Palazzo delle Esposizioni, *L'ottantatressima esposizione della Società Amatori e Cultori di Belle Arti – Roma*; **1929–30** Rome, Palazzo delle Esposizioni, *Mostra del Centenario degli Amatori e Cultori di Belle Arti. Seconda Mostra del Sindacato Laziale Fascista di Belle Arti* (solo exhibition) [*Ortolano*]; **1971–2** Rome, Galleria Nazionale d'Arte Moderna, *Giacomo Balla (1871–1958)*; **1979** Milan, Società per le Belle Arte ed Esposizione Permanente, *Arte e Socialità in Italia. Dal realismo al simbolismo. 1865–1915*; **1988** Amsterdam, Rijksmuseum Vincent Van Gogh, *Ottocento/Novecento Italiaanse Kunst 1870–1910*; **1998** Padua, Palazzo Zabarella, *Giacomo Balla 1895–1911. Verso il futurismo*

SELECTED REFERENCES
Fagiolo dell'Arco 1968, p. 22; Fiori (ed.) 1968, vol. II, p. 139, cat. X.65; Barnes Robinson 1981, p. 52; Balla 1984, vol. I, pp. 171–2, 346, 355; Drudi Gambillo and Fiori (eds) 1986, vol. II, p. 151, cat. 6; Fagiolo dell'Arco (ed.) 1998, p. 128, cat. 60

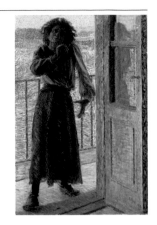

45 *The Madwoman (La folle)*, 1905; part of *The Polyptych of the Living*
Oil on canvas, 175 × 115 cm
Galleria Nazionale d'Arte Moderna, Rome (8146)

PROVENANCE
Luce and Elica Balla, donated 1984

SELECTED EXHIBITIONS
1909 Rome, Palazzo delle Esposizioni, *LXXIX Esposizione Internazionale di Belle Arti della Società Amatori e Cultori di Belle Arti in Roma* [*Dei viventi*]; **1909** Paris, Grand Palais, *Salon d'Automne* (*Section d'Art Italienne*); **1979–80** London (Royal Academy of Arts), Washington (National Gallery of Art), *Post-Impressionism: Cross Currents in European Painting;* **1986** Venice, Palazzo Grassi, *Futurismo & Futurismi;* **2001** Paris, Musée d'Orsay, *Italies 1880–1910*

SELECTED REFERENCES
Fagiolo dell'Arco 1968, cat. 57, pp. 22–3, 43–4; Fiori (ed.) 1968, vol. II, p. 142, cat. X.120; Berresford 1979, pp. 228–9, cat. 361; Barnes Robinson 1981, pp. 52–3; Drudi Gambillo and Fiori (eds) 1986, vol. II, p. 151, cat. 4; Piantoni and Pingeot (eds) 2000, p. 242

Thanks to his father's job as a government official, Boccioni's family were constantly on the move. Boccioni spent his youth in Forlì, Genoa and Padua, finishing his studies at the Istituto Tecnico in Catania, where his first working experience was as a journalist for the local newspaper, *Gazzetta della Sera*. In 1899 he moved to Rome where he attended the Scuola Libera del Nudo, studying figure drawing and anatomy while at the same time taking lessons in graphic design from a poster artist.

In 1901 Boccioni met Severini for the first time. They went on painting trips together and, in the plein-air tradition, created *vedute* and perspectival compositions of ancient Roman architectural monuments. They both became pupils of Balla who, during their regular visits to his studio at Porta Pinciana, introduced them to the principles of Divisionism. Boccioni was inspired by its tenets based on colour and light and was impressed by Balla's Divisionist approach to realism. This period marks a very productive and inspirational phase in his own development.

In 1906 Boccioni visited Paris, there familiarising himself with the work of Cézanne and the Impressionists; he was also struck by the modernity of the city. He travelled further north, to Moscow, St Petersburg and Tsaritsyn (today called Volgograd), working occasionally as a private teacher, before returning to Italy where he studied briefly at the Accademia di Belle Arti in Venice in 1907. He went on to Padua, where he produced his first series of lithographic works, before following his now-widowed mother and his sister to Milan at the end of the year. They became his preferred models for his social realist paintings and for his later works which were increasingly Symbolist in form.

The family lived together in the eastern part of Milan, which was undergoing dramatic change due to growing industrialisation. At first, with his precarious financial situation, differences with local artists, and difficulties in exhibiting his work, Boccioni found Milan alienating. His stylistic experiments, ambitions and personal doubts were recorded in a detailed diary, which he kept from 1907 to 1908 and which has become an invaluable source for studies of the artist. Despite his anguish, he was encouraged by the experiences he had had in Paris and his enthusiasm for Impressionist and Post-Impressionist works. Of special importance was his new-found relationship with Previati, whose theories and style he admired, and whose Symbolist canvases were to provide an alternative to the more realistic, Positivist-inspired paintings of Balla.

By late 1914 Boccioni began to rethink his radical approach and returned to the use of light effects and modelling of solid form. Increasingly filled with enthusiasm for nationalist ideas and the glorification of war, he joined the army as a volunteer, enlisting in the Lombard Volunteer Cyclist Battalion in 1915. He briefly returned to Milan, where he painted in a Post-Impressionist style, but was then drafted into the army artillery. He died following a horse-riding accident. **LS**

UMBERTO BOCCIONI
1882 REGGIO DI CALABRIA–
1916 VERONA

SELECTED REFERENCES
Calvesi and Coen 1983; Moeller (ed.) 1983; Coen (ed.) 1988; Mattioli Rossi and Di Carlo (eds) 1991; Schneede 1994

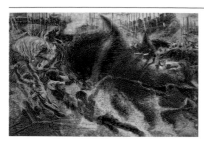

LONDON ONLY

63 The City Rises (*La città che sale*), 1910

Oil on canvas, 199.3 × 301 cm
The Museum of Modern Art, New York (Mrs Simon Guggenheim Fund, 1951) (507.1951)

This scene of Herculean labour depicts the construction of cooling reservoirs for the electricity generating plant in Piazza Trento, close to Boccioni's home in the suburbs of Milan. It is related to a series of works he produced between 1908 and 1909 featuring the industrial outskirts of the city, including *Workshops at Porta Romana* (cat. 55). These peripheral locations were informed by Balla's paintings of Rome's industrial suburbs, which Boccioni, as Balla's student, had also visited to work from life.

Though the smoking factory chimneys and scaffold-clad buildings are retained in the background, *The City Rises* presents a radical change of viewpoint from those earlier industrial paintings. That calm, detached surveillance of the suburban landscape is obliterated by a vortex of human and animal force. The viewer is placed in the thick of the action, with workers and cart-horses at full stretch in the effort of hauling the excavated earth. Originally exhibited with the title *Lavoro* (*Work*), Boccioni intended this canvas to represent an allegory of labour.

Described by the artist in a letter to Nino Barbantini as 'a great synthesis of labour, light and movement', *The City Rises* represents aKAn attempt to articulate visually the ideas expressed in the two Futurist manifestos Boccioni had signed in 1910. The painting's Futurist credentials lie primarily in the subject matter of the modern industrial city, and also in the dissolution of form, corresponding to the manifesto declaration: 'That movement and light destroy the materiality of bodies.' The resulting fusion of figures and setting reflects Boccioni's interest in the ideas of the French philosopher Henri Bergson, who maintained that 'any division of matter into independent bodies with determined outlines is artificial'.

This diffusive handling of form was also something Boccioni admired in Previati's Divisionist language: 'He has reduced classic form to luminous masses and volumes which deform atmosphere and bodies according to the artist's will.' *The City Rises* is an attempt to apply the dynamic qualities of Previati's technique to a progressive modern subject. Short directional lines of pure colour transform the horse's gigantic collar into a propeller blade in motion. But in representing the unstoppable force of the burgeoning city as animal rather than mechanical, Bocccioni chooses a Symbolist solution to a Futurist problem. The sweeping curves of his powerful equine forms recall Previati's mythological horses in *The Chariot of the Sun* (1907, cat. 33). And the diagonal inclination of the workers' bodies is reminiscent of the floating forms seen in Previati's *Dance of the Hours* (*Danza delle ore*, about 1899).

Boccioni's encounter with Cubism during a visit to Paris in November 1911 would transform his modes of representation. He would abandon the conventional way of viewing objects, fusing in a single image the interior and exterior, the actual and the recollected. This would lead to the development of his trademark lines of force, describing the trajectory of an object's movement through space. **LP**

PROVENANCE
Collection of Ferruccio Busoni, New York (purchased 1912)

SELECTED EXHIBITIONS
1911 Milan, Padiglione Ricordi, *Mostra d'Arte Libera: I Manifestazione collettiva dei Futuristi*; **1912** Paris, Galerie Bernheim-Jeune, *Les peintres futuristes italiens*; **1912** London, The Sackville Gallery, *Exhibition of Works by the Italian Futurist Painters*; **1912** Berlin, Galerie Der Sturm, *Zweite Ausstellung: Die Futuristen*; **1912** Brussels, Galerie Georges Giroux, *Les peintres futuristes italiens*; **1916–17** Milan, Palazzo Cova, *Grande esposizione Boccioni*; **1933** Milan, Castello Sforzesco, *Umberto Boccioni*; **1959–60** Winterthur (Kunstmuseum), Munich (Städtische Galerie und Lembachgalerie), *Futurismus*; **1961** New York (Museum of Modern Art), Detroit (Institute of Arts), *Futurism*; **1972–3** Newcastle upon Tyne (Hatton Gallery), Edinburgh (Royal Scottish Academy), London (Royal Academy of Arts), *Exhibition of Italian Futurism*; **1980–81** Philadelphia, Philadelphia Museum of Art, *Futurism and the International Avant-Garde*; **1986** Venice, Palazzo Grassi, *Futurismo & Futurismi*; **1988–9** New York, The Metropolitan Museum of Art, *Umberto Boccioni*

SELECTED REFERENCES
Fiori (ed.) 1968, p. 196, cat. XVIII.239; Martin 1968, pp. 85–8, no. 52; Calvesi and Coen 1983, p. 374, cat. 675; Drudi Gambillo and Fiori (eds) 1986, p. 264, cat. 216; Coen (ed.) 1988, pp. 94–7, cat. 50; Tisdall and Bozzolla 1996, pp. 39, 41; Rylands 1997, p. 54 (preparatory study); Humphreys 1999, pp. 25–6; Caroli and Masoero (eds) 2001, cat. 65 (preparatory study); Ginex 2008 in Fraquelli (ed.) 2008

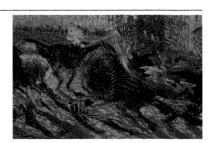

62 Study for *The City Rises* (*La città che sale*), 1910

Oil on cardboard, 33 × 47 cm
Gianni Mattioli Collection (on long-term loan to the Peggy Guggenheim Collection, Venice)

PROVENANCE

Collection of the artist; private collection, Lombardy; Rolando Ghedini, Arona (Novara); before June 1952 Giovanni Mattioli; Gianni Mattioli Collection, Milan

SELECTED EXHIBITIONS

1952 Venice, *XXVI Biennale Internazionale d'Arte* (*Mostra del Divisionismo*); **1954** New York, Sidney Janis Gallery, *Futurism: Balla, Boccioni, Carrà, Severini, Russolo* **1959** Rome, Palazzo Barberini, *Il futurismo;* **1960** Venice, *XXX Biennale Internazionale d'Arte* (*Mostra storica del Futurismo*); **1961–2** New York (The Museum of Modern Art), Detroit (Institute of Arts), Los Angeles (County Museum), *Futurism;* **1966** Venice, *XXXIII Biennale Internazionale d'Arte* (*Retrospettiva di Boccioni*); **1986** Venice, Palazzo Grassi, *Futurismo & Futurismi*

SELECTED REFERENCES

Fiori (ed.) 1968, vol. II, p. 196, cat. XVIII.238; Calvesi and Coen 1983, p. 378, cat. 683; Drudi Gambillo and Fiori (eds) 1986, p. 264, cat. 218; Rylands 1997, pp. 54–5, cat. 3; Fergonzi 2003, pp. 143–53

21 *Roman Landscape* or *Midday* (*Campagna Romana* or *Meriggio*), 1903

Oil on canvas, 58.8 × 122 cm
Museo Civico di Belle Arti, Lugano (2254)

PROVENANCE

Chiattone Collection, Lugano

SELECTED EXHIBITIONS

1904 Rome, Società degli Amatori e Cultori, *LXXVI Esposizione Internazionale di Belle Arti*; **1916–17** Milan, Palazzo Cova, *Grande esposizione Boccioni*; **1960** Milan, Famiglia Artistica, *Boccioni: Mostra di opere inedite prefuturiste, dipinti e disegni del periodo futurista*; **1983** Reggio Calabria (Museo Nazionale), Rome (Palazzo Venezia), *Boccioni prefuturista*; **1985–6** Verona (Galleria dello Scudo and Museo di Castelvecchio), Milan (Accademia di Brera), Venice (San Stae), *Boccioni a Venezia, dagli anni romani alla Mostra d'Estate a Ca' Pesaro: Momenti della stagione futurista;* **1988–9** New York, The Metropolitan Museum of Art, *Umberto Boccioni*; **1990** Trento, Palazzo delle Albere, *Divisionismo italiano;* **2006/7** Lugano, Museo Civico dei Belle Arti, *Donazione Chiattone*

SELECTED REFERENCES

Fiori (ed.) 1968, p. 196, cat. XVIII.239; Martin 1968, pp. 85–8, no. 52; Calvesi and Coen 1983, p. 374, cat. 675; Drudi Gambillo and Fiori (eds) 1986, p. 264, cat. 216; Coen 1988, pp. 94–7, cat. 50; Tisdall and Bozzolla 1996, pp. 39, 41; Rylands 1997, p. 54 (preparatory study); Humphreys 1999, pp. 25–6; Caroli and Masoero (eds) 2001, cat. 65 (preparatory study); Sonderegger 2006, p. 82; Ginex 2008

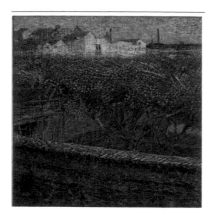

54 *April Evening (Sera d'Aprile)*, 1908

Oil on canvas, 50.3 × 50 cm
Museo Civico di Belle Arti, Lugano (2256)

PROVENANCE
Chiattone Collection, Lugano

SELECTED EXHIBITIONS
1988–9 New York, The Metropolitan Museum of Art, *Umberto Boccioni*; **2006–7** Lugano, Museo Civico di Belle Arti, Donazione Chiattone

SELECTED REFERENCES
Fiori (ed.) 1968, vol. II, p. 188, cat. XVIII.104; Calvesi and Coen 1983, p. 239, cat. 307; Drudi Gambillo and Fiori (eds) 1986, vol. II, p. 254, cat. 24 (*Primavera alla periferia di Milano*); Coen 1988, cat. 21; Sonderegger 2006, p. 88; Ginex 2008

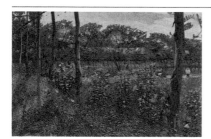

22 *Lombard Countryside (Campagna Lombarda)*, 1908

Oil on canvas, 95 × 142.2 cm
Museo Civico di Belle Arti, Lugano (2258)

PROVENANCE
Chiattone Collection, Lugano

SELECTED EXHIBITIONS
1908 Milan, Palazzo della Permanente, *Concorso Mylius alla Permanente* [*Sinfonia campestre*]; **1960** Milan, Famiglia Artistica, *Boccioni: Mostra di opere inedite prefuturiste, dipinti e disegni del periodo futurista*; **1983** Reggio Calabria (Museo Nazionale), Rome (Palazzo Venezia), *Boccioni prefuturista*; **1985–6** Verona (Galleria dello Scudo and Museo di Castelvecchio), Milan (Accademia di Brera), Venice (San Stae), *Boccioni a Venezia, dagli anni romani alla Mostra d'Estate a Ca' Pesaro: Momenti della stagione futurista*; **1988–9** New York, The Metropolitan Museum of Art, *Umberto Boccioni*; **1990** Trento, Palazzo delle Albere, *Divisionismo italiano*; **2006/7** Lugano, Museo Civico di Belle Arti, Donazione Chiattone

SELECTED REFERENCES
Fiori (ed.) 1968, vol. II, p. 188, cat. XVIII.99; Drudi Gambillo and Fiori (eds) 1986, vol. II, p. 254, cat. 21; Calvesi and Coen 1983, p. 244, cat. 323; Coen 1988, cat. 23A; Belli (ed.) 1990, cat. 145; Sonderegger 2006, p. 94

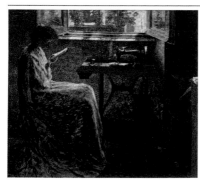

LONDON ONLY

53 *The Story of a Seamstress (Romanzo di una cucitrice)*, 1908

Oil on canvas, 150 × 170 cm
Barilla Collection of Modern Art, Parma

PROVENANCE
Procida Collection, Rome; Palazzoli Collection, Milan

SELECTED EXHIBITIONS
1908 Milan, Palazzo della Permanente, *Concorso Mylius alla Permanente*; **1916–17** Milan, Palazzo Cova, *Grande Esposizione Boccioni*; **1966** Reggio Calabria, Museo Nazionale, *Omaggio a Boccioni*

SELECTED REFERENCES
Fiori (ed.) 1968, vol. II, cat. XVIII.60; Calvesi and Coen 1983, p. 240, cat. 309; Drudi Gambillo and Fiori (eds) 1986, p. 255, cat. 48; Ginex 2008

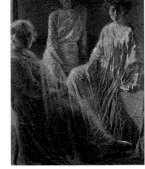

60 *Passing Train (Treno che passa)*, 1908

Oil on canvas, 23.4 × 58.3 cm
Museo Civico di Belle Arti, Lugano (2257)

PROVENANCE

Chiattone Collection, Lugano

SELECTED EXHIBITIONS

1916–17 Milan, Palazzo Cova, *Grande esposizione Boccioni;* **1960** Milan, Famiglia Artistica, *Boccioni: mostra di opere inedite prefuturiste, dipinti e disegni del periodo futurista;* **1983** Rome (Palazzo Venezia), *Boccioni prefuturista* ; **1988-9** New York, The Metropolitan Museum of Art, *Umberto Boccioni;* **2006/7** Lugano, Museo Civico di Belle Arti, Donazione Chiattone

SELECTED REFERENCES

Fiori (ed.) 1968, vol. II, p. 188, cat. XVIII.97; Martin 1968, 22; Calvesi and Coen 1983, pp. 256–7, cat. 348; Drudi Gambillo and Fiori (eds) 1986, vol. II, p. 254, cat. 33 (*Il trenino*); Coen 1988, p. 54, cat. 27; Sonderegger 2006, p. 96

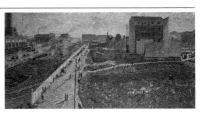

46 *Three Women (Tre donne)*, 1909–10

Oil on canvas, 180 × 132 cm
Intesa Sanpaolo Collection, Milan (98)

PROVENANCE

Collection of Vico Baer, Milan; Banca Commerciale Italiana, Milan

SELECTED EXHIBITIONS

1910 Milan, Palazzo della Permanente, *Mostra annuale degli artisti lombardi;* **1916–17** Milan, Palazzo Cova, *Grande esposizione Boccioni;* **1924** Milan, Bottega di Poesia, *Umberto Boccioni;* **1933** Milan, Castello Sforzesco, *Umberto Boccioni;* **1982-3** Milan (Palazzo Reale), Hanover (Kunstmuseum), *Boccioni a Milano;* **1988-9** New York, The Metropolitan Museum of Art, *Umberto Boccioni;* **2001** Paris, Musée d'Orsay, *Italies 1880–1910*

SELECTED REFERENCES

Fiori (ed.) 1968, vol. II, p. 193, cat.. XVIII.190; Calvesi and Coen 1983, pp. 302–3, cat. 455; Drudi Gambillo and Fiori (eds) 1986, vol. II, p. 257, cat. 87; Coen 1988, p. 78; Piantoni and Pingeot (eds) 2000, p. 253; Ginex 2008 in Fraquelli (ed.) 2008

55 *Workshops at Porta Romana (Officine a Porta Romana)*, 1909

Oil on canvas, 75 × 145 cm
Intesa Sanpaolo Collection, Milan (213)

PROVENANCE

Collezione Vico Baer, Milan; Collezione Pallini, Milan; Banca Commerciale Italiana, Rome

SELECTED EXHIBITIONS

1916–17 Milan, Palazzo Cova, *Grande Esposizione Boccioni;* **1966** Venice, *XXXIII Biennale Internazionale d'Arte (Retrospettiva di Boccioni);* **1973-4** Milan, Palazzo Reale, *Boccioni e il suo tempo;* **1979-80** London (Royal Academy of Arts), Washington (National Gallery of Art), *Post-Impressionism: Cross Currents in European Painting;* **1982-3** Milan (Palazzo Reale), Hanover (Kunstmuseum), *Boccioni a Milano;* **1986** Venice, Palazzo Grassi, *Futurismo & Futurismi;* **1988-9** New York, The Metropolitan Museum of Art, *Umberto Boccioni;* **1989** London, Royal Academy of Arts, *Italian Art in the 20th Century;* **2001** Paris, Musée d'Orsay, *Italies 1880–1910;* **2001** Milan, Palazzo Reale, *Dalla Scapigliatura al Futurismo*

SELECTED REFERENCES

Fiori (ed.) 1968, vol. II, p. 190, cat. XVIII.130; Martin 1968, p. 67; Berresford 1979, pp. 229–30, cat. 363; Calvesi and Coen 1983, p. 292, cat. 423; Drudi Gambillo and Fiori (eds) 1986, vol. II, p. 257, cat. 97 (*Periferia*); Coen 1988, cat. 38; Humphreys 1999, pp. 22–3; Piantoni and Pingeot (eds) 2000, p. 253; Caroli and Masoero (eds) 2001, cat. 64; Ginex 2008

CARLO CARRÀ
1881 QUARGNENTO,
ALESSANDRIA, PIEDMONT–1966
MILAN

Carrà grew up in impoverished circumstances in the small town of Quargnento in the province of Alessandria. At the age of seven a serious illness confined him to bed for a year and it was during his convalescence that Carrà began to draw. When he was twelve he was apprenticed to local decorators in a villa in Valenza Po, not far from the town of Alessandria. In 1895 his job took him to Milan, where he took evening classes at the Accademia di Belle Arti di Brera, and in his spare time visited museums and commercial galleries, including that of Vittore and Alberto Grubicy.

In 1899, at the age of eighteen, Carrà went to Paris for six months, attracted by the possibility of working as a decorator for the pavilions of the 1900 Exposition Universelle. While there he saw works by Géricault, Delacroix, Courbet and the Impressionists. He also immersed himself in theatre and literature, in particular the writings of Baudelaire, Verlaine, Rimbaud and Mallarmé, and joined a group of anarchists. The following year he was in London, where, through his contacts with Italian anarchists exiled in 1898, he pursued his interest in socialist ideologies, reading the works of Karl Marx and Mikhail Bakunin. On his return to Italy, during 1901–3 he again worked as a decorator, first in Bellinzona (Ticino canton, Switzerland), then in Busto Arsizio in Lombardy and in Ombriano in the province of Crema, Lombardy. He continued to read widely and enrolled for evening classes in the applied arts at Milan's Castello Sforzesco, where he won two prizes. From 1906 to 1908, financially supported by an uncle, Carrà was again able to attend the Accademia di Belle Arti di Brera. He was acquainted with the Milanese socialist and anarchist circles, and became familiar with artists from Lombardy, among them Longoni and Boccioni, whom he met in 1908. In part due to their influence, between 1907 and 1909 he devoted himself to Divisionism and was particularly impressed by the works of Segantini and Previati. The treatment of the political theme of his masterpiece *The Funeral of the Anarchist Galli*, (1910–11, cat. 61) also betrays the influence of Pellizza's Divisionist paintings.

Having become friends with Russolo and Marinetti in 1909, Carrà joined the Futurists the following year, and with this his Divisionist painting phase ended. From about 1911 he was drawn towards the portrayal of city nightlife, the urban masses and the effects of electric lighting. At the same time he worked as an art critic and, until the outbreak of the First World War, continued to visit Paris.

By 1914 Carrà had fallen out with Boccioni and become disillusioned with Futurism. He withdrew from the movement and became increasingly interested in Cubism, publishing his writings and drawings in various journals. He was called up to the army in 1917 but, because of ill health, was admitted to a psychiatric clinic in Ferrara where he met Giorgio de Chirico (1888–1978). Like de Chirico, Carrà began to produce enigmatic and dreamlike images with unexpected juxtapositions of realistically depicted objects, which they called *pittura metafisica*. After he was discharged, Carrà married Ines Minoja and in 1922 their only son, Massimo, was born. In the 1920s and 1930s he adhered to the classical principles of the *novecento italiano*, which championed a return to traditional values in art. From 1941 to 1952 he was professor of painting at the Accademia di Brera. His late paintings became looser in style, with freer brushwork in rich colour combinations. A prolific publisher and graphic designer, he continued to paint until his death at the age of eighty-five. **LS**

SELECTED REFERENCES
Carrà 1967–8; Carrà and Dell'Acqua (eds) 1987; Monferini (ed.) 1994; Fagone (ed.) 1996

LONDON ONLY

61 *The Funeral of the Anarchist Galli* (*I funerali dell'anarchico Galli*), 1910–11

Oil on canvas, 198.7 × 259.1 cm
The Museum of Modern Art, New York
(acquired through the Lillie P. Bliss bequest, 1948) (235.1948)

This canvas depicts the events surrounding the funeral of the celebrated anarchist Angelo Galli, who had been killed in Milan during the general strike of 1904. Anxious to avoid the funeral becoming a political demonstration, the police denied mourners access to the cemetery, insisting that the ceremony be held in the square outside. The anarchists resisted, and violent clashes with the police ensued. Carrà, who was closely involved with anarchist and syndicalist politics, witnessed the riot first-hand, later recalling the scene in his autobiography:

I saw the coffin in front of me, covered in red carnations, wavering dangerously on the shoulders of the pallbearers. I saw the horses becoming restive, the sticks and lances clashing, so it seemed to me that at any moment the corpse would fall to the ground and be trampled by the horses.

Carrà's composition describes this chaotic scene, with strong diagonals of banners and lances drawing the eye to Galli's precariously balanced coffin, which glows a violent red, indicating the aggressive mood as much as the colour of the carnations that adorned it. This angry light appears to radiate from the coffin and, burning more brightly than the sun, it highlights the anarchist blacks of the rioting figures with swathes of incendiary red, creating an ominous play of light and shade.

Certain elements of Carrà's iconography and composition recall the Quattrocento battle scenes of Paolo Uccello, but pictorial devices such as the multiple lines of force describing the movement of figures and weapons through space make this a conspicuously Futurist painting. In the months before the Paris exhibition, Carrà overpainted the upper part of the canvas, attempting a Cubist fragmentation of the picture plane so as to further radicalise its aesthetic (and, by association, political) message. But even within these superficially Cubist passages of painting, Carrà's application of colour in staccato lines and dabs reveals a technique still rooted in Divisionism.

Like Boccioni's *The City Rises* (1910, cat. 63), Carrà's composition places the spectator 'in the centre of the picture', as the Technical Manifesto of Futurist Painting had promised. This was a radical change from an earlier pastel study of 1910, in which Carrà had distanced the rioting mass from the viewer, using the open space in the foreground that Pellizza had employed in *The Fourth Estate* (*Il Quarto Stato*, 1898–1901, fig. 4). This compositional shift transforms the role of the spectator from passive observer to active protagonist.

By commemorating this famous political incident seven years after its occurrence with a large format canvas, Carrà sought to make a contemporary history painting. His choice of subject corresponds to the Futurist Manifesto declaration that: 'We will sing of great crowds excited by work, by pleasure, by riot.' And by reworking the composition according to the spatial dynamics outlined in the Technical Manifesto, Carrà combined radical politics with radical artistic practice to create a visual manifesto for the nascent Futurist movement. **LP**

PROVENANCE
Borchardt Collection, Berlin; Collection of P. Citroen, Amsterdam

SELECTED EXHIBITIONS
1912 Paris, Galerie Bernheim-Jeune, *Les Peintres futuristes italiens*; **1912** London, The Sackville Gallery, *Exhibition of Works by the Italian Futurist Painters*; **1912** Berlin, Galerie Der Sturm, *Zweite Ausstellung: Die Futuristen*; **1912** Brussels, Galerie Georges Giroux, *Les Peintres futuristes italiens*; **1913** Rotterdam, Rotterdamsche Kunstring, *Les Peintres et les sculpteurs futuristes italiens*; **1986** Venice, Palazzo Grassi, *Futurismo & Futurismi*; **1987** Milan, Palazzo Reale, *Carrà – mostra antologica*; **1994** Rome, Galleria Nazionale d'Arte Moderna, *Carlo Carrà 1881–1966*

SELECTED REFERENCES
Carrà 1967–8, p. 581, cat. 8/11; Fiori (ed.) 1968, vol. II, p. 204, cat. XX.24; Martin 1968, pp. 87–8, 117; Drudi Gambillo and Fiori (eds) 1986, vol. II, p. 294, cat. 12; Carrà and Dell'Acqua (eds) 1987, p. 251, cat. 16; Monferini (ed.) 1994, p. 200; Tisdall and Bozzolla 1996, p. 48; Humphreys 1999, pp. 32–4; Ginex 2008

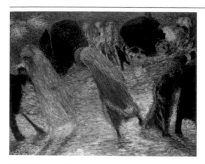

LONDON ONLY

57 *Leaving the Theatre* (*Uscita dal teatro*), 1909

Oil on canvas, 69 × 89 cm
Estorick Collection, London

PROVENANCE
Rothschild Collection, London

SELECTED EXHIBITIONS
1912 Paris, Galerie Bernheim-Jeune, *Les Peintres futuristes italiens;* **1912** London, The Sackville Gallery, *Exhibition of Works by the Italian Futurist Painters;* **1912** Berlin, Galerie Der Sturm, *Zweite Ausstellung: Die Futuristen;* **1912** Brussels, Galerie Georges Giroux, *Les Peintres futuristes italiens;* **1961** New York (Museum of Modern Art), Detroit (Institute of Arts), *Futurism;* **1972–3** Newcastle upon Tyne (Hatton Gallery), Edinburgh (Royal Scottish Academy), London (Royal Academy of Arts), *Exhibition of Italian Futurism;* **1989** London, Royal Academy of Arts, *Italian Art in the 20th Century;* **1990** Trento, Palazzo delle Albere, *Divisionismo italiano;* **1994** Rome, Galleria Nazionale d'Arte Moderna, *Carlo Carrà 1881–1966*

SELECTED REFERENCES
Carrà 1967–8, p. 580, cat. 4/09; Fiori (ed.) 1968, vol. II, p. 203, cat. XX.17; Martin 1968, pp. 87–8; Drudi Gambillo and Fiori (eds) 1986, vol. II, p. 293, cat. 1; Monferini (ed.) 1994, p. 188; Humphreys 1999, p. 23

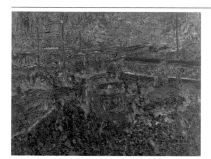

ZURICH ONLY

56 *Piazza del Duomo*, 1910

Oil on canvas, 45 × 60 cm
Private collection, courtesy Claudia Gian Ferrari, Milan

PROVENANCE
Collection of V. Dolci Mazzucotelli, Bergamo

SELECTED EXHIBITIONS
1968 Venice, *XXXIV Biennale Internazionale* (*Quattro maestri del Futurismo italiano*); **1971** Prato, Galleria Farsetti, *Cento opere di Carlo Carrà;* **1986** Venice, Palazzo Grassi, *Futurismo & Futurismi;* **1987** Milan, Palazzo Reale, *Carrà – mostra antologica;* **1987** Rome, Palazzo Braschi, *Carlo Carrà;* **1987** Baden Baden, Kunsthalle, *Carrà;* **1990** Trento, Palazzo delle Albere, *Divisionismo italiano;* **1994** Rome, Galleria Nazionale d'Arte Moderna, *Carlo Carrà 1881–1896;* **2001** Milan, Palazzo Reale, *Dalla Scapigliatura al Futurismo*

SELECTED REFERENCES
Carrà 1967–8, vol. I, p. 580, cat. 3/09; Fiori (ed.) 1968, vol. II, p. 203, cat. XX.16; Carrà and Dell'Acqua (eds) 1987, p. 250, cat. 8; Belli (ed.) 1990, p. 416, cat. 149; Monferini (ed.) 1994, pp. 190–1; Caroli and Masoero (eds) 2001, p. 212, cat. 75

ZURICH ONLY

58 *Nocturne in Piazza Beccaria* (*Notturno a Piazza Beccaria*), 1910

Oil on canvas, 60 × 45 cm
Civiche Raccolte d'Arte (Museo d'Arte Contemporanea), Milan (8734)

PROVENANCE
Collection of Riccardo Jucker, Milan; Pinacoteca di Brera, Milan (Collezione Jucker)

SELECTED EXHIBITIONS
1948 Milan, Circolo delle Arti Le Grazie, *Carlo Carrà 1903–1948;* **1952** Venice, *XXVI Biennale Internazionale d'Arte* (*Mostra del Divisionismo*); **1960** Venice, *XXX Biennale Internazionale d'Arte* (*Mostra storica del Futurismo*); **1962** Milan, Palazzo Reale, *Mostra di Carlo Carrà;* **1971** Prato, Galleria Farsetti, *Cento Opere di Carlo Carrà;* **1986** Venice, Palazzo Grassi, *Futurismo & Futurismi;* **1987** Milan, Palazzo Reale, *Carrà – mostra antologica;* **1994** Rome, Galleria Nazionale d'Arte Moderna, *Carlo Carrà 1881–1896;* **2001** Paris, Musée d'Orsay, *Italies 1880–1910*

SELECTED REFERENCES
Carrà 1967–8, vol. I, p. 580, cat. 2/10; Fiori (ed.) 1968, vol. II, p. 204, cat. XX.22; Carrà and Dell'Acqua (eds) 1987, p. 250, cat. 11; Monferini (ed.) 1994, pp. 192–3; Tisdall and Bozzolla 1996, p. 46; Piantoni and Pingeot (eds) 2000, p. 260

Fornara was born in the alpine village of Prestinone, in the valley of Vigezzo, north-east of Piedmont, near the Swiss border. His father, Giuseppe Antonio, was a coppersmith and his mother, Anna Maria Nicolai, the daughter of an established local family. Like many of his contemporaries, Fornara learned to draw from an early age, as the tradition of landscape and portrait painting was well established in Vigezzo. He was trained in the art school in nearby Santa Maria Maggiore where, under the tutelage of Enrico Cavalli (1849–1918) – a local artist who had studied in Lyon – he received the training of a progressive French atelier. In addition to the Old Masters, his early influences included the highly individual and Romantic painting style of the French artist Adolphe Monticelli (1824–1886), in which richly coloured, textured and glazed surfaces are used to produce a scintillating effect. Two of Fornara's genre paintings were shown alongside Segantini's work in the first Brera Triennale in 1891: although these scenes demonstrate the artist's early interest in light effects, they were rendered in a comparatively traditional style.

The 1892 exhibition of Antonio Fontanesi's (1818–1882) atmospheric landscapes influenced Fornara greatly. Between 1894 and 1896 he spent several months in Lyon and Paris, where he become acquainted with the works of the Impressionists and the recently formed group called the Nabis. His first Divisionist work, *En Plein Air* (private collection), dates from 1897. Refused by the jury of the third Brera Triennale of the same year, the painting was positively received by Segantini and Pellizza. Around this time Fornara was involved in one of Morbelli's thwarted plans for a Salon des Refusés. However, it was the encounter with Segantini, who in 1898 invited him to work on his project for the *Panaroma of the Engadine*, that was to prove the most lasting influence on his characteristic mountain landscapes.

In 1898 Fornara joined Alberto Grubicy's stable of artists, an arrangement that gave him financial stability and allowed him to live in his beloved Prestinone. *Washerwomen* of 1898 (cat. 41) is typical of Fornara's structured compositions which, indebted to the intense luminosity and brushwork of Segantini, also demonstrates his knowledge of the work of Jean François Millet (1814–1875) and of the Pont-Aven school. Several works by Fornara were included in the *Salon des Peintres Divisionnistes italiens* organised by Alberto Grubicy in Paris in 1907. A devoted Francophile, Fornara remained in the French capital for long periods between 1907 and 1909, where he became acquainted with Symbolist art.

Fornara travelled extensively in South America between 1910 and 1912, and participated in several exhibitions in Italy and abroad until 1922. In the same year, on the death of Alberto Grubicy, he was named executor of the dealer's will. Soon after, he retired from official exhibitions, feeling too distant from the contemporary trends in Italian art (Futurism, *Pittura metafisica* and *Valori plastici*) and European art. He continued to paint in a loosely Divisionist style until well into his nineties and died in Prestinone in 1968. **SF**

SELECTED REFERENCES
Gelli 1990; Quinsac (ed.) 1998

CARLO FORNARA
1871–1968 PRESTINONE,
VAL VIGEZZO

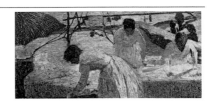

41 *Washerwomen* (*Le lavandaie*), 1898

Oil on canvas, 26.7 × 56.5 cm
Private collection, courtesy James Roundell

PROVENANCE
Alberto Grubicy, Milan–Paris (documented until 1917); Collection of Carlo Masera, Vigevano; Barbero Collection, Domodossola (documented from 1966)

SELECTED EXHIBITIONS
1966 Turin, Galleria Narciso, *Omaggio a Fornara. Artisti dell'Ottocento italiano;* **1998–9** Trento (Palazzo delle Albere), Milan (Museo della Permanente) *Carlo Fornara. Un maestro del Divisionismo*

SELECTED REFERENCES
Fiori (ed.) 1968, vol. II, p. 123, cat. VII.45; Quinsac (ed.) 1998, p. 67, cat. 33

ZURICH ONLY

23 *The Lengthening Shadow (L'ombra si stende)*, 1908
Oil on canvas, 70.5 × 81 cm
Private collection, courtesy James Roundell

PROVENANCE
Galleria Grubicy, Milan–Paris (documented until 1912); Collection of Cesare Baroncini, Milan (documented 1916); Antonioli Collection, Pavia (1920); Chierchetti Collection, Milan (documented until 1928); Ferraio Collection, Milan; Galleria Sacerdoti, Milan

SELECTED EXHIBITIONS
1908–9 Paris, *Salon pro-Musée Segantini à Saint Moritz organisé dans la Galerie d'Art Italien A. Grubicy*; **1912** London, Great White City, *Latin-British Exhibition*; **1914** Venice, *XI Esposizione Internazionale d'Arte della città di Venezia* [Biennale] (solo exhibition); **1916** Milan, Società per le Belle Arti e Associazione Lombarda dei Giornalisti, *Esposizioni collettive di Gaetano Previati e Carlo Fornara a beneficio dei soldati ciechi e mutilati in guerra*; **1970** Milan, Palazzo della Permanente, *Mostra del Divisionismo italiano*; **1998–9** Trento (Palazzo delle Albere), Milan (Museo della Permanente), *Carlo Fornara: Un maestro del Divisionismo*

SELECTED REFERENCES
Fiori (ed.) 1968, vol. II, p. 127, cat. VII.131; Quinsac (ed.) 1998, p. 90, cat. 50

VITTORE GRUBICY DE DRAGON
1851–1920 MILAN

Although born into an aristocratic family, Grubicy experienced financial difficulties after the death of his Hungarian-born father in 1870. He worked irregularly, associating with the *Scapigliatura* artists and visiting London where he became familiar with the modern art trade. In 1876 he bought the gallery Pedro Nessi & C. in Milan, opening it, with his brother Alberto, as Galleria Fratelli Grubicy. While Alberto managed the financial aspects of the new gallery, Vittore travelled to Europe's capitals each spring in order to keep abreast of current art events and to sell Italian works of art. The gallery specialised in *Scapigliatura* artists such as Tranquillo Cremona (1837–1878) and Daniele Ranzoni (1843–1889), and from 1879 they also took on younger Lombard artists, including Segantini and, later, Longoni and Morbelli. The Grubicy Gallery became one of the first art enterprises in Italy to be run on modern lines in that they actively promoted their artists. The Grubicy brothers worked in close partnership with the artists, mentoring them on creative matters such as themes, formal aspects and techniques. They also handled all the practical aspects, such as drafting contracts, organising exhibitions and auctions, and publishing catalogues.

Between 1882 and 1885 Grubicy spent long periods of time in the Netherlands where he worked as an art dealer, establishing contact with representatives of the Hague School, particularly Anton Mauve (1838–1888; the uncle of Vincent van Gogh) – who inspired him to paint and draw for himself. On his return, Grubicy continued working as an artist, focusing on lyrical landscapes, while also writing art reviews for journals such as the Milanese *Cronaca d'Arte* and newspapers such as the Roman daily *La Riforma*. Divisionism interested him from around 1886, and between 1892 and 1894 he took an active role in the movement, encouraging many other Italian artists to do the same. From 1889 he took part in exhibitions himself for the first time and exhibited regularly for the following six years. He became known – for his support as well as participation – as one of the most important figures of the Divisionist movement.

In 1889 Grubicy left the gallery for financial reasons, and because of conflicts with his brother over what direction the business should take, and became an independent talent scout. He supported Previati, among others, and was involved in organising the first and second Brera Triennale exhibitions in Milan. Once freed from responsibility for the gallery, he had time to concentrate on writing and his own art. Between 1891 and 1898 he spent the winters in Miazzina, a village above Intra on Lake Maggiore, where from 1894 onwards he was working on his eight-part polyptych *Winter in the Mountains* (see pp. 143–44).

After 1898 Grubicy suffered from depression and produced few new works, preferring to rework his early paintings, making them more Divisionist in character. He died in 1920, after donating his collection of contemporary art to the newly opened Galleria d'Arte Moderna in Milan. **LS**

SELECTED REFERENCES
Valsecchi et al. 1976; Capuano and Lardelli (eds) 1989; Rebora 1995; Quinsac (ed.) 2005; Kaufmann 2006

Winter in the Mountains. Pantheist Poem (*Inverno in montagna. Poema panteista*), 1894–7

Reworked as a polyptych 1911–17

Oil on canvas, 141 × 363.5 cm (total dimensions of all 8 panels)

Civiche Raccolte d'Arte (Galleria d'Arte Moderna) Milan

17 *Moonlight* (*Notte lunare* or *Chiaro di luna*),

(GAM 1717) 64.5 × 55.5 cm

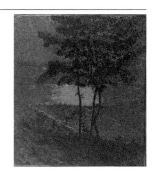

17

16 *Sheep among the Rocks* (*El crapp di rogoritt* or *Pecore sullo scoglio*),

(GAM 1720) 58 × 98 cm

Twilight (*Sinfonia crepuscolare* or *Armonia crepuscolare*),

(GAM 1716) 66 × 55.5 cm

The Spring (*La sorgente* or *La buona sorgente*),

(GAM 1722) 57 × 99 cm

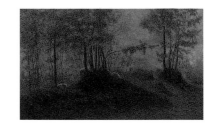

16

From the Window: Winter Evening (*A sera* or *Dalla finestra: sera d'inverno*),

(GAM 1715) 66 × 55.5 cm

Snow (*Tutto candore!* or *Neve* or *In Albis*)

(GAM 1719) 58 × 97.5 cm

18 *Morning* (*Mattino* or *Mattino gioioso*),

(GAM 1718) 75 × 56 cm

The Valley (*La vallata* or *La vallata della Toce*),

(GAM 1721) 59 × 98.5 cm

Winter in the Mountains is a polyptych composed of eight panels selected from a series of paintings executed – mainly between 1894 and 1897 – during the winters Grubicy spent in isolation at Miazzina on the shores of Lake Maggiore. Having originally planned a sixteen-panel composition titled *Winter in Miazzina*, he experimented with various polyptych configurations as the project evolved. Grubicy also reworked the individual paintings repeatedly, sometimes years after their inception, refining colours and light effects with the minute touches that characterised his Divisionist style. This gradual evolutionary process was typical of Grubicy's method of working. He arrived at the definitive composition in 1911 when he exhibited a photograph of the polyptych at the Esposizione d'Arte Libera Milanese. The eight paintings were first shown together at the Rome Biennale in 1921, the year after Grubicy's death, though most panels had been exhibited separately, or as part of other polyptychs, before this date.

The eight paintings that make up this work, like many others from the Miazzina cycle, including *Winter* (1898, cat. 15), conform to a general compositional pattern, depicting finely detailed vegetation in the foreground, from where a hill slopes down to a ledge, giving way to hazy views of the lake in the distance. Variations in location and time of day distinguish the individual panels, but all are infused with rich rose-gold and reddish tones that evoke the seasonal light and vegetation. Stylised trees feature prominently in these paintings, revealing the influence of Japanese art, also evident in *Sea of Mist* (1895, cat. 14), in which there was a Europe-wide interest during this era. These silhouetted

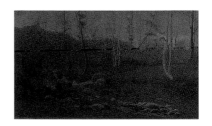

trees serve to anchor Grubicy's compositions, and at times – in *Morning* (cat. 18), for example – function as vertical devices to balance the horizontal lines of the lake seen in the distance.

The simplified compositions reflect Grubicy's emphasis on the mood conveyed in these paintings rather than the compositional motifs used to construct them. Defending *arte ideista* in 1891, Grubicy wrote:

> When the artist aims to express . . . Ideas, objects which contribute to their expression should not be of value themselves, but only as SIGNS, as letters of the alphabet: and these signs – however indispensable – are nothing in themselves: the Idea constitutes everything.

In this case, the Idea, as Grubicy's title suggests, is the pantheist belief that God is the transcendent reality manifest in nature. The panels describe the artist's awe-inspiring encounter with the immensity of nature, conveyed largely through the luminous qualities of the paintings rather than the features of the landscape. This was achieved by the careful orchestration of colour, which developed over time, following Grubicy's initial observations of the natural setting in its basic formal and tonal harmonies.

Grubicy described his spiritual contemplation of nature as a synaesthetic experience:

> The colours and forms of a scene readily assume musical values, sometimes harmonising in simple, gentle and melodic waves, sometimes becoming complicated in

18

harmonising chords of close polyphony, so detailed as to suggest the sound of specific instruments and even to see numerous violin bows while I contemplate the white flashes of the silver birches, standing out against the blue sky and the dark green of the heather and gorse-covered mountains.

Informed by the concepts of synaesthesia explored by the French Symbolists, Grubicy's personal experience of the visual as musical may have been rendered more acute by his progressive deafness. *Winter in the Mountains* can therefore be read as a visual symphony, in which each of the panels has an internal harmony, like different movements in a musical composition; but when viewed simultaneously as parts of the polyptych, they function as harmonising chords in a polyphonic arrangement.

Grubicy's use of the multi-panel format reflects the renewed popularity, among Symbolist artists across Europe, of polyptychs and other formats traditionally reserved for religious paintings. This trend can be seen in other works in this exhibition: Pellizza's *The Procession* (1892–5, cat. 10) with its curved top and gold border; and Nomellini's *Symphony of the Moon* (cat. 30), a gold-framed, multi-panel composition. These devotional formats were used to explore the alternative interpretations of spirituality current at this time. *Winter in the Mountains* is therefore configured as a Symbolist altarpiece, inviting us to engage in sublime contemplation through which the divine presence in nature will be revealed, much as it was to Grubicy in his mountain retreat. **LP**

PROVENANCE
Galleria d'Arte Moderna, Milan (bequeathed by the artist, 1920)

SELECTED EXHIBITIONS
1921 Rome, Palazzo delle Esposizioni, *I Biennale Romana*; **1990** Trento, Palazzo delle Albere, *Divisionismo italiano*

SELECTED REFERENCES
Fiori (ed.) 1968, vol. II, cat. 105; Berresford 1979, p. 232 (*Morning*); Belli (ed.) 1990, pp. 33, 38–9, cat. 3; Rebora 1995, pp. 40–4, cats 536, 574, 637, 632, 633, 672, 739, 680; Caroli and Masoero (eds) 2001, cat. 38 (*Morning*); Scotti Tosini 2007, pp. 51–2; Greene 2008

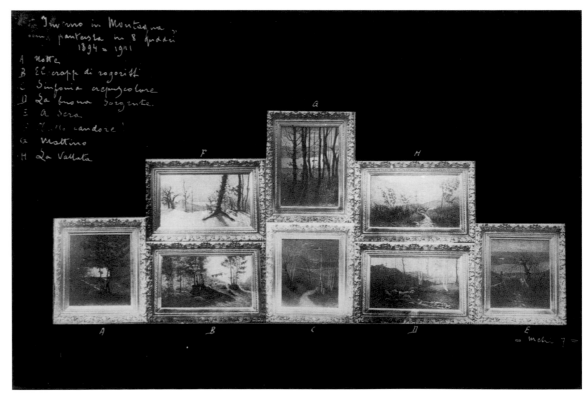

FIG. 37
Contemporary photograph of Grubicy de Dragon's polyptych *Winter in the Mountains*, 1911 Museo di Arte Moderna e Contemporanea di Trento e Rovereto

14 *Sea of Mist (Mare di nebbia)*, 1895

Oil on canvas, 38.5 × 58.5 cm
Private collection

PROVENANCE
Arturo Toscanini, Milan (until 1957); Wally Toscanini, Milan (until 1987)

SELECTED EXHIBITIONS
1910 Venice, *XI Esposizione Internazionale d'Arte della città di Venezia* [Biennale]; **1918** Milan, Galleria Pesaro, *Opere d'Arte donate per la lana ai combattenti*; **1970** Milan, Palazzo della Permanente, *Mostra del Divisionismo Italiano*; **1985** Como, Galleria d'Arte Cavour, *Omaggio a Vittore Grubicy De Dragon*; **2005** Verbania-Pallaza, Museo del Paesaggio, *Vittore Grubicy De Dragon: poeta del divisionismo*

SELECTED REFERENCES
Fiori (ed.) 1968, vol. II, p. 15, cat. I.115; Valsecchi et al. 1976, p. 71; Capuano (ed.) 1985, pp. 72–3; Rebora 1995, cat. 579

13 *Morning (Mattino)*, 1897

Oil on canvas, 47 × 41 cm
Musée d'Orsay, Paris (RF1977-426)

PROVENANCE
Musée du Luxembourg, Paris; bought through the intermediary Antonio Fradeletto, 1910

SELECTED EXHIBITIONS
1909 Venice, *VII Esposizione Internazionale d'Arte della Città di Venezia* [Biennale]; **1988** Amsterdam, Rijksmuseum Vincent Van Gogh, *Ottocento/Novecento. Italiaanse Kunst 1870–1910*; **1992–3** Baltimore (Walters Art Gallery), Worcester (Art Museum), Pittsburgh (Frick Art Museum), *Ottocento. Romanticism and Revolution in 19th-century Italian Painting*; **2001** Paris, Musée d'Orsay, *Italies 1880–1910*

SELECTED REFERENCES
Fiori (ed.) 1968, vol. II, p. 17, cat. I.145; Valsecchi et al. 1976, p. 23; Olson (ed.) 1992, p. 226; Rebora 1995, cat. 743; Piantoni and Pingeot (eds) 2000, p. 200

15 *Winter (Inverno)*, 1898

Oil on canvas, 48 × 40 cm
Musei Civici Veneziani, Galleria Internazionale d'Arte Moderna di Ca' Pesaro, Venice (163)

PROVENANCE
Purchased by the city of Venice from the 1901 Venice Biennale for the Galleria Internazionale d'Arte Moderna di Ca' Pesaro

SELECTED EXHIBITIONS
1901 Venice, *IV Esposizione Internazionale d'Arte della Città di Venezia* [Biennale]; XXVI Biennale, Venice 1952

SELECTED REFERENCES
Fiori (ed.) 1968, vol. II, p. 18, cat. I.158; Valsecchi et al. 1976, pp. 54–5; Rebora 1995, cat. 737

EMILIO LONGONI
1859 BARLASSINA, LOMBARDY–
1932 MILAN

Born in Barlassina, near the Lombard town of Seveso, to a modest family, the young Longoni went to Milan, where he was employed in various trades including poster decoration and toy-making. From 1876 to 1880 he regularly attended painting courses at the Accademia di Brera, under Raffaele Casnedi (1822–1892) and Giuseppe Bertini (1825–1892), winning some thirteen awards. Around 1881 he worked for a short period in Naples where he met the painter Domenico Morelli (1823–1901) and was influenced by the Neapolitan artist's bold rendering of chiaroscuro and strident use of colour. At the suggestion of Segantini, the gallery owner Vittore Grubicy signed up Longoni in 1880. Longoni worked alongside Segantini in Brianza from 1882 to 1884 – an especially creative and productive phase in his career. Under his contract with Grubicy, Longoni was forced to accept the dealer's right to sign his paintings with whichever signature he wished; in 1884, however, Grubicy signed one of his paintings with Segantini's name (because Segantini's work sold more easily and for higher prices), and Longoni left the gallery. He subsequently also fell out with Segantini and returned to Milan. During 1885 Longoni stayed in Ghiffa, by Lake Maggiore, where he met two *Scapigliati* artists, the painter Daniele Ranzoni (1843–1889) and the sculptor Paolo Troubetzkoy (1866–

1938). Through them he acquired some portrait commissions for Milanese aristocrats, which he did in the *Scapigliatura* style.

A turning point for Longoni was his meeting in 1890 with the critic and impresario Gustavo Macchi, who was both politically engaged and well informed about European cultural life. He introduced Longoni to the writings of Karl Marx and Friedrich Nietzsche, and also to the works of a group of Milanese socialist intellectuals. Around this time, Longoni adopted themes of social deprivation in his work, which led to the police keeping him under surveillance as an 'anarchist painter'. He began using a Divisionist technique in 1891, evident in *The Orator of the Strike* (1890–1, cat. 49). From 1900 to 1905 Longoni introduced Symbolist elements into his paintings and in 1906 he met the younger artist Carrà, who later described Longoni as a fervent reader of Arthur Schopenhauer and a devotee of Buddhism.

In his late works Longoni moved away from critical social themes towards more emotive and religious subjects. He married Fiorenza de Gasperi, his partner for many years, in 1928 and died four years later in Milan. **LS**

SELECTED REFERENCES
Dalai Emiliani (ed.) 1982; Ginex 1995; Ginex 2002

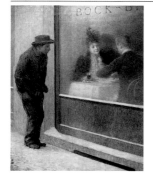

40 *Reflections of a Hungry Man* or *Social Contrasts* (*Riflessioni di un affamato* or *Contrasti sociali*), 1894

Oil on canvas, 190 × 155 cm
Fondazione Museo del Territorio Biellese, Biella (124/1980)

This literal representation of the class divide marks the peak of social engagement in Longoni's work, which was focused on the plight of the impoverished Milanese underclass between 1887 and 1897. Longoni added a real-life subtext to his painting's social critique by employing one of the city's outcasts – a young petty thief known as 'Ragno' (spider) – as model for the figure of the hungry man.

First shown at the second Brera Triennale in 1894, *Reflections of a Hungry Man* represents a coherent progression from *The Orator of the Strike* (1890–1, cat. 49), the artist's first attempt at fusing Divisionist technique with social issues, exhibited at the previous Triennale in 1891. Longoni's confident handling of paint in this canvas reveals the extent of his technical development since 1891. The Divisionist technique of individualised brushstrokes and unmixed colours, which had been only partially applied in *The Orator of the Strike*, to evoke the effects of sunlight on the orator's white shirt, is now highly accomplished.

The composition is divided into two separate zones of the haves and have-nots, which are formally differentiated by the artist. The class divide is articulated in the screen of small blue and magenta dots, behind which the dining bourgeois couple appear as a mirage-like vision to the starving man on the street.

Outside the restaurant, where the hungry man stands cramped with cold on the snow-covered pavement, Longoni employs looser brushwork, drawing attention to the window's closely woven web of dots, which seem to evoke the impenetrability of the class divide as well as the opacity of the glass.

The political impact of this painting was amplified by its reproduction in a special edition of the Socialist Party newspaper *Lotta di Classe*, published to mark Labour Day on 1 May, also the date of the Triennale's opening. Published alongside the reproduction was an anonymous dialogue, which further underlined the composition's articulation of social injustice: the over-fed bourgeois couple complain of a lack of appetite and send their unfinished meals back to the kitchen while ordering a superfluous second course, leaving the man on the street, shocked at their greed, to reflect on his own hunger and unemployment.

With a circulation of 100,000, *Lotta di Classe* ensured Longoni's painting reached audiences beyond the exhibition-going public. This increased visibility, added to the inflammatory combination of text and image, led to copies of the newspaper being impounded under the 1890 penal code for 'incitement of class hatred'. Longoni was subsequently labelled 'the painter of the Anarchists' and subject to police controls. **LP**

PROVENANCE
Pietro Curletti, Milan; Angelo Gaetano Curletti, Milan (1900); Cornelia Zuccoli, Milan (1935); Galleria dell'Annunciata, Milan; Bruno Blotto Baldo, Biella

SELECTED EXHIBITIONS
1894 Milan, Regia Accademia di Brera, *II Esposizione Triennale di Belle Arti* [Brera Triennale]; **1900** Milan, Società per le Belle Arti ed Esposizione Permanente, *La Pittura Lombarda nel secolo XIX*; **1935** Milan, Società per le Belle Arti ed Esposizione Permanente, *Mostra commemorativa di Emilio Longoni*; **1979** Milan, Palazzo della Permanente, *Arte e Socialità in Italia dal Realismo al Simbolismo 1865–1915*; **1982** Milan, Palazzo della Permanente, *Mostra di Emilio Longoni, 1859–1932*; **1988** Amsterdam (Rijksmuseum Van Gogh), Luxemburg (Musée de L'Etat du Luxembourg), Ottocento/Novecento *Italiaanse Kunst 1870–1910* **1990** Trento, Palazzo delle Albere, *Divisionismo italiano*; **2001** Milan, Palazzo Reale, *Dalla Scapigliatura al Futurismo*; **2007** Berlin (Berlin-Deutsche Guggenheim), New York (Guggenheim Museum), *Divisionism/Neo-Impressionism*

SELECTED REFERENCES
Fiori (ed.) 1968, vol. II, p. 131, no. VIII.25/1631; *Longoni* 1982, no. 37, pp. 62–3; Belli (ed.) 1990, no. 15, p. 82; Ginex 1995, no. 147; Caroli and Masoero (eds) 2001, no. 45; Ginex 2008

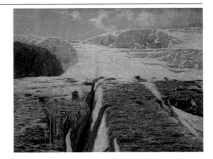

20 *Glacier (Ghiacciaio)*, 1905

Oil on canvas, 155 × 200 cm
Private collection

One of Longoni's largest canvases, *Glacier* belongs to an extensive series of alpine paintings executed during his prolonged visits to the mountains in the early 1900s. In this, he was following the example of Segantini and others, whose enthusiasm for this landscape developed alongside the growth in popularity of mountaineering. Longoni's alpine excursions were facilitated by a collapsible wooden hut that allowed him to live in self-sufficient isolation for weeks at a time.

For Longoni, as for other Divisionist artists such as Grubicy and Segantini, this solitary encounter with unspoiled nature was considered an essential experience in the process of making Symbolist works of art, allowing the artist to connect with the ideal. Unlike Grubicy's *Winter in the Mountains* (1896–1909, see pp. 143–44), in which the artist's awe-inspiring encounter with nature is primarily evoked by the luminous qualities of his paintings, Longoni's *Glacier* represents awesome nature in terms of a monumental feature of the landscape.

The isolation of Longoni's experience is evoked by the brutal composition, untempered by the grassy plains and peasant figures that feature in Segantini's alpine paintings. Longoni's abrupt framing of his subject eliminates lower levels of the mountain, where softening vegetation might be found, setting up a direct confrontation with the hard glacial mass rising sharply away from the viewer, starting with the gaping crevasse in the foreground.

As in *Reflections of a Hungry Man* (1894, cat. 40), Longoni applied unmixed colours to the canvas using a variety of mark-making techniques. In the lower part of the canvas, paint is applied directly from the tube or in wide brushstrokes that follow the contours of the cracked and pitted glacier. Towards the summit, brushstrokes become more fluid, breaking down into small dots in the sky.

The gritty moraine in the foreground is flecked with green and red, in accordance with the theory of complementary colours. The upper part of the glacier – which explores the full tonal range of whites produced by the effect of reflected light, from fluorescent greens in the icy shadows, to sun-warmed pinkish tones – can be seen as the culmination of Longoni's Divisionist experiment, which had begun with his examination of reflected sunlight on the white shirt of the protagonist in *The Orator of the Strike* (1890–1, cat. 49).

First shown, fittingly, at the exhibition marking the opening of the newly constructed Simplon Pass in 1906, *Glacier* was awarded the prestigious Prince Umberto prize, which Longoni controversially declined, sacrificing the gold medal and the considerable prize money of 6,000 Lire. Longoni was opposed to exhibition juries, art prizes and academic honours, having already refused the title of Honorary Member of the Brera Academy in 1891. His rejection of the Prince Umberto prize can also be read as a protest against the art establishment that had excluded him from the Venice Biennale in 1903. **LP**

PROVENANCE
Pietro Curletti, Milan (1906); Collection of Anna Cavaletti De Vecchi, Milan (1935); Bassetti Collection, Varese

SELECTED EXHIBITIONS
1906 Milan, Arena, *Mostra Nazionale di Belle Arti*; **1907** Venice, *VII Esposizione Internazionale d'Arte Moderna* [Biennale]; **1911** Turin, Parco del Valentino, *Mostra di quadri di alta montagna*; **1935** Milan, Società per le Belle Arti ed Esposizione Permanente, *Mostra commemorativa di Emilio Longoni*; **1990** Trento, Palazzo delle Albere, *Divisionismo italiano*; **2007** Berlin (Berlin-Deutsche Guggenheim), New York (Guggenheim Museum), *Divisionism/Neo-Impressionism: Arcadia and Anarchy*

SELECTED REFERENCES
Fiori (ed.) 1968, vol. II, p. 132, cat. VIII.49; Belli (ed.) 1990, cat. 21; Ginex 1995, cat. 322

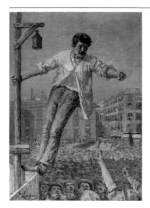

49 The Orator of the Strike (L'oratore dello sciopero), 1890–1

Oil on canvas, 193 × 134 cm
Private collection, Pisa

PROVENANCE
Ignazio Grün, Locate Triulzi; Carlo Formaggia, Busto Arsizio

SELECTED EXHIBITIONS
1891 Milan, Reale Accademia di Belle Arti di Brera, *I Esposizione Triennale di Belle Arti;* **1979** Milan, Palazzo della Permanente, *Arte e Socialità in Italia. Dal realismo al simbolismo. 1865–1915;* **2007** Berlin (Berlin-Deutsche Guggenheim), New York (Guggenheim Museum), *Divisionism/Neo-Impressionism: Arcadia and Anarchy*

SELECTED REFERENCES
Dalai Emiliani (ed.) 1982, pp. 57–8; Ginex 1995, pp. 184–6, cat. 121; Ginex 2007, pp. 29–30; Greene 2007, pp. 17, 19; Ginex 2008; Scotti Tosini 2008

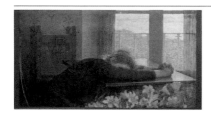

42 Alone! (Sola!), 1900

Pastel on paper, 74.5 × 125 cm
Casa di Lavoro e Patronato per i Ciechi di Guerra di Lombardia, Milan

PROVENANCE
Purchased by Queen Margherita of Savoy (1900); donated to Monsignor Edoardo Gilardi, founder of the Casa di Lavoro e Patronato per i Ciechi di Guerra di Lombardia (1935)

SELECTED EXHIBITIONS
1900 Milan, Reale Academia di Belle Arti di Brera, *IV Esposizione Triennale di Belle Arti;* **1935** Milan, Società per le Belle Arti ed Esposizione Permanente, *Mostra commemorativa di Emilio Longoni;* **1982** Milan, Palazzo della Permanente, *Mostra di Emilio Longoni, 1859–1932;* **1990** Trento, Palazzo delle Albere, *Divisionismo italiano*

SELECTED REFERENCES
Fiori (ed.) 1968, vol. II, p. 131, cat. VIII.32; Belli (ed.) 1990, p. 88, cat. 18; Ginex 1995, cat. 244

ZURICH ONLY

29 The Sound of the Stream (Il suono del ruscello), 1902–3

Oil on canvas, 106 × 165 cm
Private collection

PROVENANCE
Ignazio Grün, Locate Triulzi; Collection of Rosita Racheli Billitz (1982)

SELECTED EXHIBITIONS
1903 Venice, Palazzo delle Esposizioni, *V Esposizione Internazionale d'Arte Moderna* [Biennale]; **1935** Milan, Società per le Belle Arti ed Esposizione Permanente, *Mostra commemorativa di Emilio Longoni;* **1970** Milan, Palazzo della Permanente, *Mostra del Divisionismo Italiano*

SELECTED REFERENCES
Fiori (ed.) 1968, vol. II, p. 132, cat. VIII.41; Ginex 1995, pp. 254–5, cat. 275

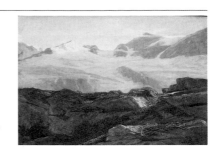

19 *Glacier, Bernina Pass* (*Passo del Bernina*), 1904–5
Oil on canvas, 103 × 150 cm
Banca di Credito Cooperativo di Barlassina, Milan

PROVENANCE
Fiorenza De Gasperi Longoni, Milan; Giuseppe Mascarini, Milan; Antonio Pavoni, Milan (1982); Vercelotti Pasini Semerano Collection, Milan

SELECTED EXHIBITIONS
1905 Milan Società per le Belle Arti ed Esposizione Permanente, *Esposizione di Primavera*; **1935** Milan, Società per le Belle Arti ed Esposizione Permanente, *Mostra commemorativa di Emilio Longoni*; **1982** Milan, Palazzo della Permanente, *Mostra di Emilio Longoni, 1859–1932*

SELECTED REFERENCES
Dalai Emiliani (ed.) 1982, cat. 63, pp. 72–3; Ginex 1995, cat. 296

Morbelli was born in the Piedmont provincial capital of Alessandria, into a wealthy family of winegrowers. He studied first in Alessandria and probably in Casale, where his parents owned land. He was forced to abandon his early music studies because of increasing deafness and in 1867 was granted a scholarship in fine art, which took him to Milan where he spent the rest of his life.

Until 1876 Morbelli trained at the Accademia di Brera under Raffaele Casnedi (1822–1892) and Giuseppe Bertini (1825–1892), winning several awards for his rural genre scenes and *vedute*. Studying alongside Segantini, Previati, Longoni and Sottocornola, among others, he became friends with them, and his paintings addressed themes of work and social deprivation, depicted in a social realist style.

In 1887 Vittore Grubicy signed him up and invited him to take part in the exhibition that he was organising in London for the following year. During 1887 Morbelli travelled to Venice and Genoa, where he worked on studies from nature. Each summer he and his wife Maria Pagani, whom he had married in 1882, stayed in the Colma di Rosignano area of Casale Monferrato in a house belonging to his parents, where he also opened a studio in 1889. Morbelli repeatedly returned to rural genre scenes, sometimes using photographs. 1889 was also marked by a visit to the *Exposition Universelle* in Paris and a short stay in London. By this time Morbelli was becoming increasingly interested in optical theories.

The collaboration with the Grubicy Gallery came to an end in 1893, with Morbelli and Grubicy disagreeing on artistic as well as business matters. Nevertheless, Morbelli still exhibited successfully in Italy and abroad. From 1892 until Pellizza's death in 1907, Morbelli and Pellizza – fifteen years his junior – had a strong friendship, captured in their lively correspondence. Morbelli made various efforts to strengthen the acceptance of the Divisionist group. One of his plans was to present an exhibition at the 1897 *Esposizione di Torino* with Segantini, Longoni, Nomellini, Sottocornola and others, but he met with resistance, especially from the influential Segantini. In late 1902 or early 1903 Morbelli set up a studio in the Pio Albergo Trivulzio in Milan, a rest home for the elderly and destitute, producing several paintings exploring the themes of old age that he had first depicted in 1883. Morbelli's thoughts on his working practice and his meticulous research into colour theory were recorded in his diary, *La Via Crucis del Divisionismo*. **LS**

SELECTED REFERENCES
Caramel (ed.) 1982; Scotti Tosini 1991; Scotti Tosini (ed.) 2001

ANGELO MORBELLI
1853 ALESSANDRIA–1919 MILAN

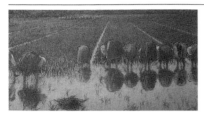

LONDON ONLY

37 *For Eighty Cents!* (*Per ottanta centesimi!*), 1893–5

Oil on canvas, 69 × 124.5 cm
Fondazione Museo Francesco Borgogna, Vercelli (no. 196)

The first of two paintings by Morbelli depicting the poorly paid seasonal labour of the *mondine* (women rice workers) in the paddies close to his family home in Casale Monferrato. Morbelli began working from life, but after encountering difficulties with the constantly changing agricultural landscape, worked from photographs in his Milanese studio.

Unlike the second painting of the same subject – *In the Rice Fields* (1898–1901, cat. 38) – the provocative title of this canvas highlights the exploitative terms of the women's employment. This was a highly topical issue in the light of the agricultural crisis of the early 1890s, which had seen wages plummet.

In contrast with the later painting's more lyrical composition showing rice workers viewed in profile, the uncompromising arrangement of faceless figures in *For Eighty Cents!* describes the relentlessness of the women's work. In a letter to Pellizza dated 1894, Morbelli wrote that he had altered his composition on the advice of Grubicy, removing the figure of the rice worker that had dominated the foreground. This change created the gap in the line of figures stretching across the foreground, leading the eye across the green expanse of still-to-be-worked field, receding between converging perspective lines into the very depths of pictorial space. By eliminating any glimpse of sky, Morbelli confines our view to the unforgiving place of work. The backbreaking act of labour reverberates around the composition, repeated in each of the figures closest to us, reflected in the flooded rice field, and echoed in the line of women working in the distance.

Morbelli's canvas combines the social theme and technical innovation that characterised many Divisionist works, including Pellizza's *The Living Torrent* (1895–6, cat. 47). In accordance with the chromatic theories of Ogden Rood, green is juxtaposed with violet (its complementary in light) rather than red (its pigment complementary) to achieve the heightened luminosity of the water-filled rice fields. Morbelli's preoccupation with these light effects caused him to retouch the canvas after its exhibition in Venice (1895) and Turin (1896). **LP**

PROVENANCE
Acquired by the Museo Borgogna from the *Esposizione Internazionale di Risicultura e Irrigazione*, Vercelli, 1912

SELECTED EXHIBITIONS
1895 Venice, *I Esposizione Internazionale d'Arte della Città di Venezia* [Biennale]; **1896** Turin, Società Promotrice di Belle Arti, *I Esposizione Triennale di Belle Arti*; **1897** Dresden, *Internationale Kunstausstellung*; **1899** Milan, Palazzo della Permanente, *Esposizione di Primavera*; **1912** Vercelli, *Esposizione Internazionale di Risicultura e Irrigazione*; **1953** Alessandria, Pinacoteca Civica, *Mostra commemorativa del pittore Angelo Morbelli*; **1970** Milan, Palazzo della Permanente, *Mostra del Divisionismo Italiano*; **1979** Milan, Palazzo della Permanente, *Arte e socialità in Italia. Dal realismo al simbolismo. 1865–1915*; **1979–80** London (Royal Academy of Arts), Washington (National Gallery of Art), *Post-Impressionism: Cross Currents in European Painting*; **1982** Alessandria (Palazzo Cuttica), Rome (Galleria Nazionale d'Arte Moderna), *Angelo Morbelli*; **1990** Trento, Palazzo delle Albere, *Divisionismo italiano*; **1991–2** Turin (Mole Antonelliana), Milan (Palazzo Reale), Piacenza (Palazzo Gotico), *Il colore del lavoro*; **2001** Paris, Musée d'Orsay, *Italies 1880–1910*; **2007** Berlin (Berlin-Deutsche Guggenheim), New York (Guggenheim Museum), *Divisionism/Neo-Impressionism: Arcadia and Anarchy*

SELECTED REFERENCES
Fiori (ed.) 1968, vol. II, cat. VI.58; Berresford 1979, p. 242; Caramel (ed.) 1982, pp. 17, 169–70; Belli (ed.) 1990, cat. 51; Gian Ferrari and Poli (eds) 1991, p. 42, cat. 3; Scotti Tosini 1991, p. 76; Piantoni and Pingeot (eds) 2000, p. 233

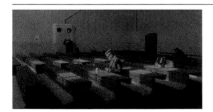

36 *The Christmas of Those left behind* (*Il Natale dei rimasti*), 1903

Oil on canvas, 61 × 110 cm
Musei Civici Veneziani, Galleria Internazionale d'Arte Moderna di Ca' Pesaro, Venice

This painting forms part of a cycle of six paintings titled *The Poem of Old Age* (*Il Poema della vecchiaia*) – which also includes *I Remember When I was a Girl (Entremets)* (1903, cat. 39) – designed to be displayed in a non-linear composition, rather like Grubicy's *Winter in the Mountains (Pantheist Poem)* (*Inverno in montagna (Poema panteista)*, 1896–1911, cats 16–18 and fig. 37). This canvas was one of first works to be purchased from the Venice Biennale – where all six panels of the cycle were exhibited – for the Galleria Internazionale d'Arte Moderna di Ca' Pesaro.

All six canvases were realised at the Pio Albergo Trivulzio, an old people's home in Milan, where Morbelli set up a studio in 1902–3, having first painted there in 1883. In the intervening years, the home had been a recurrent location in Morbelli's work, with death, loss and the remembrance of things past being key themes. *The Christmas of Those*

left behind revisits the subject of *Holiday at the Pio Albergo Trivulzio* (1892, cat. 35), which depicts some of the home's dejected residents spending Christmas Day as they would do any other: passing the time in lonely introspection, trying to keep warm, sleeping, contemplating life and loss.

Despite the sense of collectivity implied by their identical clothing, the carefully individualised poses underline the psychological as well as physical isolation of each figure. The uniform clothing also allows Morbelli to showcase his observations of the effect of different light conditions on our perception of colour: what is rendered as sludgy green-brown in tone in the shade appears as golden oatmeal in the sunlit areas. A comparison with the uniform chocolate browns of the residents' clothing in *Holiday at the Pio Albergo Trivulzio* reveals the development of Morbelli's Divisionist technique over the intervening decade.

As in *For Eighty Cents!* (1893–5, cat. 37), the locations Morbelli explored in his socially engaged paintings interested him as much for the light effects they offered as for the plight of the people that inhabited them. These formal concerns are emphasised by Morbelli's decision to paint the Pio Trivulzio in 1903 as he had found it in the 1880s, preferring the old-fashioned stove and yellowing walls to the more sterile environment of fresh whitewash and modern central heating that appears in the photographs he took there in the first years of the twentieth century.

The Poem of Old Age is one of Morbelli's most extensive experiments in painting contrasting light effects, a theme he explored in writing in *Via Crucis del Divisionismo*, the notes he compiled between 1912 and 1919. He was particularly concerned with the evocation of shadow, and whether shaded areas should be painted using mixed colours, glazes, or pure pigments. Even the light source in this painting is described by shadow – cast by the window frames beyond pictorial space – confirming its status as a representational *tour de force* of contrasting light effects.

As well as demonstrating the artist's technical abilities, the juxtaposition of sharply contrasting areas of light and shade can be understood as metaphors for life and death, which exist in close proximity in Morbelli's *Poem of Old Age*. Although he would continue to represent subjects from the hospice until 1911, by conveying symbolic meaning through a virtuoso handling of Divisionist technique, the *Poem of Old Age* effectively concludes Morbelli's artistic journey through the halls of the Pio Albergo Trivulzio that had begun in a realist idiom in 1883. **LP**

PROVENANCE
Purchased at the 1903 Venice Biennale by the City of Venice for the Galleria Internazionale d'Arte Moderna di Ca' Pesaro, Venice

SELECTED EXHIBITIONS
1903 Venice, *V Esposizione Internazionale d'Arte della Città di Venezia* [Biennale]; **1905** Munich, Glaspalast, *IX Internationale Kunstausstellung;* **1930** London, Royal Academy of Arts, *Exhibition of Italian Art;* **1952** Venice, *XXVI Biennale Internazionale d'Arte* (*Mostra del Divisionismo*) **1953** Alessandria, Pinacoteca Civica, *Mostra commemorativa del pittore Angelo Morbelli;* **1970** Milan, Palazzo della Permanente, *Mostra del Divisionismo Italiano;* **1979–80** London (Royal Academy of Arts), Washington (National Gallery of Art), *Post-Impressionism: Cross Currents in European Painting;* **1982** Alessandria (Palazzo Cuttica), Rome (Galleria Nazionale d'Arte Moderna), *Angelo Morbelli;* **1990** Trento, Palazzo delle Albere, *Divisionismo italiano*

SELECTED REFERENCES
Fiori (ed.) 1968, vol. I, pp. 138, 241; Fiori (ed.) 1968, vol. II, cat. VI.79; Berresford 1979, pp. 242–3, cat. 371; Caramel (ed.) 1982, pp. 18, 168; Damigella 1989, p. 36; Belli (ed.) 1990, p. 184, cat. 56; Scotti Tosini 1991, cat. 22; Scotti Tosini 2007, p. 54

12 *Dawn (Alba)*, 1891

Oil on canvas, 77.5 × 55 cm
MNAC. Museu Nacional d'Art de Catalunya, Barcelona (MNAC/MAM 11137)

PROVENANCE
Acquired by Museos Municipales de Arte, Barcelona, 1894

SELECTED EXHIBITIONS
1891 Milan, Reale Accademia di Belle Arti di Brera, *I Esposizione Triennale di Belle Arti;* **1892** Turin, Società Promotrice di Belle Arti, *L'Esposizione Cinquantenaria di Arte Moderna;* **1893** Genoa, Palazzo Bianco, *XLI Esposizione di ogetti d'arte della Società Promotrice di Belle Arti;* **1894** Barcelona, *II Esposición general de Bellas Artes;* **1982** Alessandria (Palazzo Cuttica), Rome (Galleria Nazionale d'Arte Moderna), *Angelo Morbelli;* **1990** Trento, Palazzo delle Albere, *Divisionismo italiano;* **2001** Turin, Galleria Civica d'Arte Moderna e Contemporanea, *Angelo Morbelli: Tra realismo e divisionismo;* **2007** Berlin (Berlin-Deutsche Guggenheim), New York (Guggenheim Museum), *Divisionism/Neo-Impressionism: Arcadia and Anarchy*

35 *Holiday at the Pio Albergo Trivulzio* (*Giorno di Festa al Pio Albergo Trivulzio*), 1892

Oil on canvas, 78 × 122 cm
Musée d'Orsay, Paris (RF1192)

PROVENANCE
Purchased by the French state for the Musée de Luxembourg (1900)

SELECTED EXHIBITIONS
1892 Turin, Parco del Valentino, Società Promotrice di Belle Arti, *L'Esposizione Cinquantenaria di Arte Moderna*; **1893–4** Florence, *XLVII Esposizione Annuale Società delle Belle Arti*; **1894** Barcelona, *II Esposiciòn General de Bellas Artes*; **1895–6** Rome, Società degli Amatori e Cultori di Belle Arti, *LXVI Esposizione*; **1900** Paris, *Exposition Internationale Universelle. Section des Beaux Arts*; **1990** Trento, Palazzo delle Albere, *Divisionismo italiano*; **2001** Paris, Musée d'Orsay, *Italies 1880–1910*; **2007** Berlin (Berlin-Deutsche Guggenheim), New York (Guggenheim Museum), *Divisionism/Neo-Impressionism: Arcadia and Anarchy*

SELECTED REFERENCES
Fiori (ed.) 1968, vol. II, cat. VI.59; Caramel (ed.) 1982, p. 43; Belli (ed.) 1990, p. 172, cat. 50; Scotti Tosini 1991, p. 74; Piantoni and Pingeot (eds) 2000, p. 230

11 *Twilight* (*S'avanza*), 1896

Oil on canvas, 85 cm diameter
Galleria d'Arte Moderna, Comune di Verona

PROVENANCE
Collection of U. Zannoni; donated to the current owner by U. Zannoni (1905)

SELECTED EXHIBITIONS
1896 Turin, Parco del Valentino, Società Promotrice di Belle Arti, *I Esposizione Triennale;* **1896–7** Florence, Società delle Belle Arti, *Festa dell'Arte e dei Fiori. Esposizione Annuale;* **1897** Dresden, *Erste Internationale Kunstausstellung;* **1900** Verona, Società di Belle Arti, *Esposizione Artistica di Verona;* **1990** Trento, Palazzo delle Albere, *Divisionismo italiano;* **1999–2000** Turin, Palazzo Cavour, *Da Segantini a Balla: un viaggio nella luce;* **2001** Turin, Galleria Civica d'Arte Moderna e Contemporanea, *Angelo Morbelli: Tra realismo e divisionismo*

SELECTED REFERENCES
Fiori (ed.) 1968, vol. I, pp. 125, 129; Fiori (ed.) 1968, vol. II, p. 111, cat. VI.61; Caramel (ed.) 1982, pp. 46, 47, 171; Belli (ed.) 1990, p. 176, cat. 52; Scotti Tosini 1991, p. 78; Vinardi 2001, p. 141, cat. 72

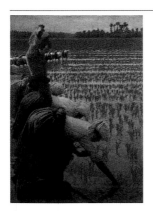

38 *In the Rice Fields* (*In risaia*), 1898–1901

Oil on canvas, 183 × 130 cm
Private collection

PROVENANCE
Collection of the artist 1905; Museum of Fine Arts, Boston

SELECTED EXHIBITIONS
1900 Milan, Reale Accademia di Belle Arti, di Brera *IV Triennale;* **1901** Munich, Glaspalast, *VIII International Kunstausstellung;* **1904** St Louis, *International Exhibition of Fine Arts* (Italian Pavilion); **1979** Milan, Palazzo della Permanente, *Arte e socialità in Italia dal realismo al simbolismo 1865–1915;* **1982** Alessandria (Palazzo Cuttica), Rome (Galleria Nazionale d'Arte Moderna), *Angelo Morbelli, 1853–1919;* **1990** Trento, Palazzo delle Albere, *Divisionismo italiano;* **2000** London, Royal Academy of Arts, *1900: Art at the Crossroads;* **2001** Paris, Musée d'Orsay, *Italies 1880–1910*

SELECTED REFERENCES
Fiori (ed.) 1968, vol. II, cat. VI.68; Belli (ed.) 1990, p. 178, cat. 53; Scotti Tosini 1991, p. 82; Piantoni and Pingeot (eds) 2000, p. 235; Rosenblum et al. 2000

39 *I Remember when I was a Girl (Entremets)* (*Mi ricordo quand'ero fanciulla, Entremets*), 1903

Oil on canvas, 74.5 x 114.3 cm
Private collection on loan to the Fondazione Cassa di Risparmio di Tortona

PROVENANCE
Collection of Aldo Borletti (purchased 1903); private collection

SELECTED EXHIBITIONS
1903 Venice, *V Esposizione Internazionale d'Arte della città di Venezia* [Biennale]; **1905** Buenos Aires, Montevideo, Valparaíso, *III Esposizione d'Arte della Galleria Stefani*; **1920** Milan, Famiglia Artistica, *Angelo Morbelli 1853–1919*; **1990** Trento, Palazzo delle Albere, *Divisionismo italiano*; **1995** Varese (Castello di Masagno), Casale Monferrato (Museo Civico), *Morbelli Angelo and Morbelli Alfredo*; **2000** London, Royal Academy of Arts, *1900: Art at the Crossroads*; **2001** Turin, Galleria Civica d'Arte Moderna e Contemporanea, *Angelo Morbelli: Tra realismo e divisionismo*

SELECTED REFERENCES
Fiori (ed.) 1968, vol. II, cat. VI.85; Belli (ed.) 1990, p. 182, cat. 55; Vinardi 2001, p. 145, cat. 84

7 *The Glacier of Forni (Il ghiacciaio dei Forni)*, 1910–12

Oil on canvas, 75 × 94 cm
Private collection

PROVENANCE
O. Morbelli, Milan

SELECTED EXHIBITIONS
1929–30 Milan, Galleria Pesaro, *Mostra postuma di Angelo Morbelli*; **1982** Alessandria (Palazzo Cuttica), Rome (Galleria Nazionale d'Arte Moderna), *Angelo Morbelli*; **1995** Varese (Castello di Masagno), Casale Monferrato (Museo Civico), *Morbelli Angelo and Morbelli Alfredo*; **2001** Turin, Galleria Civica d'Arte Moderna e Contemporanea, *Angelo Morbelli: Tra realismo e divisionismo*

SELECTED REFERENCES
Fiori (ed.) 1968, vol. II, cat. VI.205; Caramel (ed.) 1982, p. 173; Scotti Tosini 1991, p. 110; Vinardi 2001, p. 150, cat. 101

Nomellini first attended painting lessons in his home town before receiving a scholarship from the local authorities that enabled him to attend the Accademia di Belle Arti in Florence. There he studied under the famous *Macchiaiolo* artist Giovanni Fattori (1825–1908), to whom he remained indebted for the rest of his life.

In 1888 Nomellini met Pellizza and they developed a lifelong friendship. It was around this time that Nomellini began to be interested in the representation of light and his paintings show the first traces of Divisionism. Between 1890 and 1902 he lived in Genoa, where he supported radical left-wing politics and was jailed for several months in 1894, after having been accused of anarchism. His house became an important meeting place for artists and poets, and his art – which often depicted social subjects that could be interpreted as critical of the authorities – greatly influenced Divisionist painters in the Liguria region. He also wrote regularly for socialist journals such as *La Riforma*, *La Cronaca d'Arte* and *L'Idea Liberale*.

In 1902 Nomellini moved to the coastal village of Torre del Lago, south of Viareggio north of Pisa, where his circle of acquaintances included the composers Giacomo Puccini and Pietro Mascagni, painters such as Galileo Chini (1873–1956) and poets including Gabriele d'Annunzio and Giovanni Pascoli. The shared preoccupation of these individuals was the fostering of Italian nationalism, which had a major influence on Nomellini. In 1907, together with Previati, Chini and the sculptor Edoardo De Albertis (1874–1950), he organised the *Sala del Sogno* (Hall of Dreams) at the seventh Venice Biennale, which included Symbolist works by artists such as Maurice Denis (1870–1943) and Franz von Stuck (1863–

PLINIO NOMELLINI
1866 LIVORNO–1943 FLORENCE

1928). Increasingly Nomellini turned to Symbolism himself in trying to recreate atmospheres and express emotions through motifs from nature. Later, he was to abandon Divisionism in favour of a more loosely Impressionist style.

From 1908 he lived for ten years or so in Viareggio, where he mixed with the local artistic community. In 1913 he was one of the organisers of the first Roman Secession, in which he also took part. He finally moved to Florence in 1919, although he often returned to the coast around Livorno and visited the island of Elba where he had set up a studio. Alongside his career as a painter, he was also a writer, publishing poems inspired by the work of Pascoli. **LS**

SELECTED REFERENCES
Bruno et al. 1989; Nomellini (ed.) 1998

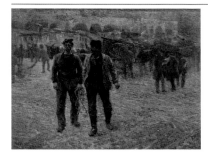

51 *Piazza Caricamento, Genoa*, 1891

Oil on canvas, 120 × 160 cm
Fondazione Cassa di Risparmio di Tortona

Presumed lost until 1983, *Piazza Caricamento* is one of a series of labour-themed paintings executed by Nomellini in the late 1880s and early 1890s, including *The Strike* (1889, cat. 50) and *The Call to Work* (*La diana del lavoro*, 1893). The painting depicts dockers in Genoa, where the anarchist-sympathising Nomellini participated in social agitations, which were gathering force in the city when he relocated there the year before making this painting.

The works produced in Genoa mark a key stage in Nomellini's stylistic development as he began to explore a Divisionist idiom, moving away from the style he had developed as a student of the *Macchiaiolo* painter Giovanni Fattori in Florence. This painting is still indebted to the *Macchiaioli* in its muted palette and loose mark-making, which is used to create atmospheric effects, as in the Impressionist technique. This distinguishes Nomellini's work from that of his northern counterparts. The rather muddy impasto of this canvas shows little evidence of the division of colours and the contrast of tones that would enhance the luminous qualities of *The Call to Work* – another painting of Genoese ship workers executed two years later – in which pigment is applied in more precise, directional dabs.

The development of a Divisionist technique through socially engaged themes was a process repeated in the careers of other Divisionist artists, including Pellizza, with whom Nomellini was in close contact at this time. Pellizza – who had not yet begun to work in a Divisionist style when he saw *Piazza Caricamento* at the 1891 Brera Triennale – was surely influenced by Nomellini's heroic workers advancing towards the spectator when he was working on the composition of *The Fourth Estate* (*Il Quarto Stato*, 1898–1901, fig. 4).

Nomellini depicts his protagonists in relief, emerging from the hazy background in comparatively sharp focus. Their solid forms, articulated in compact brushwork, stand out confidently from their dappled surroundings. This formal and spatial separation of the two foremost figures from the background scene of road-sweepers, carts and bourgeois newspaper-readers, draws attention to their act of advancement and evokes the strength of their political resolve.

At the turn of the century, Nomellini's work became increasingly concerned with Symbolist ideas, as seen in the polyptych *Symphony of the Moon* (*Sinfonia della luna*, 1899, cat. 30) which he exhibited at the Venice Biennale in 1899, signalling the thematic shift in his painting. This was cemented in 1902 by Nomellini's departure from Genoa for Torre del Lago, where he developed the Symbolist tendency in his work, surrounded by the coterie of artists, writers and musicians that formed around him and the composer Giacomo Puccini. **LP**

PROVENANCE
Collection of Pietro Mascagni, Farinelli Mascagni, Rome

SELECTED EXHIBITIONS
1891 Milan, Reale Accademia di Belle Arti di Brera, *I Esposizione Triennale di Belle Arti;* **1985** Milan (Palazzo della Permanente), Genoa (Palazzo dell'Accademia), *Plinio Nomellini;* **1990** Trento, Palazzo delle Albere, *Divisionismo italiano;* **1991–2** Turin (Mole Antonelliana), Milan (Palazzo Reale), Piacenza (Palazzo Gotico), *Il colore del lavoro;* **2001** Paris, Musée d'Orsay, *Italies 1880–1910*

SELECTED REFERENCES
Bruno (ed.) 1985, cat. 21; Belli (ed.) 1990, cat no. 65; Gian Ferrari and Poli (eds) 1991, cat. 12; Piantioni and Pingeot (eds) 2000, p. 229

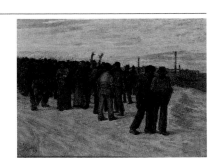

50 *The Strike* (*Lo sciopero*), 1889
Oil on canvas, 29.5 × 40.5 cm
Private collection

PROVENANCE
Private collection, Trieste; sold Stadion Auction, Milan, 20 October 1994, no. 88

SELECTED EXHIBITIONS
1889 Florence, Società Promotrice di Belle Arti; **1998** Livorno, Museo Civico Giovanni Fattori, *Plino Nomellini: I colori del sogno*, no. 9; **2000** Serravezza, Palazzo Mediceo, *Lorenzo Viani: un maestro del 900 europeo*; **2005** Piacenza, Galleria d'Arte moderna Ricci Oddi, *Un'altro 800, gusto e cultura in una quadreria oltrepadana*; **2006** Rome, Complesso Vittoriano, *1956–2006, 50 anni di Corte Costituzionale, le immagini, le idee*

SELECTED REFERENCES
Bellonzi et al. 1979, p. 162; Scotti Tosini 1985, pp. 9–10; Belli (ed.) 1990, p. 212;
Bruno 1994, p. 61, plate 13; Bruno and Frilli 1994, p. 5, fig. 3; Morel 1998, p. 529, plate 649; Nomellini (ed.) 1998, p. 9;
Fugazza et al. 2005, colour plate no. 28, pp. 78–9; Boragina and Mercenaro 2006, p. 16, colour plate no. 3, p. 27

30 *Symphony of the Moon* (*Sinfonia della luna*), 1899
Oil on canvas, 174 × 346 cm
Musei Civici Veneziani, Galleria Internazionale d'Arte Moderna di Ca' Pesaro, Venice

PROVENANCE
Purchased for the Galleria Internazionale d'Arte Moderna di Ca' Pesaro at the 1899 Venice Biennale

SELECTED EXHIBITIONS
1899 Venice, *III Esposizione Internazionale d'Arte della Città di Venezia* [Biennale]; **1985** Milan (Palazzo della Permanente), Genoa (Palazzo dell'Accademia), *Plinio Nomellini*

SELECTED REFERENCES
Fiori (ed.) 1968, vol. II, p. 78, cat. IV.38; Bruno (ed.) 1985, cat. 33; Scotti Tosini 2007, pp. 45–7

From 1883 Pellizza studied at Milan's Accademia di Brera, where he became familiar with the works and techniques of the *Scapigliatura* movement. At the same time he also took private lessons with the painter Giuseppe Puricelli. In 1887/8 he moved to Rome to continue his studies and then on to Florence to study under the renowned *Macchiaiolo* painter Giovanni Fattori at the Accademia de Belle Arti, where he struck up a long lasting friendship with Nomellini. He also took lessons at the Accademia Carrara in Bergamo, where he favoured realistically rendered rural subjects. On his first visit to Paris in 1889 he visited the *Exposition Universelle* and saw works by Bastien-Lepage, Corot and Manet, which made a lasting impression on him. After his return he stayed only a short time at the Accademia in Bergamo before moving to Genoa. In contact once more with his friend Nomellini, together they explored Divisionist technique and the representation of light.

Pellizza returned to live in his Piedmont hometown of Volpedo in 1890, marrying his muse and model Teresa Bidone in 1892. He kept abreast of developments in the metropolitan art scene, however, by regular correspondence with Segantini, Morbelli and Grubicy, and during the winter of 1893/4 he studied in Florence. In the early 1890s, together with Morbelli, he focused more deeply on the scientific theory of Divisionism, studying the writings of Ogden N. Rood and Michel-Eugène Chevreul, and his paintings became more Divisionist in style. At the same time he was increasingly interested in theories of socialism and the works of Karl Marx and Friedrich Engels. Convinced that art could have a positive influence on society, he began to introduce socialist topics into his paintings, superimposing urban protests on to the rural world of his small town. In around 1896, inspired by the work of Previati, he wrote an analysis of the relationship between colour and psychological wellbeing. The negative critical response to his masterpiece *The Fourth Estate* (*Il Quarto Stato*, 1898–1901, fig. 4) led him increasingly to abandon political subjects and embrace Symbolist motifs.

GIUSEPPE PELLIZZA
DA VOLPEDO
1868–1907 VOLPEDO,
NEAR ALESSANDRIA

In 1906 Pellizza stayed in Rome with the socialist writer and poet Giovanni Cena, working on humanitarian and social projects such as the establishment of schools in the rural areas around Rome. Around the same time he created plein-air paintings, preferring rural landscape to urban and industrial backdrops, and spent the summer of 1906 in Engadine and Savognin in the Swiss Alps, following in the footsteps of Segantini. Pellizza commited suicide in his studio the following year, after the death of his wife and one of his sons. **LS**

SELECTED REFERENCES
Scotti 1986; Scotti Tosini and Pernigotti 1996; Scotti Tosini 1999

IO *The Procession* (*Processione*), 1892–5

Oil on canvas, 95 × 157 cm
Museo Nazionale della Scienza e della Tecnologia Leonardo da Vinci, Milan (1782)

Begun in the year Pellizza started painting in a Divisionist style, *The Procession* took a further three years to complete, with the artist finding it impossible to work on the painting for more than a few months each year when the appearance of the landscape was as he wished.

Pellizza was inspired by the specific location of the tree-lined avenue in his hometown of Volpedo, as he explained in 1897:

> It seemed to me that no other subject could have been more suited to that place at that time: the lines of the landscape themselves are nearly all slightly curved [...] and seemed to me to be strictly related to the gentle religious feeling, moving upwards, which predominates in the souls of the believers who advance, praying and singing, and the prayer and song rise up as one with that offered by the whole of illuminated nature.

The curved line that defines the upper part of the painting also defines its spiritual tone, echoing the curves of the landscape – it mirrors the edge of the shaded area in the foreground – and recalling the format of Quattrocento religious painting, to which the gold border of the canvas also refers. Both the curved upper edge and gold surround were recurrent features in Pellizza's Divisionist output, including *The Dead Child* (1896–1902, cat. 9), a second interpretation of the processional theme, located in the same shaded avenue.

Dissatisfied with the predominant bluish tone, Pellizza retouched the painting after its debut exhibition at the first Venice Biennale and again in November 1896, after it was shown in Turin, when he also varnished the surface. He remained dissatisfied with the figure of the woman leaning towards her child at the back of the procession – 'a remnant of the academy' – which he felt disrupted the unity of the spiritual ideal expressed elsewhere in the composition.

However, the ethereal qualities of the painting were particularly admired at Venice, not least by those close to Pellizza. The poet Neera commended his fusion 'of the thing seen and the thing felt'; and the writer and critic Gustavo Macchi praised the unusual 'airiness', 'transparency' and 'vibration of light' in his painting. Well received at subsequent exhibitions in Italy and internationally, *The Procession* was awarded the silver medal at Saint Louis in 1904. The subtle spiritualism of the painting ensured its enduring popularity after the artist's death, when – during the 1920s – it was considered his best work. **LP**

PROVENANCE
Collection of Pellizza heirs, Volpedo; collection of G. Rossi, Milan (about 1920)

SELECTED EXHIBITIONS
1895 Venice, *I Esposizione Internazionale d'Arte della Città di Venezia* [Biennale]; **1896** Turin, Società Promotrice di Belle Arti, *I Esposizione Triennale di Belle Arti;* **1897** Brussels, *Exposition Internationale des Beaux-Arts;* **1902** Berlin, *Grosse Berliner Kunstaustellung;* **1903** Munich, Glaspalast, *Internationale Kunstausstellung;* **1904** St Louis, *International Exhibition of Fine Arts – The Universal Exhibition;* **1905** Angers, *Exposition Union Internationale des Beaux-Arts;* **1906** Rome, Società Amatori e Cultori di Belle Arti, *LXXVI Esposizione di Belle Arti;* **1920** Milan, Galleria Pesaro, *Mostra Individuale di G. Pellizza da Volpedo;* **1939** Turin, Salone della Stampa, *Mostra commemorativa di Giuseppe Pellizza da Volpedo;* **1952** Venice, *XXVI Biennale Internazionale d'Arte* (*Mostra del Divisionismo*); **1954** Alessandria, Pinacoteca Civica, *Mostra antologica del pittore Pellizza da Volpedo;* **1970** Milan, Palazzo della Permanente, *Mostra del Divisionismo Italiano;* **1979–80** London (Royal Academy of Arts), Washington (National Gallery of Art) *Post-Impressionism: Cross Currents in European Painting;* **1980–1** Alessandria, Palazzo Cuttica, *Pellizza da Volpedo.;* **1990** Trento, Palazzo delle Albere, *Divisionismo italiano;* **1999** Turin, Civica Galleria d'Arte Moderna, *Giuseppe Pellizza da Volpedo;* **2007** Berlin (Berlin-Deutsche Guggenheim), New York (Guggenheim Museum), *Divisionism/Neo-Impressionism: Arcadia and Anarchy*

SELECTED REFERENCES
Fiori (ed.) 1968, vol. I, pp. 173–4, 176–7, 185, 193, 195–6, 205, 225, 228, 241; Fiori (ed.) 1968, vol. II, V. 113; Scotti (ed.) 1974, pp. 35–9, 51, 100, 111, 115, 125, 132; Berresford 1979, p. 244; Scotti 1980, p. 68; Scotti 1986, pp. 341–2, no. 895; Belli (ed.) 1990, no. 32; Greene 2008

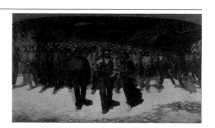

47 *The Living Torrent (Fiumana)*, 1895–6

Oil on canvas, 255 × 438 cm
Pinacoteca di Brera, Milan (Sprind gift, 1986/N.5555)

The second in the series of paintings that would culminate in Pellizza's iconic *The Fourth Estate* (*Il Quarto Stato*, 1901) after a decade's work on this theme of the proletariat rising against social injustice. In a change from the title given to the first version of this painting – *The Ambassadors of Hunger* (*Ambasciatori della fame*, about 1892) – *Living Torrent* describes the dynamic force of the ascendant working class. As Pellizza wrote in August 1895:

> I am attempting a Social painting... a crowd of people, workers of the soil, who are intelligent, strong, robust, united, advance like a torrent, overthrowing every obstacle in its path, thirsty for justice.

The evolution of this painting was informed by the development of Pellizza's socialist politics, which in turn coincided with Italy's agricultural crisis of the 1890s. His earliest sketches of striking agricultural workers (about 1890–1) date from the time of his acquaintance with the anarchist-sympathising Nomellini. And from 1894 he read socialist literature recommended by the magazine *Critica sociale*, to which he and Morbelli shared a subscription. In 1895 Pellizza became vice-president of the Peasants' and Workers' Mutual Aid Society in Volpedo, of which he had been a member since the start of the decade.

Pellizza used his hometown of Volpedo as the location for this painting, and its residents – including his wife Teresa – as the models for the figures, photographing their poses for his compositional study. However, the figures appear elongated and idealised, reflecting his belief, inspired by Max Nordau, that 'Art must give the people a portrait of themselves, but embellished.'

The scale of the canvas suggests Pellizza intended this to be his major painting on this theme. However, despite extensive reworking, he abandoned the canvas in December 1896, dissatisfied with the tonal balance of the painting and the static nature of the composition. **LP**

PROVENANCE
Collection of Pellizza heirs, Volpedo; Masera Collection, Vigevano; Bertolotto Collection, Turin; Plurinvest, Turin; Società Sprind, Milan

SELECTED EXHIBITIONS
1920–1 Rome, Palazzo delle Esposizioni, *I Biennale Romana. Esposizione Nazionale di Belle Arti nel cinquantenario della Capitale*; **1939** Turin, Salone della Stampa, *Mostra commemorativa di Giuseppe Pellizza da Volpedo*; **1980–1** Alessandria, Palazzo Cuttica, *Pellizza da Volpedo*; **1990** Trento, Palazzo delle Albere, *Divisionismo italiano*; **2000** London, Royal Academy of Arts, *1900: Art at the Crossroads*; **2001** Paris, Musée d'Orsay, *Italies 1880–1910*

SELECTED REFERENCES
Fiori (ed.) 1968, vol. I, pp. 185, 192, 198, and vol. II, V. 153; Berresford (*The Fourth Estate*); Scotti 1980, p. 89; Scotti Tosini 1986, pp. 361–2, cat. 943; Scotti Tosini 1986, pp. 409–12 (*The Fourth Estate*); Belli (ed.) 1990, cat. 35; Rosenblum et al. 2000, pp. 284–5 (incorrectly titled *The Fourth Estate*); Piantoni and Pingeot (eds) 2000, p. 237

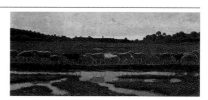

ZURICH ONLY

32 *The Mirror of Life: That which the First One does, the Others follow* (*Lo specchio della vita: e ciò che l'una fa, e l'altre fanno*), 1895–8

Oil on canvas, 132 × 291 cm
GAM – Galleria Civica d'Arte Moderna e Contemporanea, Turin (P 1017)

After spending the winter of 1893–4 in Florence, Pellizza began working on an idea for a painting inspired by a line from Dante's *Divine Comedy*: 'And that which the first one does, so the others shall do' (*Purgatory*, Canto III, line 82). Pellizza had been in close contact with the Florentine Symbolists, who were concerned with the exploration of ideal beauty and the relationship between art and literature. They were greatly influenced by the work of the Pre-Raphaelites, to which *The Mirror of Life*, with its Dantean subtitle, has been compared.

However, the geometric harmony of the composition reveals the influence of the Renaissance masters, particularly Raphael, whom Pellizza admired. The horizontal line of the raised bank is retraced by the sheep that walk across it; and the undulating line formed by the sheep's backs – which marks the halfway point of the height of the canvas – is in turn echoed by the tree line and the curves of the clouds.

Although Pellizza worked from life, inspired by the sight of a flock of sheep crossing the Curone valley, he reworked the composition to reveal an enduring symbolic meaning in these familiar aspects of nature. The rhythmic movement of the sheep reverberates in the contours of the landscape, linking all of nature to the continuous procession of the flock: a metaphor for the inescapable passing of human life. The compositional harmony is echoed by the tonal balance of light and shade. No single colour is dominant in Pellizza's

canvas; rather the application of pure pigment produces an overall radiant energy, giving the scene a spiritual aura.

This refined Divisionist technique recalls that of Morbelli, with whom Pellizza was in frequent contact at this time. The composition too is reminiscent of Morbelli's *For Eighty Cents!* (1893–5, cat. 37), with its line of figures stretching across the width of the canvas, reflected in water in the foreground, against a backdrop of expansive landscape.

The part of the canvas depicting the sheep in landscape is surrounded by a *trompe-l'œil* frame – a later addition to the central panel – painted in dark brown tones with a grain of yellow and red wavy lines, reiterating the undulating rhythms of the landscape in abstract form. Pellizza would later regret the wood-effect frame, writing in 1903 that he would have preferred a gold-coloured surround.

One of the most talked-about paintings at the 1898 Esposizione Nazionale in Turin, where it was first shown, priced at 6,000 Lire, the canvas was widely exhibited outside Italy until 1906, when it was purchased in Rome by King Victor Emmanuel III for 4,500 Lire. **LP**

PROVENANCE
Royal property, by purchase (1906); collection of Pietro Accorsi, Turin

SELECTED EXHIBITIONS
1898 Turin, Società Promotrice di Belle Arti, *Esposizione Nazionale di Belle Arti*; **1900** Paris, *Exposition Internationale Universelle – Section des Beaux Arts*; **1901** Munich, Glaspalast, *VII Internationale Kunstausstellung*; **1902** Berlin, *Grosse Berliner Kunstaustellung*; **1904** London, Earl's Court, *Italian Exhibition*; **1905** Angers, *Exposition Union Internationale des Beaux-Arts*; **1906** Rome, Società Amatori e Cultori di Belle Arti, *LXXVI Esposizione di Belle Arti*; **1939** Turin, Salone della Stampa, *Mostra commemorativa di Giuseppe Pellizza da Volpedo*; **1954** Alessandria, Pinacoteca Civica, *Mostra antologica del pittore Pellizza da Volpedo*; **1979–80** London (Royal Academy of Arts), Washington (National Gallery of Art), *Post-Impressionism: Cross Currents in European Painting*; **1980–1** Alessandria, Palazzo Cuttica, *Pellizza da Volpedo*; **1990** Trento, Palazzo delle Albere, *Divisionismo italiano*; **2000** Turin, Galleria d'Arte Moderna, *Giuseppe Pellizza da Volpedo*; **2000** London, Royal Academy of Arts, *1900: Art at the Crossroads*; **2001** Paris, Musée d'Orsay, *Italies 1880–1910*

SELECTED REFERENCES
Fiori (ed.) 1968, vol. I, pp. 135, 204–5, 207–9, 212, 214, 223, 225, 227, 230, 235, 238; Fiori (ed.) 1968, vol. II, cat. V.141; Berresford 1979, pp. 244–5; Scotti 1980, p. 80; Scotti 1986, pp. 384–6, cat. 1002; Belli (ed.) 1990, cat. 36; Rosenblum et al. 2000, p. 78; Piantoni and Pingeot (eds) 2000, p. 215; Scotti Tosini 1995, p. 280; Greene 2008

9 *The Dead Child* (*Il morticino* or *Fiore reciso*), 1896–1902
Oil on canvas, 79 × 105.5 cm
Musée d'Orsay, Paris (RF1977-281)

PROVENANCE
Musée du Luxembourg, Paris (1909)

SELECTED EXHIBITIONS
1906 Milan, Castello Sforzesco, *Mostra Nazionale di Belle Arti*; **1909** Venice, *VIII Esposizione Internazionale d'Arte della Città di Venezia* [Biennale]; **1939** Turin, Salone della Stampa, *Mostra commemorativa di Giuseppe Pellizza da Volpedo*; **1954** Alessandria, Pinacoteca Civica, *Mostra antologica del pittore Pellizza da Volpedo*; **1970** Milan, Palazzo della Permanente, *Mostra del Divisionismo Italiano* (not in catalogue); **1977** Paris, Palais de Tokyo, *Préfiguration du Musée d'Orsay*; **1990** Trento, Palazzo delle Albere, *Divisionismo italiano*; **2000** Turin, Galleria d'Arte Moderna, *Giuseppe Pellizza da Volpedo*; **2001** Paris, Musée d'Orsay, *Italies 1880–1910*

SELECTED REFERENCES
Fiori (ed.) 1968, vol. I, pp. 216, 229, 238–9; Fiori (ed.) 1968, vol. II, cat. V.193; Scotti 1986, pp. 423–4, cat. 1123; Belli (ed.) 1990, cat. 37; Piantoni and Pingeot (eds) 2000, p. 216

24 *Washing in the Sun (Panni al sole)*, 1905

Oil on canvas, 87 × 131 cm
Private collection, courtesy James Roundell

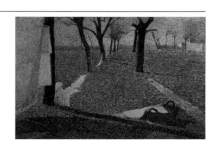

ZURICH ONLY

PROVENANCE

Private collection of heirs of the artist, Volpedo; Somaré Collection, Milan (1941); Cartotti Collection, Lessona Biellese; Galleria Sacerdoti, Milan (1964)

SELECTED EXHIBITIONS

1941 Milan, Galleria L'Esame, *Opere scelte dell'Ottocento;* **1947** Bergamo, Galleria La Rotonda, *Mostra postuma di Giuseppe Pellizza da Volpedo;* **1948** New York, Galleria Wittgenstein, *Loan Exhibition of Italian Nineteenth Century Painting;* **1952** Venice, *XXVI Biennale Internazionale d'Arte* (*Mostra del Divisionismo*); **1954** Alessandria, Pinacoteca Civica, *Giuseppe Pellizza da Volpedo mostra antologica;* **1968** New York, Guggenheim Museum, *Neo-Impressionism;* **1970** Milan, Palazzo della Permanente, *Mostra del Divisionismo italiano;* **1979–80** London (Royal Academy of Arts), Washington (National Gallery of Art), *Post-Impressionism: Cross Currents in European Painting*

SELECTED REFERENCES

Fiori (ed.) 1968, vol. II, p. 102, cat. V.248; House and Stevens (eds) 1979, p. 247, cat. 377; Scotti 1986, pp. 344–5, cat. 899

Previiati grew up in a moderately prosperous and highly religious family. He studied at the local technical institute, but left after a year to attend the School of Fine Arts at the Ateneo Civico, studying the works of the Renaissance masters in the local art gallery. After his military service in Livorno (1873–6), Previati moved to Florence to study, with the financial support of the local authorities and his brother Giuseppe. Attracted by the work of the Lombard artists, especially Giuseppe Bertini (1825–1898; see fig. 1), in 1877 he transferred to Milan, enrolling at the Accademia di Brera where he won several prizes and got to know various painters working in the *Scapigliatura* tradition.

Previiati's career as an artist was interrupted by a lengthy period of illness but he started to paint again in 1883 and moved permanently to Milan where he shared a studio with the *Scapigliato* painter and illustrator Luigi Conconi (1852–1917). His early works were romantic in style although, while searching for a way to represent light, he soon discovered his own form of expression. At the same time, he distanced himself from historic and patriotic subjects, focusing instead on spiritual motifs. This approach was fuelled by his enthusiasm for the art of the Pre-Raphaelites, particularly that of Dante Gabriel Rossetti (1828–1882), and he also illustrated books, including Edgar Allan Poe's *Tales.*

In 1889 Previati met Vittore Grubicy, who encouraged him to adopt a Divisionist technique in order to produce more luminous effects in his paintings. Typical of his work were vibrant, light-flooded Symbolist paintings featuring religious and allegorical subjects, such as his famous canvas, *Motherhood* (1891, cat. 25), which caused a furore at the 1891 Brera Triennale. However, in the early 1890s he was selling only a small proportion of his works and was still dependent on the financial support of his brother. Previati's friendship with Segantini, whom he had first met at the Accademia di Brera, intensified during 1892 and Segantini persuaded Previati to develop his Divisionist technique further. For the Brera Triennale exhibition of 1894, he planned a panorama depicting Dante's *Inferno*, to be created jointly with other artists, but the project was abandoned. Previati was the most important theorist of the Divisionists, and in 1895 he began writing treatises such as *La tecnica della pittura* (published in 1905) and *I principii scientifici del divisionismo* (published in 1906).

His precarious financial situation only improved when, in 1899, Alberto Grubicy gave him a ten-year contract with the Grubicy Gallery, which allowed Previati to dedicate himself solely to his art. Thanks to this financial stability, from 1901 onwards Previati was able to spend every summer on the Italian Riviera. In 1911 the Grubicy Gallery honoured his success by founding the Società per l'Arte di Gaetano Previati. However, the First World War brought with it renewed financial difficulties and Previati's health worsened. Depressed by the deaths of his wife and one of his children, he stopped painting in 1917 and lived out the rest of his life in isolation in the Riviera resort of Lavagna. **LS**

SELECTED REFERENCES

Bucarelli et al. (eds) 1969; Mazzocca (ed.) 1999

GAETANO PREVIATI
1852 FERRARA–1920 LAVAGNA

25 *Motherhood (Maternità)*, 1891

Oil on canvas, 174 × 411 cm
Collection of Banca Popolare di Novara (38)

Motherhood was Previati's first mature Divisionist painting and his first exploration of Symbolist themes and forms. Shown for the first time at the 1891 Brera Triennale, where Divisionism also made its public debut, Previati's work represented the alternative Symbolist tendency in Divisionist painting, in comparison with other Divisionist and proto-Divisionist works exhibited at the Triennale – Nomellini's *Piazza Caricamento, Genoa* (1891, cat. 51) and Longoni's *The Orator of the Strike* (1890–1, cat. 49) – which explored the new technique through social themes.

Despite the politicised messages of these exhibits, Previati's *Motherhood* attracted more negative press comment than any other work at the Triennale. Criticism focused on the formal qualities of the painting, professing bafflement at the flowing curves of the figures and the sweeping, linear brushwork used to create light, fluid forms that dissolve into their surroundings: precisely the qualities the Futurists would most admire in Previati's work. The most scathing reviews came from Luigi Chirtani, pseudonym of Luigi Archinti, professor of art history at the Reale Accademia di Belle Arti di Brera, who wrote: 'One struggles to understand what the artist wanted to represent . . . The painting resembles woollen embroidery.'

The attacks on *Motherhood* sparked a polemical debate between those who *did* understand what Previati wanted to represent – the idea or essence of maternal love – and those, like Chirtani, who favoured naturalistic representation. Alfredo Melani pinpointed the key objective of Previati's anti-naturalistic approach: 'the author has painted that which he has felt: he has seen to *feel*, he has not seen to *see*.' Grubicy entered the debate with an article dedicated to *Motherhood*, defending the artist's right to express an 'abstract, mystical, indefinite' idea in a way that maintains 'its vague, fluctuating character of an indeterminate vision or dream'.

The most conventionally religious of the Divisionist painters, Previati sought to develop a contemporary Christian art. In this he was influenced by foreign Symbolist artists, including the Pre-Raphaelites, as well as by Italian Quattrocento painters such as Botticelli. The Madonna and Child – the subject of this painting – was a recurrent theme in his oeuvre. This Symbolist reworking of a Christian subject at the very core of Italian visual culture may have aggravated some of the negative responses to *Motherhood* at the Triennale.

Previati sought to suggest the religious mysticism of his subject through the evocation of light, which radiates non-naturalistically from the figure of the Madonna in a diffused aureole, echoing the curve of her head and shoulders. He considered 'the illusion of light produced by the painting' to be 'the new element essential to the art of painting, after the very important choice of subject matter'. This was the primary function of the Divisionist technique in Previati's work. Despite publishing theoretical texts on Divisionism – chiefly, *I principii scientifici del divisionismo (la tecnica della pittura)*, 1906 – he rarely applied pigment to the canvas in pure colours and complementary contrasts. The luminosity of this painting is produced by the addition of whites and pale golden yellows, demonstrating Previati's exploration of colour by gradations within its own hue or by using similar – as opposed to contrasting – tones.

Motherhood gained almost immediate recognition within international Symbolist circles through its inclusion in the first *Salon de la Rose + Croix* in Paris the year after its completion. Previati's work would gain wider recognition in Italy as public and critical appreciation of Symbolism's objectives grew. *Motherhood* is now considered the most complete example of Previati's Symbolist-Divisionist aesthetic, as well as one of the cardinal works of the Symbolist movement in Italy. **LP**

PROVENANCE
Galleria Grubicy, Milan; Birachel Minerbi, Venice

SELECTED EXHIBITIONS
1891 Milan, Reale Accademia di Belle Arti di Brera, *I Esposizione Triennale di Belle Arti*; **1892** Paris, Galerie Durand Ruel, *Salon de la Rose + Croix*; **1901** Venice, *IV Esposizione Internazionale d'Arte della Città di Venezia* [Biennale]; **1902** Turin, *Arte Decorativa e Moderna;* **1906** Milan, Galleria Grubicy, *Mostra collettiva Segantini – Previati;* **1912** London, Great White City, *Latin–British Exhibition;* **1952** Ferrara, Società Promotrice di Belle Arti, *Mostra del Centenario di Gaetano Previati;* **1969** Ferrara, Palazzo dei Diamanti, *Gaetano Previati;* **1970** Milan, Palazzo della Permanente, *Mostra del Divisionismo Italiano;* **1988** Castano Primo, Villa Rusconi, *Mostra celebrativa di Gaetano Previati;* **1990** Trento, Palazzo delle Albere, *Divisionismo italiano;* **2001** Paris, Musée d'Orsay, *Italies 1880–1910*

SELECTED REFERENCES
Fiori (ed.) 1968, vol. II, p. 48, cat. III.79; Belli (ed.) 1990, cat. 74; Piantoni and Pingeot (eds) 2000, p. 207; Greene 2007, pp. 19–21; Scotti Tosini 2007, p. 54; Greene 2008

33 *The Chariot of the Sun* (*Il carro del sole*), 1907

Central panel of *The Day* (*Il giorno*), triptych
Oil on canvas, 127 × 185 cm
Camera di Commercio, Industria, Artigianato e Agricoltura, Milan (1680)

PROVENANCE
Galleria Grubicy, Milan

SELECTED EXHIBITIONS
1907 Paris, *Salon des Peintres Divisionnistes Italiens;* **1907** Venice, *VII Esposizione Internazionale d'Arte della Città di Venezia* [Biennale]; **1910** Milan, Palazzo della Permanente, *Esposizione di duecento opere di Gaetano Previati;* **1921** Rome, Palazzo delle Esposizioni, *I Biennale romana. Esposizione nazionale di Belle Arti nel Cinquantenario della capitale;* **1970** Milan, Palazzo della Permanente, *Mostra del Divisionismo Italiano;* **1990** Trento, Palazzo delle Albere, *Divisionismo italiano;* **1995** Milan, Fondazione Mazzotta, *Boccioni. 1912 Materia;* **1999** Milan, Palazzo Reale, *Gaetano Previati, 1852–1920: un protagonista del simbolismo europeo;* **2001** Paris, Musée d'Orsay, *Italies 1880–1910*

SELECTED REFERENCES
Fiori (ed.) 1968, vol. II, p. 70, cat. III.540-542 (*Trittico del Giorno*); Belli (ed.) 1990, cat. 77 (*Trittico del Giorno*); Mazzocca (ed.) 1999, cat. 61a, p. 214; Piantoni and Pingeot (eds) 2000, p. 210; Caroli and Masoero (eds) 2001, cat. 55

34 *The Dream* (*Il sogno*), 1912

Oil on canvas, 226 × 166 cm
Private collection

PROVENANCE
Unknown

SELECTED EXHIBITIONS
1912 Venice, *X Esposizione Internazionale d'Arte della Città di Venezia* [Biennale]; **1913** New York, Catholic Club, *Gaetano Previati;* **1916** Milan, Società per le Belle Arti e Associazione Lombarda dei Giornalisti, *Esposizioni collettive di Gaetano Previati e Carlo Fornara a beneficio dei soldati ciechi e mutilati in guerra;* **1919** Milan, Società per le Belle Arti ed Esposizione Permanente, *Mostra di Gaetano Previati pro tubercolosario Cuasso al Monte;* **1921** Rome, Palazzo delle Esposizioni, *I Biennale romana. Esposizione nazionale di Belle Arti nel Cinquantenario della capitale;* **1999** Milan, Palazzo Reale, *Gaetano Previati, 1852–1920: un protagonista del simbolismo europeo*

SELECTED REFERENCES
Fiori (ed.) 1968, vol. II, cat. III.595; Mazzocca (ed.) 1999, cat. 16

Born in Portogruaro, a town north-east of Venice, Russolo was taught music by his father, a clockmaker and organist, and music remained important to him all his life. His family moved to Milan so that his two older brothers could study music at the conservatory, while Luigi was left in the care of his aunt in Portogruaro. He joined his family in Milan in 1901 and attended courses at the Accademia di Brera; his first paintings and drawings were inspired by Symbolism and Divisionism.

While working as a trainee for the conservator Crivelli on the restoration of decorations at the Castello Sforzesco as well as Leonardo da Vinci's *Last Supper* in the church of Santa Maria delle Grazie, Russolo met Previati and became acquainted with members of the group of Symbolist poets who were collaborating on the international review *Poesia*. Around 1907/8 he created a series of Symbolist etchings that used curved forms to represent musical rhythms. The works were shown in 1909 at the annual exhibition of the *Bianco-Nero* at the Famiglia Artistica, an exhibiting group in Milan, where he met Boccioni. A deep friendship developed, which opened new artistic horizons for Russolo. Clearly inspired by Boccioni, he distanced himself from typical nineteenth-century academic themes and turned to portraits and urban landscapes. Having also forged friendships, in 1910, with Marinetti and Carrà, he became part of the Futurist movement, signing the Manifesto of Futurist Painters and participating in their performance projects. He was increasingly interested in the portrayal of movement, speed and light, while his paintings were shaped by Divisionist technique.

LUIGI RUSSOLO
1885 PORTOGRUARO–
1947 CERRO DI LAVENO

In 1913 Russolo abandoned painting and focused solely on experiments with music. While writing about and studying the meaning of noise in music, he constructed, together with the painter Ugo Piatti (1880–1953), instruments that could most vividly express the noise of the city and went on to conduct concerts of their so-called '*intonarumori*' ('noise intoners' or 'noise machines').

During the First World War he volunteered for the army and received a serious head injury that prevented him from being creatively active for long periods, although after the war he did organise concerts once again. Between 1927 and 1932, in reaction against the Fascist regime, Russolo spent much time in Paris, giving concerts, publishing his writings and exploring Eastern philosophies and occultism. After a period in Spain, he returned to Italy in 1933. In the last years of his life he began to paint again, in a style which he described as 'classic-modern'. He died in 1947 at Cerro di Laveno on the shores of Lake Maggiore. **LS**

SELECTED REFERENCES
Zanovello Russolo 1958

59 *Lightning (I lampi)*, 1909–10

Oil on canvas, 100 × 100 cm
Galleria Nazionale d'Arte Moderna, Rome (5025)

Completed in the year he signed the Manifesto of Futurist Painters and the Technical Manifesto of Futurist Painting, Russolo's canvas depicts the urban context favoured by his fellow signatories. In particular, Russolo's industrial scene recalls the locations explored by Boccioni – whom he befriended in 1909 – in paintings such as *Workshops at Porta Romana* (1909, cat. 55). Boccioni's influence is evident in the diagonal slant of the road cutting through Russolo's urban landscape, anticipating the dynamic lines of force that would characterise the Futurist idiom. But where Boccioni surveys the urban periphery from above as a working landscape of smoking factory chimneys and workers on the move, Russolo shifts the dynamic focus to the night sky, prioritising the drama of this atmospheric phenomenon over the deserted man-made environment.

This fusion of modern industrial location with mysterious spectral light effects reveals the dual Symbolist and Futurist tendencies in Russolo's work at this time. The influence of Previati – whose work was also an important source of inspiration for Boccioni – is evident in the painting's allegorical qualities. Russolo's exploration of Divisionist principles is most evident in the stormy sky, where blues and violets are applied as separate strokes of colour, interspersed with dabs of green, the light complementary of violet.

This was Russolo's second rendition of the composition, following an earlier version of around 1909–10, also titled *Lightning (I lampi)*, measuring exactly half the size of this canvas. Both versions were exhibited in Milan in 1910, where the larger canvas attracted critical acclaim. **LP**

PROVENANCE
Francesco Pennazzo, Milan; Galleria Nazionale d'Arte Moderna, Rome (purchased 1958)

SELECTED EXHIBITIONS
1910 Milan, Famiglia Artistica, *Esposizione Annuale d'Arte;* **1912** Paris, Galerie Bernheim-Jeune, *Les peintres futuristes italiens;* London, The Sackville Gallery, *Exhibition of Works by the Italian Futurist Painters;* **1912** Berlin, Galerie Der Sturm, *Zweite Ausstellung Die Futuristen;* **1958** Milan, Galleria Barbaroux, *Luigi Russolo;* **1968** Venice, *XXXIV Biennale Internazionale d'Arte* (*Quattro maestri del primo Futurismo italiano*); **1970** Milan, Palazzo della Permanente, *Mostra del Divisionismo Italiano;* **1973–4** Milan, Palazzo Reale, *Boccioni e il suo tempo;* **1990** Trento, Palazzo delle Albere, *Divisionismo italiano;* **1991–2** Turin (Mole Antonelliana), Milan (Palazzo Reale), Piacenza (Palazzo Gotico), *Il colore del lavoro;* **2001** Milan, Palazzo Reale, *Dalla Scapigliatura al Futurismo*

SELECTED REFERENCES
Fiori (ed.) 1968, vol. II, p. 221, cat. XXIX.8; Martin 1968, pp. 82, 84, 109, 150; Drudi Gambillo and Fiori (eds) 1986, vol. II, p. 305, cat. 3; Belli (ed.) 1990, cat. 151; Gian Ferrari and Poli (eds) 1991, cat. 32

Segantini was born in 1858 in Arco, at the north end of Lake Garda. His childhood was evidently a lonely and unhappy one: orphaned by the age of eight, he was sent to Milan to live with his half-sister, Irene, and was found abandoned several times. In 1873/4 he worked in his half-brother's photography and chemist's shop in Borgo Valsugana (east of Trento), and then in Luigi Tettamanzi's decoration studio in Milan where, from 1875 to 1879, he attended classes at the Brera Academy. Here he became friends with fellow students Longoni and Carlo Bugatti (1855–1940), a furniture designer who later became his brother-in-law. During his training Segantini won several awards for his work, which was still based on the Lombard *Scapigliatura* tradition.

Segantini came to the notice of art dealer Vittore Grubicy and art critics in 1879 when he showed his painting *The Choir of Saint Anthony* (1879; private collection) at the annual exhibition of the Brera Academy. In 1880 he married Luigia (known as Bice) Bugatti and the couple moved near to Lake Pusiano, north of Milan, financially supported by Grubicy. From 1882 to 1884 the Segantinis lived and worked in the same house as Longoni; the following years were spent in the villages of Carella and Corneno where he and Bice raised their four children. In 1883 Grubicy entered into a three-year contract with the painter and encouraged his development, introducing him to the works of the Barbizon and The Hague Schools. In late 1885 Segantini started to paint large landscapes and a year later, through Grubicy's initiation, experimented with Divisionist technique.

As his work began to sell and was included in several exhibitions in Italy and abroad, Segantini's financial position was improving. In 1886, after his move to Savognin in Switzerland, Segantini signed a contract with Alberto Grubicy, Vittore's brother. This caused a rift with Vittore, with whom he increasingly disagreed about painting. In 1894 he moved to Maloja in the Engadine, where he focused on depicting peasant life and nature viewed in the clear light of the Alps – rendered in Symbolist mode, often with a pantheist outlook. In the increasingly popular tourist region of the Engadine he encountered people from all over the world. They included the doctor Oskar Bernhard, who later co-founded the Segantini museum, and the painter Giovanni Giacometti (1868–1933), through whom Segantini was introduced to the works of Ferdinand Hodler (1853–1918) and Cuno Amiet (1868–1961).

From 1896 Segantini and his family moved each winter to the village of Soglio. During the 1890s Segantini participated in exhibitions in Italy and elsewhere, acquiring an international reputation, and he was commissioned to make a huge panorama for the Swiss pavilion as part of Paris's *Exposition Universelle* in 1900. Although the project was co-financed by a consortium of Engadine hotels, i3t had to be scaled down for financial reasons and so Segantini planned a smaller triptych, *Life, Nature and Death* (*La vita, La natura, La morte*, 1896–9). While working on *Nature*, the central panel of the series featuring the Schafberg mountain, the artist unexpectedly died from peritonitis, at the age of forty-one. **LS**

SELECTED REFERENCES
Servaes (ed.) 1902; Baumann and Magnaguagno (eds) 1990; Belli and Quinsac (eds) 1999; Stutzer and Wäspe 1999

27 *The Bad Mothers* (*Le cattive madri*) 1896/7
Oil on card, 40 × 74 cm
Kunsthaus Zürich (1967/66)

This is the companion piece to *The Punishment of Lust* (1896/7, cat. 28), executed using the same technique, materials and dimensions. Both sgraffito works, which share provenance and exhibition history, are variations on themes already explored in large format paintings of the same title earlier in the decade.

Inspired by Luigi Illica's poem 'Nirvana' – ostensibly a translation of a Buddhist text – both compositions represent different stages in this narrative of women subjected to torturous punishment for rejecting motherhood, before being rehabilitated through reunion with their abandoned children, achieving redemption and being freed to attain nirvana:

Thus the evil mother hovers in the icy valley / amongst eternal glaciers / where no branch has leaves and no flower has blooms. / No smile, no kiss for your son / oh futile mother? / And so the torments of silence / drive and buffet you, / a frozen mask with tears of ice in its eyes. / Look at her there! / Anxiously, she wafts aimlessly / like a leaf! . . . / And her pain is simply silence; / all things are silent. / Now in the icy valley trees appear! / From every branch there cries a soul / that suffers and loves; / and the silence is broken and the so-human voice says: / 'Come! Come to me, oh Mother! Give me / your breast, life itself. / Come, oh Mother! . . . Forgiveness be yours! . . .' [. . .] The branch has life! / Behold, it is the face of a child that sucks greedily at her breast / that sucks and kisses her!

Segantini set both compositions in the frozen mountain landscape of the Upper Engadine – his home since 1894 – recalling the icy desert of Illica's poem. The all-over bluish tones of these paintings evoke an eerie light, sometimes thought to represent twilight and as often, disconnected from any particular time of day. Combined with the sgraffito technique, consisting mainly of horizontal lines etched into the paint surface, these light effects enhance the

otherworldly qualities of Segantini's vision of purgatory for failed mothers.

The Punishment of Lust, with its floating female figures, relates to the first part of this extract, describing the silent punishment of the failed mothers. *The Bad Mothers* pictures the moment of redemption when the mother is reunited with her child. Segantini imagines the reunion as a more traumatic experience than the earlier stage of punishment. The resistant mother is painfully ensnared in the branches of the tree, as the head of her abandoned child, sprouting from a twisted branch, shaped like an umbilical cord, finds its way to her exposed breast.

The poses of the figures in both paintings suggest a conflict between maternity and female sexuality. As Segantini's title suggests, the women in the first painting are being punished for their submission to lust, suspended in the horizontal state of their sexual abandon. The second painting codes this sexual desire as un-maternal. At the moment of redemption, the foremost Bad Mother is contorted in a state of ecstasy, suggestive of religious transformation or exorcism, evoking the idea of her deviant sexuality being expelled from her body by the child sucking at her breast. Behind her, two floating figures, apparently released from the torture of the tree, can be understood to represent different stages in the process of the Bad Mother's redemption as she is freed to attain the nirvana of Illica's poem.

Although the Buddhist idea of overcoming worldly desires to attain the ultimate peace of nirvana is present in Segantini's compositions, the notion of achieving atonement through penance is closer to the Christian conception of redemption. The Christian basis of Segantini's vision is reinforced by his representation of the Bad Mother's opposite as a secular Madonna in *The Angel of Life* (1894, cat. 26). Here, the mother and child are enthroned by the branches of a tree, like those that had ensnared the Bad Mother, restoring the harmonious relationship between woman and nature that Segantini used repeatedly to convey positive images of motherhood, most notably in *The Two Mothers* (*Le due madri*, 1891), which juxtaposes a cow and her calf with a human mother and child.

Although the dichotomy of holy mother and fallen woman was a typical of *fin-de-siècle* Symbolism, this theme of negligent mothers may have had a more personal significance for Segantini informed by his own traumatic childhood. After the death of his mother from ill health induced by his birth, Segantini's father, who died the year after his wife, entrusted the seven-year-old Giovanni to his half-sister Irene, who left her young brother locked in the attic while she was at work. Left to his own devices, the twelve-year-old Segantini was detained for vagrancy in the Marchiondi reform school in Milan. His guilt-ridden memory of his mother – who had been unable to care for him, but made the ultimate sacrifice for him – seems to underlie his representations of women. In a letter to the poet Neera, Segantini wrote: 'I always loved and honoured any woman, in whatever situation she might be, as long as she had the appearance of a mother.' This sentiment is implicit in his frequent portrayal of women as devoted mothers; or as victims of physical torment on account of their lack of maternal qualities. **LP**

PROVENANCE
Zuppinger Collection, Zurich (1926); Galerie Fischer, Lucerne (1956–67); acquired by Kunsthaus Zürich (1967)

SELECTED EXHIBITIONS
1899 Milan, Palazzo della Permanente, Comitato per le onoranze a Giovanni Segantini, *Esposizione di alcune opere di Segantini;* **1900** Paris, *Exposition Universelle. Exposition décennale des Beaux Arts, 1889–1899* (Segantini retrospective); **1903** Munich, Kunstsalon Heinemann, *Segantini Ausstellung;* **1904** London, Earl's Court, *Italian Exhibition;* **1926** Venice, *XV Biennale Internazionale d'Arte* (*Esposizione individuale di Giovanni Segantini*); **1949** St Moritz, Kunstverein St Moritz, *Esposizione commemorativa di Giovanni Segantini;* **1956** St Gallen, Kunstmuseum, *Ausstellung Giovanni Segantini;* **1970** Milan, Palazzo della Permanente, *Mostra del Divisionismo Italiano;* **1978** Kobe, Tokyo, Hiroshima, Takasaki, Kita-Kyushu, *Giovanni Segantini Japan 1978;* **1985** Trento, Palazzo delle Albere, *Segantini;* **1990–1** Zurich, Kunsthaus, *Giovanni Segantini. 1858–1899;* **1999** St Moritz (Segantini Museum), St Gallen (Kunstmuseum), *Giovanni Segantini*

SELECTED REFERENCES
Fiori (ed.) 1968, vol. II, p. 40, cat. II.354; Gozzoli 1973, p. 121, cat. 383; Quinsac 1982, vol. II, p. 485, cat. 576; Baumann and Magnaguagno (eds) 1990, p. 180, cat. 98; Greene 2008
Bad Mothers cycle: Frehner 1999, pp. 11, 30–2; Klemm 1999, pp. 140–1; Quinsac 2000, p. 34

28 *The Punishment of Lust* (*Il castigo delle lussuriose*), 1896/7

Oil on card, 40 × 74 cm

Kunsthaus Zürich, purchased with the support of A. Hansmann and Dr Meyer-Mahler (1967/67)

PROVENANCE

Zuppinger Collection, Zurich (1926); Galerie Fischer, Lucerne (1956–67); acquired by Kunsthaus Zürich (1967)

SELECTED EXHIBITIONS

1899 Milan, Palazzo della Permanente, Comitato per le onoranze a Giovanni Segantini, *Esposizione di alcune opere di Segantini;* **1900** Paris, *Exposition Universelle. Exposition décennale des Beaux Arts, 1889–1899* (Segantini retrospective); **1903** Munich, Kunstsalon Heinemann, *Segantini Ausstellung;* **1904** London, Earl's Court, *Italian Exhibition;* **1926** Venice, *XV Biennale Internazionale d'Arte* (*Esposizione individuale di Giovanni Segantini*); **1956** St Gallen, Kunstmuseum, *Ausstellung Giovanni Segantini;* **1970** Milan, Palazzo della Permanente, *Mostra del Divisionismo Italiano;* **1978** Kobe, Tokyo, Hiroshima, Takasaki, Kita-Kyushu, *Giovanni Segantini Japan 1978;* **1990–1** Zurich (Kunsthaus), Vienna (Österreichische Galerie), *Giovanni Segantini. 1858–1899;* **1999** St Moritz (Segantini Museum), St Gallen (Kunstmuseum), *Giovanni Segantini;* **2001** Paris, Musée d'Orsay, *Italies 1880–1910*

SELECTED REFERENCES

Fiori (ed.) 1968, vol. II, p. 40, cat. II.353; Gozzoli 1973, p. 121, cat. 382; Quinsac 1982, vol. II, cat. 573; Baumann and Magnaguagno (eds) 1990, p. 181, cat. 99; Piantoni and Pingeot (eds) 2000, p. 204

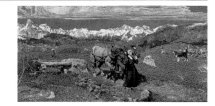

4 *Spring in the Alps* (*Primavera sulle Alpi*), 1897

Oil on canvas, 116 × 227 cm

French & Company, New York

Segantini accepted the commission for this painting with the understanding that it would be exhibited at the Munich Secession before being shipped to the United States. In a letter he wrote to his friend Domenico Tumiati (dated 29 May 1897) during the course of the Secession exhibition, Segantini described the unfinished state of the painting and his intention to rework the canvas, which he would do on its return from Munich.

In the same letter, Segantini described *Spring in the Alps* as an example of 'naturalist symbolism'. Writing in *L'Arte* in 1898, Tumiati further defined this Symbolism as being 'drawn from the elements which the landscape itself offers, without the intrusion of abstract figures', such as those featured in the Alpine landscape of *The Bad Mothers* (1896/7, cat. 27), for example. Here, the symbolism is not expressed through literary or allegorical figures, but in the representation of an unspoiled landscape, alive with the vibrant intensity of colour and linear mark-making, intended to function as a pantheistic vision of the springtime reawakening of nature. The figures seen sowing the newly-ploughed field and leading the harnessed horses through the landscape, function as markers of springtime in the cycle of nature. Their labour is not the thematic focus of this painting as it had been in Segantini's *Ploughing* (*Aratura*, 1887–90), which Rosenthal may have had in mind when commissioning *Spring in the Alps*.

The ultra-violet intensity of the midday sky is evoked by the juxtaposition of blue and red brushstrokes. Segantini further enhanced the scintillating effects of the alpine sunlight by applying dabs of gold dust to the canvas using a tempera technique, interspersed with the streaks of oil paint. No longer clearly visible due to chemical decomposition, these touches of gold would have lent the surface of the painting a mosaic-like quality.

Like the earlier *Ploughing*, with which *Spring in the Alps* shares exact dimensions, this composition is a composite of multiple viewpoints of the mountain landscape. Based on the landscape surrounding the Pian Lutero plateau, behind the village of Soglio, where the artist spent his winters, Segantini suggested the vastness of this breathtaking panorama by manipulating the landscape using a series of formal devices.

The village of Soglio is repositioned to the far right of the composition, inverting its actual location in the landscape; an elevated viewpoint is adopted, creating a simplified foreshortening of the mountains, which appear as distinct peaks; and, crucially, the horizon line is raised and emphasised by a continuous line of cloud running the width of the canvas, enabling Segantini to fill the canvas with this unbroken view of expansive Alpine landscape. **LP**

PROVENANCE

Commissioned by the painter Rosenthal for the Stern Gallery, San Francisco; Jacob Stern Collection, San Francisco; on loan to the Fine Arts Museum, California Palace of the Legion of Honour (July 1926 – September 1999); transferred by inheritance to Haas (until 1999); sold at Christie's, New York, and acquired by the current owner (9 November 1999)

SELECTED EXHIBITIONS
1897–8 Munich, Glaspalast, Secession, *Internazionale Kunstausstellung;* **1914** St Petersburg, *Segantini Exhibition;* **1979–80** London (Royal Academy of Arts), Washington (National Gallery of Art), *Post-Impressionism: Cross Currents in European Painting;* **2000–1** Varese (Villa Menafoglio Litta Panza), Venice (Peggy Guggenheim Collection), *Giovanni Segantini: Luce e simbolo/Light and Symbol, 1884–1899*

SELECTED REFERENCES
Fiori (ed.) 1968, vol. II, p. 39, cat. II.341; Gozzoli 1973, p. 120, cat. 376; Berresford 1979, pp. 250–1, cat. 384 (*La raffigurazione della primavera*); Quinsac 1982, vol. II, p. 350, cat. 434; Quinsac 2000, pp. 20, 23; Quinsac (ed.) 2000, p. 72, cat. XI

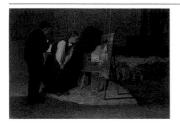

ZURICH ONLY

5 *My Models* (*I miei modelli*), 1888
Oil on canvas, 65.5 × 92.5 cm
Kunsthaus Zürich, Society of Zurich Friends of Art (1975/16)

PROVENANCE
Dowdeswell Collection, London (until 1902); O. Bernhard, St. Moritz (1949); acquired by Kunsthaus Zürich from the Galerie Dr Peter Nathan, Zurich (1975)

SELECTED EXHIBITIONS
1926 Venice, *XV Esposizione Internazionale della città di Venezia* [Biennale] (solo exhibition); **1935** Basel, Kunsthaus, *Giovanni Segantini Ausstellung;* **1956** St Gallen, Kunstmuseum, *Ausstellung Giovanni Segantini;* **1987** Trento, Palazzo delle Albere, *Giovanni Segantini. Mostra antologica;* **1988** Amsterdam, Rijksmuseum Vincent Van Gogh, *Ottocento/Novecento. Italiaanse Kunst 1870–1910;* **1990** Trento, Palazzo delle Albere, *Divisionismo italiano;* **1990–1** Zurich (Kunsthaus), Vienna (Österreichische Galerie), *Giovanni Segantini. 1858–1899;* **1999** St Moritz (Segantini Museum), St Gallen (Kunstmuseum), *Giovanni Segantini*

SELECTED REFERENCES
Fiori (ed.) 1968, vol. II, p. 32, cat. II.225; Gozzoli 1973, p. 110, cat. 282; Quinsac 1982, vol. II, p. 370, cat. 462; Belli (ed.) 1990, p. 64, cat. 6; Baumann and Magnaguagno (eds) 1990, pp. 148–9, cat. 74

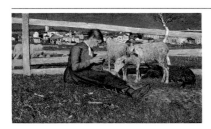

ZURICH ONLY

6 *Girl Knitting* (*Ragazza che fa la calza*), 1888
Oil on canvas, 53 × 91.5 cm
Kunsthaus Zürich, on loan from Gottfried Keller Foundation (884)

PROVENANCE
Collection of A. Arozzi, Milan (1890–8); Galerie Alberto Grubicy, Milan; Schneider, Frankfurt am Main (1901); acquired by Kunsthaus Zurich from the art dealer M. Goldschmidt, Frankfurt (1909)

SELECTED EXHIBITIONS
1894 Milan, Reale Accademia di Belle Arti di Brera, *II Esposizione Triennale di Belle Arti;* **1896** Munich, *Ausstellung der Münchner Sezession;* **1897** Milan, *Esposizione della Famiglia Artistica;* **1899** Milan, Comitato per le onoranze a G. Segantini, *Esposizione di alcune opere di Segantini;* **1926** Venice, *XV Esposizione Internazionale della città di Venezia* [Biennale] (solo exhibition); **1935** Basel, Kunsthaus, *Giovanni Segantini Ausstellung;* **1953** Zurich, Kunsthaus, *Falsch oder echt;* **1956** St Gallen, Kunstmuseum, *Ausstellung Giovanni Segantini;* **1990–1** Zurich, Kunsthaus, *Giovanni Segantini. 1858–1899;* **1999** St Moritz (Segantini Museum), St Gallen (Kunstmuseum), *Giovanni Segantini*

SELECTED REFERENCES
Fiori (ed.) 1968, vol. II, p. 32, cat. II.232; Gozzoli 1973, pp. 110–1, cat. 287; Quinsac 1982, vol. I, p. 364, cat. 456; Baumann and Magnaguagno (eds) 1990, pp. 136–7, cat. 65

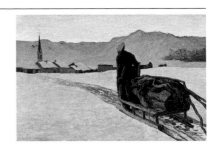

8 *Return from the Woods* (*Ritorno dal bosco*), 1890

Oil on canvas, 64 × 95 cm
Segantini Museum, St Moritz, on loan from the Otto Fischbacher Giovanni Segantini Foundation

PROVENANCE
Alberto Grubicy, Milan (until 1902); Gallina collection, Milan (until 1945); then unknown; Otto Fischbacher Giovanni Segantini Stiftung, St Gallen

SELECTED EXHIBITIONS
1896 Dresden, Ernst Arnold Galerie, *Gemälde, Zeichnungen, Radierungen von Giovanni Segantini und William Strang;* **1901** Budapest, *Spring Exhibition* (solo exhibition); **1935** Basel, Kunsthalle Basel, *Giovanni Segantini Ausstellung;* **1949** St Moritz, Kunstverein St Moritz, *Esposizione commemorativa di Giovanni Segantini;* **1956** St Gallen, Kunstmuseum, *Ausstellung Giovanni Segantini;* **1958** Arco, Palazzo Marchetti, *Mostra Commemorativa del Centenario di Giovanni Segantini;* **1980** St Gallen, *Otto Fischbacher Giovanni Segantini Stiftung* (first exhibition of the foundation); **1990–1** Zurich (Kunsthaus), Vienna (Österreichische Galerie) *Giovanni Segantini. 1858–1899;* **1999** St Moritz (Segantini Museum), St Gallen (Kunstmuseum), *Giovanni Segantini;* **2000–1** Varese (Villa Menafoglio Litta Panza), Venice (Peggy Guggenheim Collection), *Giovanni Segantini: Luce e simbolo/ Light and Symbol, 1884–1899;* **2007** Berlin (Berlin-Deutsche Guggenheim), New York (Guggenheim Museum), *Divisionism/ Neo-Impressionism: Arcadia and Anarchy*

SELECTED REFERENCES
Fiori (ed.) 1968, vol. II, p. 34, cat. II.252; Gozzoli 1973, cat. 304; Quinsac 1982, cat. 412; Baumann and Magnaguagno (eds) 1990, p. 155, cat. 80; Quinsac (ed.) 2000, p. 58, cat. IV

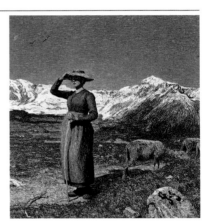
ZURICH ONLY

2 *Midday in the Alps* (*Mezzogiorno sulle Alpi*), 1891

Oil on canvas, 77.5 × 71.5 cm
Segantini Museum, St Moritz on loan from the Otto Fischbacher Giovanni Segantini Foundation

PROVENANCE
Neisser Collection, Breslaw; Otto Fischbacher Giovanni Segantini Stiftung, St Gallen

SELECTED EXHIBITIONS
1892 Amsterdam, *Levende Meesters;* **1956** St Gallen, Kunstmuseum, *Ausstellung Giovanni Segantini;* **1980** St Gallen, *Otto Fischbacher Giovanni Segantini Stiftung* (first exhibition of the foundation); **1985** Trento, Palazzo delle Albere, *Segantini;* **1987** Trento, Museo di Arte Moderna e Contemporanea di Trento e Rovereto, *Giovanni Segantini. Mostra antologica;* **1990–1** Zurich (Kunsthaus), Vienna (Österreichische Galerie), *Giovanni Segantini. 1858–1899;* **1999** St Moritz (Segantini Museum), St Gallen (Kunstmuseum), *Giovanni Segantini;* **2000–1** Varese (Villa Menafoglio Litta Panza), Venice (Peggy Guggenheim Collection), *Giovanni Segantini: Luce e simbolo/Light and Symbol, 1884–1899*

SELECTED REFERENCES
Fiori (ed.) 1968, vol. II, p. 36, cat. II.297; Gozzoli 1973, p. 114, cat. 320; Quinsac 1982, cat. 465; Baumann and Magnaguagno (eds) 1990, pp. 158–9, cat. 83; Quinsac (ed.) 2000, p. 60, cat. V

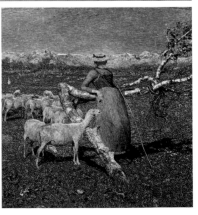

1 *Afternoon in the Alps* (*Pomeriggio sulle Alpi*), 1892

Oil on canvas, 85.5 × 79.5 cm
Ohara Museum of Art, Kurashiki (1022)

PROVENANCE
Collection of T. Knorr, Munich (until 1907); Wendland Collection, Berne; purchased by Magojiro Ohara, Kurashiki (1922)

SELECTED EXHIBITIONS
1892 Munich, *Internationale Kunstausstellung;* **1999-2000** Trento, Palazzo delle Albere, *Segantini. La vita, la natura, la morte. Disegni e dipinti*

ZURICH ONLY

SELECTED REFERENCES

Fiori (ed.) 1968, vol. II, p. 37, cat. II.299; Gozzoli 1973, p. 116, cat. 338; Quinsac 1982, vol. II, pp. 378-9, cat. 466; Belli and Quinsac (eds) 1999, p. 221, cat. Tav.III

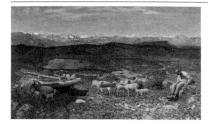

3 *Alpine Meadows* (*Pascoli alpini*), 1893–4

Oil on canvas, 169 × 278 cm
Kunsthaus Zürich (1985/28)

PROVENANCE

Collection of Magda Mautner von Morkhof, Vienna (1902); private collection, Italy (1932/3); Kunstsalon Bollag, Zurich (1937-51); Nyffeler collection, Zurich; acquired by Kunsthaus Zürich 1985

SELECTED EXHIBITIONS

1894 Milan, Società Permanente di Belle Arti, Castello Sforzesco, *Esposizioni Riunite* (solo exhibition); **1926** Venice, *XV Esposizione Internazionale della città di Venezia* [Biennale]; **1956** St Gallen, Kunstmuseum, *Ausstellung Giovanni Segantini;* **1990–1** Zurich (Kunsthaus), Vienna (Österreichische Galerie), *Giovanni Segantini. 1858–1899;* **1999** St Moritz (Segantini Museum), St Gallen (Kunstmuseum), *Giovanni Segantini*

SELECTED REFERENCES

Fiori (ed.) 1968, vol. II, p. 38, cat. II.328; Gozzoli 1973, p. 118, cat. 360; Quinsac 1982, vol. I, cat. 371; Baumann and Magnaguagno (eds) 1990, pp. 176–7, cat. 96

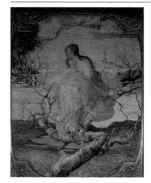

26 *The Angel of Life* (*L'angelo della vita*), 1894

Oil on canvas, 276 × 212 cm
Galleria d'Arte Moderna, Milan (GAM 1592)

PROVENANCE

Commissioned by Leopoldo Albini; Alberici Collection; bequeathed to the Galleria d'Arte Moderna, Milan (1920)

SELECTED EXHIBITIONS

1894 Milan, Società Permanente di Belle Arti, Castello Sforzesco, *Esposizioni Riunite* (solo exhibition); **1895** Munich, *Jahresausstellung der Münchner Sezession;* **1896** Dresden, Ernst Arnold Galerie, *Gemälde, Zeichnungen, Radierungen von Giovanni Segantini und William Strang;* **1912** London, Great White City, *Latin-British Exhibition;* **1916** Zurich, Salon Bollag, *Giovanni Segantini;* **1926** Venice, *XV Esposizione Internazionale d'Arte della città di Venezia* (solo exhibition); **1956** St Gallen, Kunstmuseum, *Ausstellung Giovanni Segantini;* **1958** Arco, Palazzo Marchetti, *Mostra Commemorativa del Centenario di Giovanni Segantini;* **1970** London, Piccadilly Gallery, *Symbolists*

SELECTED REFERENCES

Fiori (ed.) 1968, vol. II, cat. II.315; Gozzoli 1973, pp. 116–7, cat. 348; Quinsac 1982, cat. 566; Greene 2008 in Fraquelli (ed.) 2008

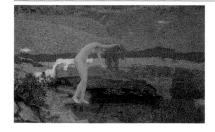

31 *Vanitas* (*La vanità*), 1897

Oil on canvas, 77 × 124 cm
Kunsthaus Zürich, purchased with the support of UBS (1996/3)

PROVENANCE

Wittgenstein Collection, Vienna (until 1936); Vivegano collection, Milan; private collection, Zurich (1971–3); London's art market (1974–5); private collection, Tokyo (until 1996); Artemis Group, David Carritt Ltd, London

SELECTED EXHIBITIONS

1897–8 Pittsburgh, Carnegie Institute, *Second Annual International Exhibition;* **1898** Vienna, *Erste Internationale Ausstellung der Vereinigung bildender Künstler Österreichs* (Vienna Secession) (one-room solo exhibition); **1898** St Petersburg, *Esposizione*

Italiana di Pittura e di Scultura a Pietroborgo (including a solo exhibition); **1900** Paris, *Exposition Universelle. Exposition décennale des Beaux Arts, 1889–1899* (Segantini retrospective); **1914** St Petersburg, *Segantini Exhibition;* **1956** St Gallen, Kunstmuseum, *Ausstellung Giovanni Segantini;* **1999** St Moritz (Segantini Museum), St Gallen (Kunstmuseum), *Giovanni Segantini;* **1999–2000** Trento, Museo di Arte Moderna e Contemporanea di Trento e Rovereto, *Segantini. La vita, la natura, la morte. Disegni e dipinti;* **2000–1** Varese (Villa Menafoglio Litta Panza), Venice (Peggy Guggenheim Collection), *Giovanni Segantini: Luce e simbolo/Light and Symbol, 1884–1899;* **2007** Berlin (Berlin-Deutsche Guggenheim), New York (Guggenheim Museum), *Divisionism/Neo-Impressionism: Arcadia and Anarchy*

SELECTED REFERENCES

Fiori (ed.) 1968, vol. II, p. 41, cat. II.375; Gozzoli 1973, p. 122, cat. 401; Quinsac 1982, cat. 587; Quinsac (ed.) 2000, p. 68, cat. IX

Born in Milan, where he lived all his life, Sottocornola worked as an errand boy after the early death of his father. Having learned to draw in his spare time, from 1877 to 1880 he trained at the Brera Academy under Giuseppe Bertini (1825–1898; see fig. 1) and became friends with fellow students Segantini, Morbelli, Previati, Longoni and the sculptor Medardo Rosso (1858–1928). His employment at the municipal Treasury and his marriage in 1883 to Luigia Carati, the daughter of a wealthy merchant, who introduced him to upper-class Milanese society, provided Sottocornola with emotional and financial stability.

Sottocornola first exhibited at the Brera Academy's annual exhibition held in 1882 and thereafter his work became well known. He benefited from the active art market in the last two decades of the century, receiving several commissions for portraits and selling his still lifes – many to collectors in South America. During the 1890s he became interested in the socialist movement, and this is reflected in the subject matter of his paintings. At the same time, influenced by Segantini, he began using the Divisionist technique. Among his best known paintings is *December. The Workers' Dawn* (1897, cat. 48), which was exhibited at the Brera Triennale of 1897. After the turn of the century,

this naturally introverted and reserved artist began painting in a Symbolist style, his preferred subjects being alpine landscapes, genre scenes and portraits of women, mostly of his wife and his daughters, Anita and Maria.

Throughout his career Sottocornola also worked as a house decorator and restorer, decorating Morbelli's house in Colma near Casale Monferrato and restoring frescoes in Milan's Church of San Antonio and the Monastero Maggiore di San Maurizio as well as Pavia's Church of San Teodoro. Although his paintings were not included in the Divisionist exhibitions organised by the Grubicy Gallery in 1907 and 1912, he was represented in many of the major exhibitions of the period: the Brera Triennales of 1891, 1897, 1900, 1910 and 1914 and also the Venice Biennales from 1905 onwards. In 1917 the Famiglia Artistica, a Milanese artists' association, held a posthumous exhibition of his work. **LS**

SELECTED REFERENCE
Ginex 1985

GIOVANNI SOTTOCORNOLA
1855–1917 MILAN

48 *December. The Workers' Dawn* (*Dicembre. L'alba dell'operaio*), 1897

Oil on canvas, 142 × 253 cm
Civiche Raccolte d'Arte (Galleria d'Arte Moderna), Milan (GAM 1596)

PROVENANCE
G. Treves, Milan, at the Galleria d'Arte Moderna from 1918

SELECTED EXHIBITIONS
1897 Milan, Società per le Belle Arti ed Esposizione Permanente, *III Esposizione Triennale di Belle Arti di Brera;* **1979** Milan, Palazzo della Permanente, *Arte e socialità in Italia. Dal realismo al simbolismo 1865–1915;* **1990** Trento, Palazzo delle Albere, *Divisionismo italiano;* **1991–2** Turin (Mole Antonelliana), Milan (Palazzo Reale), Piacenza (Palazzo Gotico), *Il colore del lavoro;* **2007** Berlin (Berlin-Deutsche Guggenheim), New York (Guggenheim Museum), *Divisionism/Neo-Impressionism: Arcadia and Anarchy*

SELECTED REFERENCES
Fiori (ed.) 1968, vol. II, cat. XXXI.6; Ginex 1985, p. 27; Belli (ed.) 1990, p. 198, cat. 63; Gian Ferrari and Poli (eds) 1991, p. 34, cat. 4

CHRONOLOGY 1876–1915

LARA PUCCI

1876

ART Vittore Grubicy is given the Galleria Pedro Nessi & Co., Milan, by its previous owner, for whom Grubicy had worked since 1872. Grubicy runs the gallery with his brother Alberto, initially focusing on the work of the *Scapigliato* artists such as Tranquillo Cremona and Daniele Ranzoni.

CULTURE Carlo Collodi publishes the school textbook *Gianettino*, emphasising patriotism and industriousness, key themes in popular education. Collodi explains the importance of increasing national production: 'so that Italians should not be forced to ask France, England and Germany for so many, many goods, to pay for which, millions of lire are escaping beyond the Alps.'

HISTORY March: Fall of Marco Minghetti's government of the right, following the defection of a large group of Tuscan deputies who voted against the government's plans to nationalise the railway system, previously having been angered by the refusal to compensate Florence for the transfer of the capital to Rome in 1871. The leader of the parliamentary left, Agostino Depretis, forms a new government.
Launch of the iron-clad battleship *Duilio*, designed by naval minister Benedetto Brin, a brilliant engineer.

1877

HISTORY July: The Coppino Law makes primary education for 6 to 9-year-olds compulsory, free and secular. Intended to combat illiteracy, it has little impact in poorer regions of southern Italy, such as Calabria, where illiteracy figures in 1901 were 79%, compared to just 18% in Piedmont.

1878

ART Parliament announces a commission for the construction in Rome of the Altar of the Fatherland, a national monument dedicated to Vittorio Emanuele II, as liberator of the nation and the father of unified Italy. This was one of the many strategies devised by the ruling elite to encourage a secular religion of nationalism to rival Catholicism and socialism.
Death of Cremona. Grubicy organises a retrospective exhibition of Cremona's work in Milan.

HISTORY January: Death of Vittorio Emanuele II and succession of Umberto I. The deceased king is buried in the Pantheon in Rome, at the insistence of Francesco Crispi, minister of the interior.

Death of Pius IX. Leo XIII is elected pope and issues the encyclical *Quod Apostolici muneris*, condemning socialism, communism and nihilism.
March: Benedetto Cairoli takes over from Depretis as prime minister.
June/July: The Congress of Berlin inaugurates a new period of concern about Italian security: Austria acquires Bosnia-Herzegovina; Britain, Cyprus; France is given a free hand in North Africa; while Italy refuses to pursue territorial claims on Trieste and Trentino Alto Adige.
November: Attempted assassination of Umberto I by the anarchist Giovanni Passannante, during a parade in Naples. Prime Minister Cairoli, a former republican, intercepts the assailant's knife.
December: Depretis becomes prime minister for the second time, taking over from Cairoli.

1879

ART Federico Zandomeneghi participates in the *IV Impressionist Exhibition* in Paris.

CULTURE The 16-year-old Gabriele D'Annunzio publishes his first collection of poems, *Primo vere*, under the pseudonym Floro Bruzio.
Luigi Capuana publishes *Giacinta*. Dedicated to Emile Zola, this was the first of a series of novels exploring the social and psychological factors that restrict their (predominantly female) protagonists. Capuana, like fellow Sicilian novelist Giovanni Verga, was a major exponent of *verismo*, the realist tendency in Italian literature influenced by French authors such as Zola and Gustave Flaubert.

HISTORY July: Cairoli takes over from Depretis as prime minister.
The first woman to receive a degree in letters from an Italian university graduates from the University of Naples.

1880

CULTURE Verga publishes *Vita dei campi*, a collection of short stories, including *Cavalleria rusticana*, a love story that takes a harsh look at peasant life, which would soon be made into a play.
Peppino Turco and Luigi Denza write *Funiculì, funiculà*, a popular song inspired by the opening of the Vesuvius funicular railway. From the 1880s to the 1950s the Neapolitan song was the best-known type of Italian popular song, both in Italy and abroad.

HISTORY Inauguration of the funicular railway on Vesuvius.

1881

ART Exhibition in Rome of the projects entered in the international competition for the Monument to Vittorio Emanuele II. Paul Henri Nenot's entry is chosen.
French edition of Ogden Rood's *Modern Chromatics* is published.

CULTURE Verga publishes *I Malavoglia*, a story of the epic struggles of a Sicilian fishing family against nature, fate and society. It would become his best-known novel.

HISTORY May: Depretis becomes prime minister for a third time, taking over from Cairoli.
Partito socialista rivoluzionario di Romagna (Revolutionary Socialist Party of the Romagna) is founded by former anarchist Andrea Costa.
France occupies Tunisia – 100 miles south-west of Sicily – thus gaining the upper hand in the competition with Italy for economic and political influence in North Africa.

1882

ART Segantini paints first version of *Ave Maria a trasbordo* (*Ave Maria crossing the Lake*). Grubicy makes a brief visit to Milan, where Segantini introduces him to Longoni.
Second competition for the Monument to Vittorio Emanuele II, reserved for Italian artists.

CULTURE Italy's most important poet of the post-unification period, Giosuè Carducci, publishes his second collection of *Odi barbare* (The Barbarian Odes: first collection, 1877; third collection, 1889). *Barbara* was Carducci's term for the re-creation of the metre of ancient Greek and Latin verse in Italian language poetry, meaning that this could only ever be approximate, as if 'barbarians' had attempted to appropriate classical verse. As a poet, essayist, editor and critic, Carducci sought to make Italians more aware of their historic heritage. His oration on the death of Garibaldi confirmed the hero's mythical status.

HISTORY January: Electoral reform gives the vote to all men who can prove literacy, increasing the electorate from 2% to 7% of the population.
May: Triple Alliance between Germany, Austria-Hungary and Italy. This is intended to provide some protection against future aggression by France; to increase Italy's influence in Africa as the scramble for colonies gets underway. The alliance with two safe, conservative powers is also an attempt to uphold social order and reinforce the institution of the monarchy in response to fears caused by the expansion of suffrage. Italy is forced to renounce its irredentist claims against Austria and to increase spending on the armed forces.
Partito dei Lavoratori Operaio Italiano (Italian Workers' Party) is founded in Milan. Party membership is exclusive to manual labourers.
Costa becomes the first socialist deputy elected to parliament in the first elections under the new suffrage. The far left, also including the radicals and republicans, double their number of seats to 40.
Death of Giuseppe Garibaldi at Caprera. The pressure placed on his family to have the hero buried in the Pantheon and to prevent his body being cremated, reflects his status as primary 'saint' within the secular religion of *la patria* (the Italian fatherland).

1883

ART Pio Piacentini's Palazzo delle Esposizioni, Rome, is completed. Galleria Nazionale d'Arte Moderna opens at the Palazzo delle Esposizioni in Rome, following the founding of the Galleria d'Arte Moderna in Turin in 1860. The majority of works purchased by the state for the new museum are by Italian artists.
Segantini exhibits at the Universal Exhibition, Amsterdam.
Morbelli begins his *Poema della vecchiaia* (terminated in 1910).

CULTURE Publication of Verga's *Novelle rusticane*.
D'Annunzio publishes *Intermezzo de rime*, a collection of poems exploring decadent themes. A significantly revised second edition, titled *Intermezzo*, is published in 1894.
Camillo Boito, professor of architecture at Milan's Brera Academy, publishes the short story *Senso*, a relatively new genre in Italian literature. A bold portrayal of female sexuality, *Senso* would be adapted for cinema by Luchino Visconti in 1953.
Publication of Carlo Collodi's *Le avventure di Pinocchio* (The Adventures of Pinocchio), written for a new children's magazine to demonstrate the value of honesty and good citizenship.

HISTORY Cessation of the *corso forzato* – the suspension of currency conversion imposed in 1866 to protect the exchange value of the lira.
A national fund is established to assist victims of accidents at work.

1884

ART National exhibition in Turin at which work is exhibited by Telemaco Signorini, Previati, Segantini, Teofilo Patini, Giulio Monteverde,

Leonardo Bistolfi.
Segantini exhibits work at the Paris Salon.
Medardo Rosso exhibition in London.

CULTURE A national 'pilgrimage' is organised to Vittorio Emanuele's tomb in the Pantheon, marking the sixth anniversary of his death.
January: Première of *Cavalleria rusticana*, the play based on Verga's eponymous novella, with Eleonora Duse, one of Italy's most famous actresses, in the lead. Has since been credited with signalling the beginning of modern Italian drama.

HISTORY The government acts as guarantor for the building of Italy's first steelworks at Terni in Umbria. Sponsored by naval minister Brin, who believes that national security demands that the steel as well as the ships should be Italian. Government subsidies are provided to modernise the merchant fleet and navy.
Cholera epidemic in Naples.
1884–5: The first major strikes by agricultural labourers occur in the province of Mantua.

1885

ART February–April: Segantini exhibits work at the Glasgow Institute.
Work begins in Rome on the construction of Giuseppe Sacconi's prize-winning project for the Monument to Vittorio Emanuele II.
Luca Beltrami's Palazzo della Permanente, Milan, is built.
The Villa Borghese is left to the city of Rome.
Rosso exhibits at the Paris Salon.

HISTORY 1882–5: Publication of the findings of the parliamentary inquiry into agriculture led by Stefano Jacini.
Italian occupation of the port of Massawa in Eritrea.
In Lombardy, the Partito Operaio Italiano breaks from the radical left, rejecting electoral politics in favour of direct action through trade unions and strikes. The government attempts to suppress it in response to the strikes in Mantua.

1886

ART *In Arte Libertas*, a society dedicated to the promotion of foreign and symbolist art in Italy, is founded by Nino Costa in Rome. Artists participating in its first exhibition include Dante Gabriel Rossetti, Franz von Lenbach, Arnold Böcklin and Lawrence Alma-Tadema.
First neo-Impressionist paintings shown at the 8th and final Impressionist group exhibition, Paris.
Rosso exhibits at the Salon des Indépendants, Paris.
At Grubicy's suggestion, Segantini paints a second version of *Ave Maria a trasbordo* (*Ave Maria crossing the Lake*), his first Divisionist painting.

CULTURE Former army officer Edmondo De Amicis publishes *Cuore*, a novel providing moral instruction and reflecting its author's patriotic socialism. It would soon become the most widely read book in Italy, with a copy assigned to every schoolchild.
Publication of D'Annunzio's collection of poems *Isaotta Guttadauro*.

HISTORY The Partito Operaio is disbanded in Milan and its leaders arrested.

1887

HISTORY January: 500 Italian troops are killed by Ethiopian forces at Dogali, near the under-equipped Italian garrison at Massawa, Eritrea. This disaster boosts patriotic opinion in Italy, which proves instrumental in bringing Crispi to power.
July: Death of Depretis. Crispi, who had been highly critical of Depretis's government for its decadence, corruption and inertia, becomes prime minister, unopposed. Support for the new prime minister is unprecedented.

1888

ART The Galleria Grubicy travels to London for the Italian Exhibition at Earl's Court.

CULTURE July–December: Verga's *Mastro-don Gesualdo* is published in instalments in *Nuova Antologia*. The definitive edition, incorporating significant linguistic and structural changes, is published in 1889.

HISTORY Italy's first electro-generating plant opens in Milan.

1889

HISTORY A local government law doubles those eligible to vote in administrative elections to 4 million. The office of mayor is made elective in larger communities.
Emperor Menelik II of Ethiopia signs the Treaty of Uccialli, announcing the official foundation of the Italian colony of Eritrea in 1890. Italy's claim that the treaty establishes a protectorate over the whole of Ethiopia is left deliberately unclear in the Amharic version of the text.

1890

ART Longoni begins work on his first Divisionist painting, *L'oratore dello sciopero* (*The Orator of the Strike*, cat. 49), representing the scene of the illegal May Day demonstration in Milan's Piazza Fontana, 1890.

CULTURE May: Première of Pietro Mascagni's first opera, *Cavalleria rusticana*, based on the play inspired by Verga's short story. It marks the beginning of the *verismo* (realist) period in opera.

HISTORY 1 May: The socialists initiate May Day as an international celebration of proletarian solidarity. Strikes and demonstrations are held across Europe and America.
The charitable foundations known as *opere pie*, many of them religious, are placed under public control – to the anger of the Church – making the welfare of the poor the responsibility of the state.

1891

ART Nomellini paints *Piazza Caricamento, Genoa* (cat. 51), representing ship workers in Genoa, where the artists had participated in the agitations of the city's nascent worker movements.
Previati finishes *Maternità* (*Motherhood*, cat. 25).
Italian Divisionism makes its public debut with works exhibited by Longoni, Morbelli, Previati and Segantini at the *I Esposizione Triennale*

di Belle Arti, Reale Accademia di Belle Arti di Brera, Milan. The anti-naturalistic style of Previati's *Maternità (Motherhood)* was the subject of a fierce critical debate between those, including Luigi Chirtani, who disparagingly claimed not to understand what the artist sought to represent; and those, including Grubicy, who praised the abstract, symbolic qualities of the painting.

CULTURE Pellegrino Artusi publishes *La scienza in cucina e l'arte di mangiar bene (The Science of cooking and the Art of eating Well)*. Including recipes from each region of Italy, it seeks to demonstrate to Italians that they have a national cuisine.
Filippo Turati, one of the founders of the Italian Socialist Party, establishes the magazine *La Critica Sociale*, with Anna Kuliscioff. Increasing attention is given to Marxist theory.

HISTORY A largely court-orchestrated plot results in the fall of Crispi, precipitated by the financial crisis caused by excessive taxation and military expenditure.
February: Antonio Starabba, Marquis Di Rudinì, forms a new government.
Leo XIII's encyclical *Rerum novarum* addresses the social question, rejecting socialism but calling for action to resolve the social injustices of capitalism. Considered to be the first statement of the modern Church's position on social policy, it boosts the Catholic social movement.

1892

CULTURE Première of Ruggiero Leoncavallo's short *verismo* opera *Pagliacci*, conducted by Arturo Toscanini. Inspired by Mascagni's success with *Cavalleria rusticana*, alongside which *Pagliacci* is usually performed.

HISTORY May: Former bureaucrat Giovanni Giolitti replaces Di Rudinì as prime minister when the king and ministers of war and the navy reject proposed cuts in military expenditure.
August: Partito Socialista Italiano (Italian Socialist Party) is founded at the Genoa Congress (although the name is not adopted until 1895). Milanese lawyer Filippo Turati is instrumental in organising a national party based on socialist principles.

1893

CULTURE Première of Giuseppe Verdi's *Falstaff* in Milan attracts a distinguished audience, including the actress Eleanora Duse and composers Mascagni and Giacomo Puccini.
Puccini composes *Manon Lescaut*.

HISTORY Xenophobic feelings towards Italian immigrant workers in France result in the riots of Aigues-Mortes in which 8 Italians are killed.
Menelik II repudiates the Treaty of Uccialli.
December: Fall of Giolitti following the revelation of a banking scandal: the Banca Romana, one of 6 regional banks authorised to print banknotes, is found to have exceeded its permitted circulation by almost 100%, with much of the surplus loaned on very favourable terms to journalists and politicians.
Crispi becomes prime minister for the second time and declares martial law in Sicily, sending 40,000 troops to restore order.
Bank of Italy is founded to regulate the banking system. The Banks of Naples and Sicily retain the right to issue banknotes.

1894

ART *II Esposizione Triennale di Belle Arti*, Milan.

HISTORY October: Crispi dissolves the Socialist Party and has its deputies arrested. He disenfranchises almost a third of voters to create a more manageable electorate.
Banca Commerciale – the first of the German-style mixed banks – is founded in Milan with German capital and under German management. These banks would be much more effective than their predecessors in raising capital for industry and help promote entrepreneurial and managerial skills.
At the end of the year Crispi prorogues parliament after Giolitti produces documents claiming to show Crispi was also implicated in the banking scandal. Parliament remains closed for 5 months.

1895

ART First Venice Biennale: Max Liebermann and James Abbott McNeill Whistler are awarded the international prizes. Grubicy, Morbelli, Pellizza, Previati and Segantini exhibit works.

CULTURE 20 September: The first celebration of a public holiday to mark the anniversary of the capture of Rome by Italian troops in 1870. To mark the event, a huge equestrian statue of Garibaldi is erected on the Janiculum hill overlooking the Vatican.

HISTORY Italy is ruled by decree for much of the year, Crispi now believing that Italy is unsuited to parliamentary government.

1896

ART Grubicy publishes 'Tecnica ed estetica divisionista' in *La Triennale*.
Pellizza finishes *Fiumana (The Living Torrent)*, cat. 47.

CULTURE First performance of Puccini's *La Bohème* in Turin, conducted by Toscanini. For this *verismo* narrative about starving artists in a Paris garret, Puccini developed a musical style in which singing voices resemble conversational speech and the orchestra provides a musical commentary.
Foundation of Socialist Party newspaper *Avanti!*

HISTORY 1 March: Over 5,000 Italian troops are killed during a reckless attack on the town of Adwa, Ethiopia, in the worst defeat ever inflicted on a colonial power in Africa. Umberto I makes Crispi – who had pushed for military action in Ethiopia to compensate for domestic problems – the scapegoat. March: Fall of Crispi. Di Rudinì forms a new government. Turati is elected to parliament.

1897

ART Galleria Internazionale d'Arte Moderna is founded in Venice. The international label was intended to distinguish it from Rome's Galleria Nazionale d'Arte Moderna.

HISTORY Gabriele D'Annunzio is elected to parliament as an independent with the support of the right.
22 April: The increasingly unpopular Umberto I is attacked by an unemployed ironsmith, Pietro Acciarito, who tries to stab him.

1898

ART Pellizza begins work on *Il Quarto Stato* (*The Fourth Estate*).

CULTURE Neapolitan songwriters Alfredo Mazzucchi and Edoardo Di Capua achieve success with *O sole mio*.

HISTORY Riots are provoked across Italy by a sharp rise in grain prices. In Milan, wrongly suspecting a planned insurrection, General Bava-Beccaris uses artillery to storm a Capuchin monastery, killing over 100 and wounding over 400 unarmed demonstrators. A wave of government repression follows: radical newspapers are banned, trade unions suppressed, socialist leaders arrested and imprisoned. The Catholic social movement is subject to similar repression.
Di Rudinì is forced to resign as the cabinet is divided on the treatment of the Catholics. Endorsed by the king, General Luigi Pelloux heads the next government.

1899

ART Death of Segantini. Exhibition in memory of Segantini is organised by the Comitato per le onoranze a Giovanni Segantini at Palazzo della Permanente, Milan.

HISTORY February: Pelloux introduces legislation to punish strikes, prohibit meetings and restrict the freedom of the press.
The Fiat firm is founded in Turin by a group of young aristocrats and former cavalry officers.

1900

ART Segantini retrospective at the *Exposition Universelle. Exposition décennale des Beaux Arts, 1889–1899*, Paris.

CULTURE 14 January: First performance of Puccini's *Tosca* at the Teatro Costanzi, Rome. D'Annunzio publishes the novel *Il Fuoco*, describing with cruel candour his love affair with Eleonora Duse. Antonio Fogazzaro publishes his novel *Piccolo Mondo Moderno*.

HISTORY June: Parliamentary obstruction by the socialists and the opposition of Giolitti and Giuseppe Zanardelli prompt the government to call elections. Pelloux wins a majority due to government influence in the south. Elsewhere, opposition parties win over half the seats and the socialists double their parliamentary presence to 33 seats. Pelloux resigns. Giuseppe Saracco becomes prime minister.
July: Umberto I is shot dead at Monza by the anarchist Gaetano Bresci, who claims to be avenging the deaths of those killed in the 1898 Bava-Beccaris massacre. Vittorio Emanuele III succeeds.

1901

CULTURE January: Death of Verdi.
Capuana publishes his last novel, *Il marchese di Roccaverdina*, after almost 20 years in preparation. The narrative explores the persistence of the values and customs of medieval feudalism in contemporary rural Sicily.

HISTORY February: Zanardelli and Giolitti form a government, with Zanardelli as prime minister. As minister of the interior, Giolitti grants the unions of rural labourers the freedom to strike. 200,000 agricultural workers come out on strike compared to 2,000 in 1899. To minimise unemployment and unrest, the government awards public works contracts to labourers' cooperatives organised by the socialists. This strategy of collaboration between unions and government was criticised by both the left and the right.
Guglielmo Marconi establishes the first radio communication between England and Canada.

1902

ART Galleria Internazionale d'Arte Moderna moves to Ca' Pesaro after the Duchess Felicita Bevilacqua La Masa bequeaths Palazzo Pesaro del Longhena to the City of Venice, on the grounds that it should be used to benefit young artists who were often excluded from major exhibitions.

CULTURE Publication of Benedetto Croce's *Estetica*, intended to be the first part of his 'philosophy of the spirit', in which he proposes a systematic general theory intended to solve all philosophical problems.

HISTORY Supreme Council of Labour is founded, allowing the trade unions to contribute to the preparation of social legislation. Laws are passed banning the use of under-12s for child labour, limiting the working day for women, and establishing a maternity fund.

1903

CULTURE Nationalist writer Enrico Corradini founds the journal *Il Regno*.

HISTORY August: Pius X succeeds Leo XIII as pope.
October: Giolitti becomes prime minister for the second time

1904

ART *Italian Exhibition* at Earl's Court in London. Includes works by Pellizza, Previati and Segantini.

CULTURE Luigi Pirandello publishes *Il fu Mattia Pascal*.
2 March: First performance of D'Annunzio's successful play, *La Figlia di Lorio*, in Milan.

HISTORY September: National general strike is the culmination of a campaign for direct action led by Arturo Labriola of the revolutionary syndicalist faction of the Socialist Party. He challenges Turati's leadership, accusing the reformist wing of the party of having neglected class struggle for parliamentary manoeuvre.
November: Pius X sanctions Catholic participation in elections.

1905

HISTORY March: Tommaso Tittoni briefly becomes prime minister before being replaced by Alessandro Fortis later the same month.

1906

ART Previati publishes *I principii scientifici del divisionismo: la tecnica della pittura*.

CULTURE December: Carducci is awarded the Nobel prize for literature and Camillo Golgi for medicine.

HISTORY February: Sidney Sonnino becomes prime minister.
May: Giolitti replaces Sonnino, becoming prime minister for the third time.
June: Simplon Tunnel is opened.
September: Confederazione Generale del Lavoro (CGdL) is founded.

1907

ART Pellizza commits suicide.

CULTURE Pius X condemns modernism.
Ernesto Moneta is awarded the Nobel peace prize.
Death of Carducci.

1908

ART The first exhibition opens at the Galleria Internazionale d'Arte Moderna di Ca' Pesaro, Venice, following Nino Barbantini's appointment as director. This prompts a fierce rivalry between the young artists of Ca' Pesaro and the more conservative and academic institution of the Biennale.

CULTURE Guglielmo Marconi wins the Nobel prize for physics.
First *Giro d'Italia* cycling race.
December: Giuseppe Prezzolini founds the review *La Voce*.

HISTORY 80,000 people are killed in Messina earthquake.
Demonstrations in Rome and Trieste against the annexation of Bosnia-Herzegovina by Austria.
Foundation of the Olivetti typewriter company.

1909

ART 20 February: First Futurist Manifesto published in *Le Figaro*.

HISTORY Pius X allows Catholic candidates to stand in elections.
December: Sonnino becomes prime minister for the second time, replacing Giolitti.

1910

ART 11 February: Balla, Boccioni, Carrà, Russolo and Severini publish the Manifesto of Futurist Painting.
18 March: Futurist Painting: Technical Manifesto is launched at a riotous event at the Chiarella Theatre, Turin.
27 April: The Futurists stage their famous demonstration from the Clock Tower in St Mark's Square, dropping leaflets titled 'Venezia passatista'. Barbantini greets the Futurists with enthusiasm, offering Boccioni his first major solo exhibition at Ca' Pesaro.
IX Venice Biennale brought forward by one year to avoid clashing with Rome's major international art exhibition in 1911. First Biennale exhibitions for Renoir, Courbet and Klimt.
August: Boccioni exhibition at Ca' Pesaro, Venice. Although Marinetti wrote the catalogue introduction, the 42 paintings and

drawings were executed in a pre-Futurist style, showing the influence of the Divisionist idiom.
Encouraged by the success of the Venice exhibition, Boccioni begins work on *La città che sale* (*The City Rises*, cat. 63), in which he applies a Divisionist-informed technique to a Futurist-inspired theme.

1911

ART *Esposizione Internazionale di Belle Arti* is held at Palazzo Bellonzi, Rome, to celebrate the 50th anniversary of the Kingdom of Italy.
Balla completes *Lampada – studio di luce* (*Street Light*, cat. 64). Dated 1909 by the artist.
Carrà completes *I funerali dell'anarchico Galli* (*The Funeral of the Anarchist Galli*, cat. 61), his first artistic response to the Futurist Manifestos.

CULTURE Inauguration of the Vittorio Emanuele Monument in Rome. Designed by Giuseppe Sacconi in 1895 as a monument to Vittorio Emanuele II, the first king of Italy, it would be completed in 1925. Also known as the Altar of the Fatherland, it formed part of a series of initiatives to promote patriotism in the newly-united Italy.
The nationalist and colonialist journal *Idea Nazionale* is launched, directed by Corradini.
Pratella publishes the Futurist Music – Technical Manifesto.
Theatre and film director Anton Giulio Bragaglia writes his manifesto: Futurist Photodynamism. Although Bragaglia claimed it was written in 1911, the first published record of it dates from 1913.

HISTORY Demonstrations in Rome and Turin to commemorate the 50th anniversary of the Kingdom of Italy.
March: Giolitti returns to power. He unexpectedly adopts the cause of universal male suffrage, seeking to achieve a socialist majority with the promise of a renewed social reform programme.
Italy declares war on Turkey and invades Libya and the Dodecanese islands. Giolitti sees this as Italy's last chance to gain territory in North Africa, following France's gains in the Second Moroccan crisis. He also hopes it will appease the right-wing nationalists at home. The Libyan War would be a major factor in destabilising the international situation in the run-up to the First World War.

1912

ART 11 April: Boccioni's Technical Manifesto of Futurist Sculpture is published in *Poesia*.
Fernand Khnopff exhibition is held at the Belgian Pavilion, X Venice Biennale.
Boccioni paints *Materia*.
Balla paints *La mano del violinista* (*The Hand of the Violinist*) and *Dinamismo di un cane al guinzaglio* (*Dynamism of a Dog on a Leash*).
Futurist exhibition at the Galerie Bernheim-Jeune, Paris. The exhibition travels to London, Berlin, Brussels, The Hague and Amsterdam.

CULTURE Benito Mussolini becomes director of *Avanti!*
D'Annunzio's *Canzoni d'Oltremare* (Songs of Overseas) fuel nationalist enthusiasm for the Libyan War.

HISTORY May: Universal suffrage granted for men, increasing the electorate from 9% to 24% of the population.
July: Socialist Party Congress in Reggio Emilia. Protest over the Libyan War results in the triumph of the maximalist socialists – including the

young Benito Mussolini – over the moderates.

October: Treaty of Lausanne ends war between Italy and Turkey, which cedes Libya. Guerrilla warfare continues.

November: Italy renews the Triple Alliance.

Giovanni Agnelli of Fiat visits the USA. On his return, he introduces Ford's assembly-line production methods to produce a more economical 'utility' car.

1913

ART Publication of Previati's *Della pittura. Tecnica ed Arte.*

CULTURE Giovanni Papini launches the journal *Lacerba*, which would become the official organ of the Futurist movement.

Release of Mario Caserini's film *Ultimi giorni di Pompeii.* Italy had established itself as one of the major film-producing countries, and was particularly renowned for this kind of lavish costume epic.

HISTORY Giolitti's government retains its majority in the general elections, but only with the intervention of the Catholics. The Gentiloni Pact between Giolitti and the Catholic Electoral Union promises Catholic support for liberal candidates in exchange for their support for Church demands, such as opposition to divorce and promotion of religious education.

1914

ART XI Venice Biennale: Longoni, Nomellini and Previati are among those who exhibit works in the separate gallery dedicated to Italian Divisionist artists. Fornara and Rosso have solo exhibitions.

CULTURE Giovanni Pastrone's film *Cabiria* is released, with intertitles by D'Annunzio.

Antonio Sant'Elia publishes the Manifesto of Futurist Architecture in Lacerba.

Sant'Elia produces architectural designs for a power station and his Città Nuova project. None of his major designs would be realised, but these drawings would be highly influential on modern planning and architecture after his death in 1916.

Marinetti publishes *Zang Tumb Tuum*, a radical experiment in the use of typography and visual text, which sought to break down the barriers between word and image. This work is an extended sound poem in which Marinetti uses onomatopoeic sounds to evoke his experiences as a war reporter in the 1912 Balkan Wars.

November: Mussolini resigns as editor of *Avanti!* and founds the newspaper *Il Popolo d'Italia* to campaign for war.

HISTORY March: Resignation of Giolitti, provoked by anti-clerical opposition following the revelation of the Gentiloni Pact. Antonio Salandra succeeds.

June: 'Red Week' is the culmination of a wave of social unrest. A general strike is called after 3 anti-militarist demonstrators were killed in Ancona. In Romagna and the Marches, anarchists, republicans, revolutionary socialists and syndicalists stage a spontaneous insurrection against the state, proclaiming the republic. Military intervention is required to restore state authority.

August: Outbreak of the First World War. Austria violates the terms of the Triple Alliance by invading Serbia without offering Italy territorial compensation, allowing the Italian government to declare neutrality. Syndicalist leaders join the agitation for war against the 'neutralists'.

August: Pius X dies, and is succeeded by Benedict XV.

November: Mussolini is expelled from the Socialist Party.

1915

HISTORY May: Italy declares war on the Austro-Hungarian Empire.

Antonioli and Berti (eds) 2004
eds M. Antonioli, G. Berti, S. Fedele and P. Iuso, *Dizionario Biografico degli Anarchici Italiani*, Pisa 2004, vol. I, A–G.

Anzani 2006
G. Anzani, *Angelo Morbelli e il Pio Albergo Trivulzio. Un capolavoro ritrovato (Un Consiglio del nonno, Parlatorio del Pio Albergo Trivulzio)*, Lainate 2006.

Apollonio (ed.) 2001
ed. U. Apollonio, *Futurist Manifestos*, trans. R. Brain, new afterword by R. Humphreys, R.W. Flint, J.C. Higgins, C. Tisdall, Boston 2001 (original edn Cologne and Milan 1970).

Asciamprener (ed.) 1946
ed. S. Asciamprener, *Gaetano Previati: Lettere al fratello*, Milan 1946.

Aurier 1891
G.-A. Aurier, 'Le Symbolisme en peinture: Paul Gauguin', *Mercure de France*, II (1891), pp. 155–64.

Balla 1984
E. Balla, *Con Balla*, 3 vols, Milan 1984 (vol. I), Milan 1986 (vols II–III).

Barbantini 1919
N. Barbantini, *Gaetano Previati*, Rome and Milan 1919.

Barnes Robinson 1981
S. Barnes Robinson, *Balla, Divisionism to Futurism, 1871–1912*, Ann Arbor 1981.

Baumann and Magnaguagno (eds) 1990
eds F. Baumann and G. Magnaguagno, *Giovanni Segantini, 1858–1899*, exh. cat., Zurich (Kunsthaus Zürich) and Vienna (Österreichische Galerie) 1990.

Belli (ed.) 1987
ed. G Belli, *Segantini*, exh. cat., Trento (Palazzo delle Albere) 1987.

Belli (ed.) 1990
ed. G. Belli, *Divisionismo italiano*, exh. cat., Trento (Palazzo delle Albere) 1990.

Belli and Quinsac (eds) 1999
eds G. Belli and A.-P. Quinsac, *Segantini. La vita, la natura, la morte. Disegni e dipinti*, exh. cat., Trento (Palazzo delle Albere) 1999.

Belli and Rella (eds) 1990
G. Belli and F. Rella, *L'età del divisionismo*, Milan 1990.

Bellonzi et al. 1979
F. Bellonzi, R.Bossaglia, D.Bacile et al., *Arte e Socialità in Italia dal realismo al simbolismo 18865-1915*, exh. cat., Milan (Palazzo della Permanente) 1979.

Bellotti 1887
G. Bellotti, *Luce e colore*, Milan 1887.

Benetti 1892
G. Benetti, 'A Parigi: Il "Salon" della Rosa + Croce', *Vita Moderna*, I/11 (1892), pp. 82–3.

Bensi 1984
P. Bensi, 'Materiali e procedimenti della pittura italiana fra Ottocento e Novecento', *Ricerche di storia dell'arte*, XXIV (1984), pp. 75–81.

Bensi 2000
P. Bensi, 'Appunti sulla tavolozza del *Quarto Stato*' in ed. A. Scotti Tosini, *Giuseppe Pellizza. Quarto Stato*, exh. cat., Milan (Civiche Raccolte d'Arte) 2000, pp. 25–30.

Berresford 1979
S. Berresford, 'Divisionism: Its Origins, Its Aims and Its Relationship to French Post-Impressionist Painting' in *Post-Impressionism, Cross Currents in European Painting*, exh. cat., eds J. House and M.A. Stevens, London (Royal Academy of Arts) 1979, pp. 218–51.

Bestetti et al. 2007
R. Bestetti, M. Cagna, P. Cremonesi and M. Fratelli, 'L'uso della vernice in Vittore Grubicy de Dragon. Analisi e riflessioni su alcuni dipinti di Villa Belgiojoso Bonaparte, Museo dell'Ottocento, Milan' in ed. A. Scotti Tosini 2007.

Bettini 1891
P. Bettini, 'La nuova tendenza nelle opere esposte a Brera', *Cronaca dell'Esposizione di Belle Arti*, I (1891), p. 5.

Bettini 1894
P. Bettini, 'Alla Triennale di Belle Arti', *Vita Moderna*, III/38 (1894),
pp. 296–8.

Boccioni 1914
U. Boccioni, *Pittura Scultura Futuriste (Dinamismo plastico)*, Milan 1914.

Boccioni 1916
U. Boccioni, 'Le arti plastiche', *Gli Avvenimenti*, II/13 (1916), p. 3.

Boccioni (1971)
U. Boccioni, *Gli scritti editi e inediti*, ed. Z. Birolli, intro. M. De
Micheli, Milan 1971.

Boccioni (1972)
U. Boccioni, *Umberto Boccioni. Altri inediti e apparati critici*, ed. Z.
Birolli, Milan 1972.

Boccioni and Carrà 1910
U. Boccioni, C. Carrà, L. Russolo, G. Balla and G. Severini, *Manifesto dei
Pittori futuristi*, published as a leaflet by *Poesia*, Milan, 11 February 1910.

Bomford et al. 1990
D. Bomford, J. Kirby, J. Leighton and A. Roy, *Art in the Making:
Impressionism*, New Haven and London 1990.

Boragina and Mercenaro 2006
P. Boragina and G. Mercenaro, *1956–2006 – 50 anni di Corte
Costituzionale: le immagini, le idee*, exh. cat., Rome (Complesso del
Vittoriano), 2006.

Bordini 1993
S. Bordini, 'Scienza, tecnica e creatività artistica negli scritti di
Gaetano Previati', *Ricerche di storia dell'arte*, LI (1993), pp. 40–51.

Bordini 1999
S. Bordini, 'Colori e tubetti' in ed. S Bordini, *L'occhio, la mano e la
macchina. Pratiche artistiche dell'Ottocento*, Rome 1999, pp. 13–19.

Bordini (ed.) 2003
ed. S. Bordini, *Dipingere con la luce. Teoria e tecnica del colore nel
Divisionismo italiano*, Rome 2003.

Bordini 2007
S. Bordini, 'La percezione dei colori nella trattatistica dell'Ottocento'
in ed. A. Scotti Tosini 2007.

Bruno (ed.) 1969
ed. G. Bruno, *L'opera completa di Boccioni*, Milan 1969.

Bruno (ed.) 1985
ed. G. Bruno, *Plinio Nomellini*, exh. cat., Milan (Palazzo della
Permanente) 1985.

Bruno et al. 1989
G. Bruno and E.B. Nomellini, *Plinio Nomellini. La Versilia*, ed. U.
Sereni, exh. cat., Serravezza (Palazzo Mediceo) 1989.

Bruno 1994
G. Bruno, *Plinio Nomellini*, Genoa 1994.

Bruno and Frilli 1994
G. Bruno and L. Frilli 'Nomellini a Genova', in *Quaderni del Museo
Accademia Ligustica di Belle Arti,* no. 15, Genoa 1994.

Bucarelli et al. (eds) 1969
eds P. Bucarelli, F. Bellonzi, M. Calvesi and R. Barilli, *Gaetano Previati
(1852–1920)*, exh. cat., Ferrara (Palazzo dei Diamanti) 1969.

Calvesi and Coen 1983
M. Calvesi and E. Coen, *Boccioni. L'opera completa*, Milan 1983.

Canavero and Ginex (eds) 1998
eds A. Canavero and G. Ginex, *Il '98 a Milano. Fatti, personaggi,
immagini*, exh. cat., Milan (Società Umanitaria) 1998.

Capuano (ed.) 1985
ed. V. Capuano, *Omaggio a Vittore Grubicy De Dragon. Mostra
Retrospettiva nel 65 anno della scomparsa*, exh. cat., Como (Galleria
Cavour) 1985.

Capuano and Lardelli (eds) 1989
eds V. Capuano and D. Lardelli, *Der italienische Divisionismus der
Galerie Grubicy, Hauptvertreter und Anhänger der ersten Generation*, exh.
cat., Como (Museo Broletto) and St Moritz (Museo Segantini) 1989.

Caramel (ed.) 1982
ed. L. Caramel, *Angelo Morbelli*, exh. cat., Alessandria (Palazzo
Cuttica) 1982.

Caroli and Masoero (eds) 2001
eds F. Caroli and A. Masoero, *Dalla Scapigliatura al Futurismo*, exh.
cat., Milan (Palazzo Reale) 2001.

Carrà 1967–8
M. Carrà, *Carrà. Tutta l'opera pittorica*, 3 vols, Milan 1967–8.

Carrà 2002
C. Carrà, *La mia vita*, Milan 2002 (reprint of 1943 edition).

Carrà and Dell'Acqua (eds) 1987
eds M. Carrà and G.A. Dell'Acqua, *Carlo Carrà: Mostra Antologica*,
exh. cat., Milan (Palazzo Reale) and Rome (Palazzo Braschi) 1987.

Castelnuovo (ed.) 1990
ed. E. Castelnuovo, *La pittura in Italia. L'ottocento*, Milan 1990.

Cena 1901
G. Cena, 'L'Esposizione veneziana', *Nuova Antologia*, XCIII (1901),
p. 306.

Centelli 1895
A. Centelli, 'All'Esposizione di Venezia gli acquisti dei sovrani',
L'Illustrazione Italiana, XXII/19 (1895), p. 291.

Chevreul 1839
M.-E. Chevreul, *De la loi du contraste simultané des couleurs et de
l'assortiment des objets colorés*, Paris 1839.

Chirtani 1891
L. Chirtani, 'A Brera, Discorsi e ritagli', *Il Corriere della Sera*, XVI/132
(1891), p. 3.

Cisternino 2007
B. Cisternino, 'Il sole di Giuseppe Pellizza. Temi di colore e problemi di conservazione e restauro' in ed. A. Scotti Tosini 2007.

Clair et al. 1999
J. Clair, G. Cogeval, L. d'Argencourt et al., *Lost Paradise: Symbolist Europe*, exh. cat., Montreal (The Museum of Fine Arts) 1999.

Coen 1988
E. Coen, *Umberto Boccioni*, exh. cat., New York (The Metropolitan Museum of Art) 1988.

Colombo 1895
V. Colombo, *Gli artisti lombardi a Venezia*, Milan 1895.

Corradini 1906
E. Corradini, 'Gaetano Previati', *Nuova Antologia*, 1 December 1906.

Dalai Emiliani (ed.) 1982
ed. M. Dalai Emiliani, *Mostra di Emilio Longoni (1859–1932)*, exh. cat., Milan (Palazzo della Permanente) 1982.

Damigella 1981
A.M. Damigella, *La pittura simbolista in Italia, 1885–1900*, Turin 1981.

Damigella 1989
A.M. Damigella, 'Divisionism and Symbolism in Italy at the Turn of the Century' in ed. E. Braun, *Italian Art in the Twentieth Century*, exh. cat., London (Royal Academy of Arts) 1989, pp. 33–41.

Damigella 1989a
A.M. Damigella, 'Divisionism and Symbolism' in eds P. Hulten and G. Celant, *Italian Art, 1900–1945*, exh. cat., Venice (Palazzo Grassi) 1989, pp. 37–49.

da Siena 1898
M. da Siena, 'Note sull'Esposizione Nazionale di Torino', *Il Marzocco*, III/38 (1898), p. 3.

Davis (ed.) 2000
ed. J.A. Davis, *Italy in the Nineteenth Century, 1796–1900*, Oxford 2000.

Drudi Gambillo and Fiori (eds) 1986
eds M. Drudi Gambillo and T. Fiori, *Archivi del Futurismo*, 2 vols, Rome and Milan 1986 (2nd edn).

Fagiolo dell'Arco 1968
M. Fagiolo dell'Arco, *Balla pre-futurista*, Rome 1968.

Fagiolo dell'Arco 1987
M. Fagiolo dell'Arco, *Balla, the Futurist*, Milan 1987.

Fagiolo dell'Arco (ed.) 1989
ed. M. Fagiolo dell'Arco, *Balla e i futuristi*, exh. cat., Rome (Galleria Sprovieri), Milan 1989.

Fagiolo dell'Arco (ed.) 1998
ed. M. Fagiolo dell'Arco, *Giacomo Balla. 1885–1911. Verso il futurismo*, exh. cat., Padua (Palazzo Zabarella) 1998.

Fagone (ed.) 1996
ed. V. Fagone, *Carlo Carrà: la matita e il pennello*, exh. cat., Bergamo (Galleria d'Arte Moderna e Contemporanea) 1996.

Falcucci 2007
C. Falcucci, 'Problematiche metodologiche per l'identificazione dei materiali: alcuni casi campione' in ed. A. Scotti Tosini 2007.

Falqui 1895
L. Falqui, *Ascoltare l'incenso. Confraternite di pittori nell'Ottocento: Nazareni, Preraffaelliti, Rosa+Croix, Nabis*, Florence 1895.

Feller 1986–97
R.L. Feller, *Artists' Pigment*, 4 vols, Washington 1985.

Fergonzi 1999
F. Fergonzi, 'Gaetano Previati disegnatore' in ed. F. Mazzocca, *Gaetano Previati, 1852–1920: Un protagonista del simbolismo europeo*, exh. cat., Milan (Palazzo Reale) 1999, pp. 82–3.

Fergonzi 2003
F. Fergonzi, *The Mattioli Collection, Masterpieces of the Italian Avant Garde*, Milan 2003.

Fiori (ed.) 1968
ed. T. Fiori, *Archivi del Divisionismo*, intro. F. Bellonzi, 2 vols, Rome 1968.

Flint 1993
K. Flint, 'Blood and milk: painting and the state in late nineteenth-century Italy' in eds K. Adler and M. Pointon, *The Body Imaged: The Human Form and Visual Culture since the Renaissance*, Cambridge 1993, pp. 109–23.

Fogazzaro 1900
A. Fogazzaro, *Ascensioni umane*, Milan 1900 (6th edn).

Foucart 1990
B. Foucart, 'Le polyptique au XIXe siècle: une sacralisation laïque' in M. Laclotte et al., *Polyptyques. Le Tableau multiple du moyen âge au vingtième siècle*, Paris 1990, pp. 130–9.

Fraquelli (ed.) 2008
ed. S. Fraquelli, *Radical Light: Italy's Divisionist Painters 1891–1910*, exh. cat., London (National Gallery) and Zurich (Kunsthaus Zürich) 2008.

Frehner 1999
M. Frehner, 'The Path to Modernism: Giovanni Segantini – Life and Work' in B. Stutzer and R. Wäspe, *Giovanni Segantini*, exh. cat., St Gallen (Kunstmuseum) and St Moritz (Museo Segantini) 1999, pp. 8–33.

Fugazza et al. 2005
S. Fugazza, A Guarnaschelli and P. Nicholls, *Un altro 800, gusto e cultura in una quadreria oltrepadana*, Piacenza (Galleria d'arte moderna Ricci Oddi) 2005.

Gage 1993
J. Gage, *Colour and Culture, Practice and Meaning from Antiquity to Abstraction*, London 1993.

Gallarati-Scotti 1922
T. Gallarati-Scotti, *The Life of Antonio Fogazzaro*, trans. M. Prichard Agnetti, London 1922.

Gelli 1990
A. Gelli, *Una scuola di pittura in Valle Vigezzo 1881–1919: Carlo Giuseppe e Enrico Cavalli, Giovanni Battista Ciolina, Carlo Fornara*, Turin 1990.

Gian Ferrari and Poli (eds) 1991
eds C. Gian Ferrari and F. Poli, *Il colore del lavoro. Il lavoro come oggetto e soggetto nella pittura italiana fra Ottocento e Novecento*, exh. cat., Turin (Mole Antonelliana), Milan (Palazzo Reale) and Piacenza (Palazzo Gotico) 1991.

Gibson 2002
M. Gibson, *Born to Crime: Cesare Lombroso and the Origins of Biological Criminology*, Westport and London 2002.

Ginex 1985
G. Ginex, *Giovanni Sottocornola: Dal Realismo sociale al quotidiano familiare*, exh. cat., Milan (Circolo della Stampa) 1985.

Ginex 1994
G. Ginex, 'Le *Riflessioni di un affamato* di Emilio Longoni' in R. Pavoni and A. Selvafolta, *Milano 1894. Le Esposizioni Riunite*, exh. cat., Cinisello Balsamo (Camera di Commercio Industria Artigianato e Agricoltura di Milano) 1994, pp. 101–4.

Ginex 1994a
G. Ginex, 'Le Belle Arti alle Esposizioni Riunite' in R. Pavoni and A. Selvafolta, *Milano 1894. Le Esposizioni Riunite*, exh. cat., Cinisello Balsamo (Camera di Commercio Industria Artigianato e Agricoltura di Milano) 1994.

Ginex 1995
G. Ginex, *Emilio Longoni. Catalogo ragionato*, Milan 1995.

Ginex 1999
G. Ginex, '"Un sogno che svanisce nella luce della modernità": Gaetano Previati nella lettura della critica, dalle suggestioni antipositiviste all'influsso su Umberto Boccioni' in ed. F. Mazzocca, *Gaetano Previati, 1852–1920: Un protagonista del simbolismo europeo*, exh. cat., Milan (Palazzo Reale) 1999.

Ginex 2002
G. Ginex, *Emilio Longoni: Opere scelte e inediti*, Milan 2002.

Ginex 2007
G. Ginex, 'Divisionism, Neo-Impressionism, Socialism' in ed. V. Greene, *Divisionism/Neo-Impressionism: Arcadia and Anarchy*, exh. cat., Berlin (Berlin-Deutsche Guggenheim) and New York (Guggenheim Museum) 2007, pp. 29–40.

Ginex 2008
G. Ginex, 'Divisionism to Futurism: Art and Social Engagement' in ed. S. Fraquelli, *Radical Light: Italy's Divisionist Painters 1891–1910*, exh. cat., London (National Gallery) and Zurich (Kunsthaus Zürich) 2008, pp. 37–46.

Goldwater 1979
R. Goldwater, *Symbolism*, New York 1979.

Gozzoli 1973
M.C. Gozzoli, *L'opera completa di Segantini*, Milan 1973.

Granata 2003
O. Granata, 'Gli scienziati (Chevreul, Rood, Bellotti e Guaita)' in ed. S. Bordini, *Dipingere con la luce. Teoria e tecnica del colore nel Divisionismo italiano*, Rome 2003, pp. 54–152.

Greene 2004
V. Greene, '"Universal Synthesis", Boccioni's Development from Divisionism to Futurism' in ed. L. Mattioli Rossi, *Boccioni's 'Materia': A Futurist Masterpiece and the Avant-garde in Milan and Paris*, exh. cat., New York (Guggenheim Museum) 2004, pp. 23–33.

Greene 2007
V. Greene, '"Painted Measles": The Contagion of Divisionism in Italy' in ed. V. Greene, *Divisionism/Neo-Impressionism: Arcadia and Anarchy*, exh. cat., Berlin (Berlin-Deutsche Guggenheim) and New York (Guggenheim Museum) 2007, pp. 19–21.

Greene (ed.) 2007
ed. V. Greene, *Divisionism/Neo-Impressionism: Arcadia and Anarchy*, exh. cat., Berlin (Berlin-Deutsche Guggenheim) and New York (Guggenheim Museum) 2007.

Greene 2008
V. Greene, 'Divisionism's Symbolist Ascent' in ed. S. Fraquelli, *Radical Light: Italy's Divisionist Painters 1891–1910*, exh. cat., London (National Gallery) and Zurich (Kunsthaus Zürich) 2008, pp. 47–59.

Grew 2000
R. Grew, 'Culture and Society, 1796–1896' in ed. J.A. Davis, *Italy in the Nineteenth Century, 1796–1900*, Oxford 2000, pp. 206–29.

Grubicy 1888
The Illustrated Catalogue of Alberto Grubicy's Picture Gallery in the Italian Exhibition in London with a Preface and Biographical Notes by 'Vittore' Art-critic of the Riforma *of Rome*, exh. cat., publisher Alberto Grubicy, Milan 1888.

Grubicy 1891
V. Grubicy, 'Alla Triennale di Brera: Pittura "ideista" – "Maternità di Previati"', *La Riforma*, XXV/187 (1891), pp. 1–2.

Grubicy 1892
V. Grubicy, 'La ginnastica dei sensi: Nuovi orizzonti d'estetica', *La Riforma*, XXVI/213 (1892), p. 1.

Grubicy 1892a
V. Grubicy, 'M. Guyau', *La Riforma*, XXVI/220 (1892), p. 1.

Grubicy 1896
V. Grubicy, 'Non c'è arte vera senza suggestione', *La Triennale*, VIII (1896), pp. 57–9.

Grubicy 1896a
V. Grubicy, 'Tecnica ed estetica divisionista', *La Triennale*, XIV–XV (1896), pp. 110–12.

Guyau 1884
J.-M. Guyau, *Les Problèmes de l'esthétique contemporaine*, Paris 1884.

Guyau 1889
J.-M. Guyau, *L'Art au point de vue sociologique*, Paris 1889.

Helmholtz 1856–66
H.L.F. von Helmholtz, *Handbuch der phisiologische Optik*, Leipzig 1856–66.

Helmholtz and Brücke 1878
E.W. von Brücke, *Principes scientifiques des Beaux Arts. Suivis de l'optique de la peinture par H. von Helmholtz*, Paris 1878.

House and Stevens (eds) 1979
eds J. House and M.A. Stevens, *Post-Impressionism: Cross Currents in European Painting*, exh. cat., London (Royal Academy of Arts) 1979.

Hulten (ed.) 1986
ed. P. Hulten, *Futurismo & Futurismi*, exh. cat., Venice (Palazzo Grassi) 1986.

Humphreys 1999
R. Humphreys, *Futurism*, London 1999.

Kaufmann 2006
S. Kaufmann, *Die Galerie Grubicy in Mailand (1876–1910)*, Zurich 2006.

Kemp 1992
M. Kemp, *The Science of Art: Optical Themes in Western Art from Brunelleschi to Seurat*, New Haven 1992.

Klemm 1999
C. Klemm, 'Towards Symbolism: Paintings by Segantini in the Kunsthaus Zürich and other Swiss Museums' in B. Stutzer and R. Wäspe, *Giovanni Segantini*, exh. cat., St Gallen (Kunstmuseum) and St Moritz (Museo Segantini) 1999, pp. 134–43.

Laclotte et al. 1990
M. Laclotte et al., *Polyptyques. Le Tableau multiple du moyen âge au vingtième siècle*, Paris 1990.

Leighton et al. 1997
J. Leighton, R. Thomson et al., *Seurat and the Bathers*, London 1997.

Lista 1982
G. Lista, *Giacomo Balla*, Modena 1982.

Lista, Baldacci and Velani 2008
G. Lista, P. Baldacci and L. Velani, *Balla: La modernità futurista,* exh. cat., Milan (Palazzo Reale) 2008.

Lobstein 2007
D. Lobstein, 'Paris 1907: The Only Salon of Italian Divisionists' in ed. V. Greene, *Divisionism/Neo-Impressionism: Arcadia and Anarchy*, exh. cat., Berlin (Berlin-Deutsche Guggenheim) and New York (Guggenheim Museum) 2007, pp. 58–68.

Lombroso 1892
C. Lombroso, 'La menzogna delle donne', *Vita Moderna*, I/38 (1892), pp. 297–8.

Lombroso 1893
C. Lombroso, 'Tipi di criminale', *Vita Moderna*, II/1 (1893), pp. 4–5.

Lombroso 1893a
C. Lombroso, 'Gli spettri di Ibsen e la psichiatria', *Vita Moderna*, II/3 (1893), pp. 17–18.

Longoni 1982
Mostra di Emilio Longoni, 1859–1932, exh. cat., Milan (Palazzo della Permanente) 1982.

***Lotta di Classe* 1894**
La Lotta di Classe del Primo Maggio, III/17 (1894), p. 2, ill.

Macchi 1891
G. Macchi, 'L'arte a Brera, II', *La Lombardia*, 8 July 1891.

Macchi 1893
G. Macchi, 'L'oratore popolare', *Lotta di Classe del Primo Maggio*, II/17 (1893), p. 6, ill.

Macchi 1894
G. Macchi, 'Artisti moderni. Longoni', *Vita Moderna*, III/41 (1894), pp. 321–2, ill. p. 322.

Macchi 1895
G. Macchi, 'L'Esposizione d'arte a Venezia – Fisionomia generale', *Cronaca Moderna*, I/18 (1895), pp. 137–8.

Macchi 1905
G. Macchi, 'Impressioni individualiste sull'esposizione de Venezia', *L'Idea Liberale*, XI/31 (1905), pp. 480–1.

Marangon 1998
P. Marangon, *Il modernismo di Antonio Fogazzaro*, Bologna 1998.

Marinetti 1909
F.T. Marinetti, *Fondazione e Manifesto del Futurismo*, published in *Le Figaro*, Paris, 20 February 1909.

Marinetti (1969)
F.T. Marinetti, *La grande Milano tradizionale e futurista*, preface G. Ferrata, Milan 1969.

Martin 1968
M.W. Martin, *Futurist Art and Theory: 1909–1915*, Oxford 1968.

Martin Crew 1888
T. Martin Crew, *The Italian Exhibition in London, The Official Catalogue*, exh. cat., London 1888.

Mattioli Rossi (ed.) 2004
ed. L. Mattioli Rossi, *Boccioni's 'Materia': A Futurist Masterpiece and the Avant-garde in Milan and Paris*, exh. cat., New York (Guggenheim Museum) 2004.

Mattioli Rossi and Di Carlo (eds) 1991
eds L. Mattioli Rossi and M. Di Carlo, *Boccioni 1912 Materia*, exh. cat., Verona (Galleria dello Scudo) 1991.

Mazzocca (ed.) 1999
ed. F. Mazzocca, *Gaetano Previati, 1852–1920: Un protagonista del simbolismo europeo*, exh. cat., Milan (Palazzo Reale) 1999.

Mazzocca, Marini Clarelli and Sisi 2008
F. Mazzocca, M. V. Marini Clarelli and C. Sisi, *Ottocento da Canova al Quarto Stato*, exh. cat., Rome (Scuderie del Quirinale) 2008.

Meighan 2002
J. Meighan, 'In Praise of Motherhood: The Promise and Failure of Painting for Social Reform in Late-Nineteenth-Century Italy', *Nineteenth-Century Art Worldwide: A Journal of Nineteenth-Century Visual Culture*, I/1 (2002), http://19thc-artworldwide.org/spring_02, p. 3.

Moeller (ed.) 1983
ed. M.M. Moeller, *Boccioni and Milan*, exh. cat., Milan (Palazzo Reale) 1983.

Monferini (ed.) 1994
ed. A. Monferini, *Carlo Carrà 1881–1966*, exh. cat., Rome (Galleria Nazionale d'Arte Moderna) 1994.

Monti 1995
R. Monti, 'Il divisionismo in Toscana' in *Il divisionismo toscano*, exh. cat., Livorno (Villa Mimbelli) 1995, pp. 7–14.

Morel 1998
P. Morel, *L'art italien. De la Renaissance à 1905*, Paris 1998.

Mucchi 1898
A.M. Mucchi, 'Il divisionismo', *L'arte all'esposizione del 1898*, XXI (1898), pp. 171–4.

Nomellini (ed.) 1998
ed. E.B. Nomellini, *Plinio Nomellini. I colori del sogno*, exh. cat., Livorno (Museo Civico Giovanni Fattori) 1998.

Olson (ed.) 1992
ed. R.J.M. Olson, *Ottocento. Romanticism and Revolution in 19th-century Italian Painting*, exh. cat., Baltimore (Walters Art Gallery) 1992.

Omarini 2007
Serge Omarini, *Misure colorimetriche di 'Angolo di giardino' di Angelo Corbelli*, in ed. A. Scotti Tosini 2007, pp. 64–8.

Pavoni and Selvafolta (eds) 1994
eds R. Pavoni and A. Selvafolta, *Milano 1894. Le Esposizioni Riunite*, exh. cat., Cinisello Balsamo (Camera di Commercio Industria Artigianato e Agricoltura di Milano) 1994.

Pelissero 1977
G. Pelissero, 'Le genesi del Quarto Stato' in *Pellizza per il Quarto Stato*, Turin 1977, pp. 24–35.

Pellizza 1897
G. Pellizza, 'Il pittore e la solitudine', *Il Marzocco*, I/53 (1897), pp. 2–3.

Piantoni 1990
G. Piantoni, 'Nota su Gaetano Previati e la cultura simbolista europea' in ed. G. Belli, *Divisionismo italiano*, exh. cat., Trento (Palazzo delle Albere) 1990, pp. 230–41.

Piantoni and Pingeot (eds) 2000
eds G. Piantoni and A. Pingeot, *Italies, 1880–1910: Arte alla prova della modernità*, Turin 2000 (French edn: *Italies: L'art italien à l'épreuve de la modernité, 1880–1910*, exh. cat., Paris (Musée d'Orsay) 2001).

Pica 1895
'Vittorio Pica, Impressionisti, divisionisti, sintetisti' in *L'Arte Europea a Venezia*, 1895, pp. 112–35.

Pincus-Witten 1976
R. Pincus-Witten, *Occult Symbolism in France: Joséphin Péladan and the Salons de la Rose-Croix*, New York 1976.

Plebani 2007
P. Plebani, 'Questioni palpitanti! Appunti inediti di Angelo Morbelli sulla tecnica pittorica' in ed. A. Scotti Tosini 2007, pp. 191–213.

Poldi 2007
G. Poldi, 'Ricostruire la tavolozza di Pellizza da Volpedo mediante la spettrometria in riflettanza' in ed. A. Scotti Tosini 2007.

Previati 1905
G. Previati, *La tecnica della pittura*, Turin 1905 (republished Milan 1990).

Previati 1906
G. Previati, *I principii scientifici del divisionismo*, Turin 1906.

Previati 1910
L'arte di Gaetano Previati nella stampa italiana. Articoli critici-biografici e conferenze, Milan, Turin and Rome 1910.

Previati 1913
G. Previati, *Della pittura. Tecnica ed arte*, Turin 1913 (new edition, ed. A.P. Torresi, Ferrara 1992).

Previati 1918
Manuale del restauratore dei dipinti di G. Secco Suardo, preface G. Previati, Milan 1918.

Pugliese 2000
M. Pugliese, *Materiali e tecniche dell'arte contemporanea*, Rome 2000.

Quinsac 1972
A.-P. Quinsac, *La Peinture divisionniste italienne: origines et premiers développements, 1880–1895*, Paris 1972.

Quinsac 1982
A.-P. Quinsac, *Segantini: Catalogo generale*, 2 vols, Milan 1982.

Quinsac (ed.) 1985
ed. A.-P. Quinsac, *Segantini, Trent'anni di vita artistica europea nei carteggi inediti dell'artista e dei suoi mecenati*, Oggiono 1985.

Quinsac 1990
A.-P. Quinsac, 'Die Mutter, der Tod und die katholische Tradition im Werk von Giovanni Segantini' in eds F. Baumann and G. Magnaguagno, *Giovanni Segantini, 1858–1899*, exh. cat., Zurich (Kunsthaus Zürich) and Vienna (Österreichische Galerie) 1990, pp. 47–58.

Quinsac (ed.) 1998
ed. A.-P. Quinsac, *Carlo Fornara: Un Maestro del Divisionismo*, exh. cat., Trento (Palazzo dell'Albere) 1998 and Milan (Museo della Permanente) 1999.

Quinsac 2000
A.-P. Quinsac, 'Light and Nature Transcended: Pantheism in Segantini's Mature Oeuvre' in ed. A.-P. Quinsac, *Giovanni Segantini: Luce e simbolo/Light and Symbol, 1884–1899*, exh. cat., Varese (Villa Menafoglio Litta Panza), Venice (Peggy Guggenheim Collection) 2000, pp. 14–37.

Quinsac (ed.) 2000
ed. A.-P. Quinsac, *Giovanni Segantini: Luce e simbolo/Light and Symbol, 1884–1899*, exh. cat., Varese (Villa Menafoglio Litta Panza), Venice (Peggy Guggenheim Collection) 2000.

Quinsac 2005
A.-P. Quinsac, 'Londra 1888: The Italian Exhibition' in ed. A.-P. Quinsac, *Vittore Grubicy e l'Europa. Alle radici del divisionismo*, exh. cat., Turin (Galleria Civica d'Arte Moderna) 2005, Trento (Museo di Arte Moderna e Contemporanea di Trento e Rovereto) and Milan (Civiche Raccolte d'Arte Moderna, Villa Belgiojoso Bonaparte, Museo dell'Ottocento) 2006, pp. 151–69.

Quinsac (ed.) 2005
ed. A.-P. Quinsac, *Vittore Grubicy e l'Europa. Alle radici del divisionismo*, exh. cat., Turin (Galleria Civica d'Arte Moderna) 2005, Trento (Museo di Arte Moderna e Contemporanea di Trento e Rovereto) and Milan (Civiche Raccolte d'Arte Moderna, Villa Belgiojoso Bonaparte, Museo dell'Ottocento) 2006.

Radelet and Laquale 2007
Th. Radelet and G. Laquale, 'Le analisi su Nomellini e Pellizza: risultati e prospettive di ricerca' in ed. A. Scotti Tosini 2007.

Rebora 1995
S. Rebora, *Vittore Grubicy De Dragon: pittore divisionista 1851–1920*, Rome and Milan 1995.

Rebora 1999
S. Rebora, 'Arte come impresa, Il caso Previati–Grubicy' in ed. F. Mazzocca, *Gaetano Previati, 1852–1920: Un protagonista del simbolismo europeo*, exh. cat., Milan (Palazzo Reale) 1999, pp. 46–53.

Rebora (ed.) 2005
ed. S. Rebora, *Vittore Grubicy De Dragon, poeta del divisionismo, 1851–1920*, exh. cat., Pallanza (Museo del Paesaggio) 2005.

Rinaldi (ed.) 1986
ed. S. Rinaldi, *La fabbrica dei colori*, Rome 1986.

Rinaldi 1999
S. Rinaldi, 'Per uno studio sulla tecnica pittorica di Previati: i risultati delle analisi a fluorescenza' in ed. S Bordini, *L'occhio, la mano e la macchina. Pratiche artistiche dell'Ottocento*, Rome 1999, pp. 107–12.

Rinaldi 2003
S. Rinaldi, 'Colori e pigmenti di alcuni dipinti divisionisti analizzati mediante XRF' in ed. S. Bordini, *Dipingere con la luce. Teoria e tecnica del colore nel Divisionismo italiano*, Rome 2003, pp. 54–152.

Rinaldi 2004
S. Rinaldi, *Colore e pittura. Teorie cromatiche e tecniche pittoriche dall'Impressionismo all'Astrattismo*, Rome 2004.

Rinaldi 2007
S. Rinaldi, *Pigmenti e lunghezze d'onda: per un progetto di ricerca integrato*, appendices by S. Omarini, in ed. A. Scotti Tosini 2007, pp. 53–63.

Rood 1879
O.N. Rood, *Modern Chromatics*, New York, 1879 (French edn: *Théorie scientifique des couleurs et leurs application à l'arte et à l'industrie*, Paris 1881).

Rood (1986)
O.N. Rood, *La moderna scienza dei colori*, ed. M. Bordone (intro. and critical edn), Rome 1986.

Rosenblum 2000
R. Rosenblum, 'Giovanni Segantini: an International View' in ed. A.-P. Quinsac, *Giovanni Segantini: Luce e simbolo/Light and Symbol, 1884–1899*, exh. cat., Varese (Villa Menafoglio Litta Panza), Venice (Peggy Guggenheim Collection) 2000, pp. 38–49.

Rosenblum et al. 2000
R. Rosenblum, M.A. Stevens, A. Dumas, *1900: Art at the Crossroads*, exh. cat., London (Royal Academy of Arts), New York (Solomon R. Guggenheim Museum) 2000.

Rylands 1997
P. Rylands, 'Catalogue' in *Masterpieces from the Gianni Mattioli Collection*, Venice (Peggy Guggenheim Collection) 1997, pp. 49–103.

Schiaffini 2002
I. Schiaffini, *Umberto Boccioni. Stati d'animo: Teoria e pittura*, Milan 2002.

Schneede 1994
U.M. Schneede, *Umberto Boccioni*, Stuttgart 1994.

Scotti (ed.) 1974
ed. A. Scotti, *Catalogo dei manoscritti di Giuseppe Pellizza da Volpedo provenienti dalla donazione Eredi Pellizza*, Tortona 1974.

Scotti 1976
A. Scotti, *Giuseppe Pellizza da Volpedo: 'Il Quarto Stato'*, Milan 1976.

Scotti 1980
A. Scotti, *Pellizza da Volpedo*, exh. cat., Alessandria (Palazzo Cuttica) 1980.

Scotti 1982
A. Scotti, 'Milano 1891, La prima Triennale di Brera', *Ricerche di storia dell'arte*, XVIII (1982), pp. 55–72.

Scotti 1986
A. Scotti, *Pellizza da Volpedo: Catalogo generale*, Milan 1986.

Scotti Tosini 1985
A. Scotti, 'Genova 1892: l'incontro divisionista di Plinio Nomellini e di Giuseppe Pellizza' in *Quaderni del Museo Accademia Ligustica di Belle Arti*, Genova 1885 pp. 9–10.

Scotti Tosini 1991
A. Scotti Tosini, *Angelo Morbelli*, Soncino 1991.

Scotti Tosini 1995
A. Scotti Tosini, 'Divisionist Painters in Italy between Modern Chromatics and New Symbols' in ed. J. Clair, *Lost Paradise: Symbolist Europe*, exh. cat., Montreal (Musée des Beaux Arts de Montréal) 1995, pp. 274–82.

Scotti Tosini 1998
A. Scotti, *Il Quarto Stato di Giuseppe Pellizza da Volpedo*, Milan 1998.

Scotti Tosini 1999
A. Scotti Tosini, *Giuseppe Pellizza da Volpedo*, Turin 1999.

Scotti Tosini 2001
A. Scotti Tosini, 'Luce e colore, realtà e simbolo nella pittura di Morbelli' in ed. A. Scotti Tosini, *Angelo Morbelli tra realismo e divisionismo*, exh. cat., Turin (Galleria Civica d'Arte Moderna e Contemporanea) 2001, pp. 11–14.

Scotti Tosini (ed.) 2001
ed. A. Scotti Tosini, *Angelo Morbelli tra realismo e divisionismo*, exh. cat., Turin (Galleria Civica d'Arte Moderna e Contemporanea) 2001.

Scotti Tosini 2005
A. Scotti Tosini, 'L'influenza "positiva" delle scienze: la pittura in trasformazione' in ed. M. Hansmann, *Pittura italiana nell'Ottocento*, Venice and Marseilles 2005.

Scotti Tosini (ed.) 2006
ed. A. Scotti Tosini, *Pellizza e i Grubicy. Il Carteggio di Giuseppe Pellizza da Volpedo con Vittore e Alberto Grubicy De Dragon*, Tortona 2006.

Scotti Tosini 2007
A. Scotti Tosini, 'The Divisionists and the Symbolist Cycle' in ed. V. Greene, *Divisionism/Neo-Impressionism: Arcadia and Anarchy*, exh. cat., Berlin (Berlin-Deutsche Guggenheim) and New York (Guggenheim Museum) 2007, pp. 43–57.

Scotti Tosini (ed.) 2007
ed. A. Scotti Tosini, *Il Colore dei Divisionisti (Proceedings of International Conference, Volpedo–Tortona 2005)*, Volpedo 2007.

Scotti Tosini 2008
A. Scotti Tosini, 'Divisionist Painting Technique' in ed. S. Fraquelli, *Radical Light: Italy's Divisionist Painters 1891–1910*, exh. cat., London (National Gallery) and Zurich (Kunsthaus Zürich) 2008, pp. 21–35.

Scotti Tosini and Pernigotti 1996
A. Scotti Tosini and P. Pernigotti, *Lo Studio-Museo di Giuseppe Pellizza da Volpedo e i luoghi Pellizziani (Guidi ai Musei in Piemonte, 2)*, Turin 1996.

Scotti Tosini and Pernigotti (eds) 2006
eds A. Scotti Tosini and P. Pernigotti, 'Osservazioni pella Risaia. Taccuino del 1898–1899' in *Angelo Morbelli. Documenti inediti*, Tortona 2006, pp. 19–45.

Segantini 1891
G. Segantini, 'Così penso e sento la pittura', *Cronaca d'Arte*, I/7 (1891), p. 55.

Servaes (ed.) 1902
ed. F. von Servaes, *Giovanni Segantini. Sein Leben und sein Werk*, Ministerium für Kultur und Unterricht, Vienna 1902.

Sestetti, Cagna and Fratelli 2005
R. Sestetti, M. Cagna, M. Fratelli, 'L'uso della vernice in Vittore Grubicy' in ed. A.-P. Quinsac, *Vittore Grubicy e l'Europa. Alle radici del divisionismo*, exh. cat., Turin (Galleria Civica d'Arte Moderna) 2005, Trento (Museo di Arte Moderna e Contemporanea di Trento e Rovereto) and Milan (Civiche Raccolte d'Arte Moderna, Villa Belgiojoso Bonaparte, Museo dell'Ottocento) 2006, pp. 137–43.

Settima Esposizione Internazionale 1907
Settima Esposizione Internazionale d'Arte della Città di Venezia, exh. cat., Venice (Palazzo delle Esposizioni) 1907.

Severini (1995)
G. Severini, *The Life of a Painter: The Autobiography of Gino Severini*, trans. J. Franchina, Princeton 1995.

Sonderegger 2006
C. Sonderegger, *Donazione Chiattone*, Lugano, Museo Civico dei Belle Arti 2006–7.

Souriau 1909
P. Souriau, *La Suggestion dans l'art*, Paris 1909 (2nd edn).

Stuart Hughes 2002
H. Stuart Hughes, *Consciousness and Society: The Reorientation of European Social Thought, 1890–1930*, New Brunswick 2002 (original edn New York 1958).

Stutzer and Wäspe 1999
B. Stutzer and R. Wäspe, *Giovanni Segantini*, exh. cat., St Gallen (Kunstmuseum) and St Moritz (Museo Segantini) 1999.

Tisdall and Bozzolla 1996
C. Tisdall and A. Bozzolla, *Futurism*, London 1996 (first published 1977).

Townsend, Ridge and Hackney (eds) 2004
eds J.H. Townsend, J. Ridge and S. Hackney, *Pre-Raphaelite Painting Techniques 1848–1856*, London 2004.

Tumiati 1898
D. Tumiati, 'Ascensioni umane', *Il Marzocco*, III/45 (1898), pp. 1–2.

Tumiati 1901
D. Tumiati, 'Artisti contemporanei: Gaetano Previati', *Emporium*, XIII/73 (1901), pp. 3–25.

Valsecchi et al. 1976
M. Valsecchi, F. Vercellotti and G. Gavazzeni, *Vittore Grubicy de Dragon*, Milan 1976.

Velardita 2005
F. Velardita, 'Vittore Grubicy e il culto per Tranquillo Cremona' in ed. A.-P. Quinsac, *Vittore Grubicy e l'Europa. Alle radici del divisionismo*, exh. cat., Turin (Galleria Civica d'Arte Moderna) 2005, Trento (Museo di Arte Moderna e Contemporanea di Trento e Rovereto) and

Milan (Civiche Raccolte d'Arte Moderna, Villa Belgiojoso Bonaparte, Museo dell'Ottocento) 2006, pp. 171–5.

Vibert 1891
J.G. Vibert, *La science de la peinture*, Paris 1891.

Vibert (1893)
J.G. Vibert, *La scienza della pittura*, ed. G. Previati, preface A.P. Torresi, Ferrara 2005.

Vinardi 2001
M. Vinardi, 'Schede' in ed. A. Scotti Tosini, *Angelo Morbelli tra realismo e divisionismo*, exh. cat., Turin (Galleria Civica d'Arte Moderna e Contemporanea) 2001, pp. 135–58.

Vinardi 2006
M. Vinardi, 'Gli scritti di Vittore Grubicy per *La Riforma* e la raccolta di articoli conservati fra le carte di Giuseppe Pellizza' in ed. A. Scotti Tosini, *Pellizza e i Grubicy. Il Carteggio di Giuseppe Pellizza da Volpedo con Vittore e Alberto Grubicy De Dragon*, Tortona 2006.

Zanovello Russolo 1958
A. Zanovello Russolo, *Luigi Russolo: L'uomo, l'artista*, Milan 1958.

Zeki 1999
S. Zeki, *Inner Vision: An Exploration of Art and the Brain*, Oxford and New York 1999.

LENDERS TO THE EXHIBITION

Barcelona
MNAC. Museu Nacional d'Art de Catalunya

Biella
Museo del Territorio Biellese

Kurashiki
Ohara Museum of Art

London
Estorick Collection

Lugano
Museo Civico di Belle Arti

Milan
Banca di Credito Cooperativo, Barlassina
Camera di Commercio, Industria, Artigianato e Agricoltura
Casa di Lavoro e Patronato per i Ciechi di Guerra di Lombardia
Civiche Raccolte d'Arte (Galleria d'Arte Moderna)
Civiche Raccolte d'Arte (Museo d'Arte Contemporanea)
Museo Nazionale della Scienza e della Tecnologia
Pinacoteca di Brera

New York
The Museum of Modern Art
French & Company LLC

Paris
Musée d'Orsay

Rome
Accademia Nazionale di San Luca
Galleria Nazionale d'Arte Moderna

St Moritz
Segantini Museum

Tortona
Fondazione Cassa di Risparmio di Tortona

Turin
Galleria Civica d'Arte Moderna

Venice
Musei Civici Veneziani, Galleria Internazionale d'Arte Moderna di
Ca' Pesaro
Peggy Guggenheim Collection

Vercelli
Fondazione Museo Francesco Borgogna

Verona
Banca Popolare di Novara
Galleria d'Arte Moderna

Zurich
Kunsthaus Zürich

And all lenders and private collectors who wish to remain anonymous

PHOTOGRAPHIC CREDITS

Barcelona © MNAC. Museu Nacional d'Art de Catalunya, Barcelona: cat. 12
Berlin © bpk/Gemäldegalerie, Staatliche Museen, Berlin/Jörg P. Anders: fig. 31
Biella © Fondazione Museo del territorio Biellese, Biella: cat. 40
Chicago, Illinois © The Art Archive/Art Institute of Chicago/Album/Joseph Martin: fig. 2
The Hague © Gemeentemuseum, Den Haag: fig. 25
Kurashiki © Ohara Museum of Art, Kurashiki: cat. 1, p. 10
Leipzig © bpk/Museum der bildenden Künste Leipzig/Ursula Gerstenberger: fig. 5
Liverpool © Walker Art Gallery, National Museums Liverpool/Bridgeman Art Library, London: fig. 7
London © Estorick Collection, London/Bridgeman Art Library/DACS, London 2008: cat. 57
Lugano © Museo Civico di Belle Arti, Lugano: cats 21, 22, 54, 60; fig. 24
Madrid © Museo Thyssen-Bornemisza, Madrid/Bridgeman Art Library, London: fig. 27
Milan © Banca di Credito Cooperativo di Barlassina, Milan: cat. 19; © Camera di Commercio, Industria, Artigianato e Agricoltura, Milan: cat. 33; © Casa di Lavoro e Patronato per i Ciechi di Guerra di Lombardia, Milan: cat. 42; Civiche Raccolte d'Arte, Milan: © Comune di Milano. All rights reserved: cat. 58; Galleria d'Arte Moderna, Milan: © Comune di Milano. All rights reserved: cats 16, 17, 18, 26, 48; figs 4, 26, 35; p. 6; © Galleria d'Arte Moderna, Milan/The Art Archive/Dagli Orti: fig. 1; © akg-images/Electa: fig. 8; © akg-images: fig. 32; © photo Aurora Scotti: fig. 13; © Intesa Sanpaolo Collection, Milan: cats 46, 55; © Museo Nazionale della Scienza e della Tecnologia Leonardo da Vinci, Milan: cat. 10; Pinacoteca di Brera, Milan: © Photo Bridgeman Art Library, London: fig. 23; © Su concessione del Ministero per i beni e le Attività Culturali: cat. 47, pp. 8–9
New York © French & Company: cat. 4; The Museum of Modern Art, New York: © Photo: MOMA, NY/SCALA/DACS, London 2008: cat. 61; © Photo: MOMA, NY/SCALA: cat. 63, p. 128–9; © Photo: Bridgeman Art Library/MOMA, NY/DACS London 2008: cat. 64
Paris Musée d'Orsay, Paris: © RMN, Paris: cat. 35, fig. 14; Photo Hervé Lewandowski: cats 9, 13
Parma © Barilla Collection of Modern Art: cat. 53
Private collections © Photo courtesy of the owners: cats 7, 14, 20, 29, 34, 38, 43, 44, 49, 50; figs 10, 19, 20, 21; © Photo courtesy of the owner/DACS London 2008: fig. 9; © Photo Bridgeman Art Library, London/DACS London 2008: fig. 22; © courtesy Claudia Gian Ferrari, Milan/DACS London 2008: cat. 56, p. 127; © courtesy James Roundell: cats 23, 24, 41, fig. 16
Ravenna Church of St Vitale: © The Art Archive/Dagli Orti: fig. 33
Rome Accademia Nazionale di San Luca, Rome: © akg-images/Electa/DACS London 2008: cat. 52; © Associazione Nazionale Mutilati e Invalidi di Guerra, Rome: fig. 10; Galleria Nazionale d'Arte Moderna e Contemporanea, Rome: © akg-images/Pirozzi: fig. 18; © akg-images/Pirozzi/DACS London 2008: fig. 36; © Galleria d'Arte Moderna e Contemporanea di Roma/Alinari/The Bridgeman Art Library/DACS London 2008: cat. 45; © Galleria Nazionale d'Arte Moderna e Contemporanea, Rome. Photo Alessandro Vasari: cat. 59; Santa Maria della Vittoria: © The Art Archive/Album/Joseph Martin: fig. 30
Rovereto © Museo di arte moderna e contemporanea di Trento e Rovereto: fig. 37
Siena © The Art Archive/Opera della Metropolitana di Siena/Dagli Orti: fig. 28
St Moritz Segantini Museum, St Moritz: © Segantini Museum, St Moritz: cats 2, 8; © akg-images: fig. 6
Tortona © Fondazione Cassa di Risparmio di Tortona: cats 39, 51; fig. 12
Turin © Galleria Berman: fig. 17; GAM – Galleria Civica d'Arte Moderna e Contemporanea di Torino: © The Art Archive/Galleria Civica d'Arte Moderna e Contemporanea di Torino/Dagli Orti: fig. 3; © GAM – Galleria Civica d'Arte Moderna e Contemporanea di Torino: cat. 32, fig. 34
Venice Gianni Mattioli Collection (on long-term loan to the Peggy Guggenheim Collection, Venice): © Photo 2008 The Gianni Mattioli Collection: cat. 62; © Musei Civici Veneziani, Galleria Internazionale d'Arte Moderna di Ca' Pesaro, Venice: cats 15, 30, 36
Vercelli © Fondazione Museo Francesco Borgogna, Vercelli: photo Aurora Scotti: fig. 11; © Fondazione Museo Francesco Borgogna, Vercelli, Photo Giacomino Gallarate, Oleggio: cat. 37
Verona Banca Popolare di Verona e Novaro: © Photo Bridgeman Art Library, London: cat. 25, fig. 15; © Galleria d'Arte Moderna, Comune di Verona: cat. 11
Vienna Österreichische Galerie Belvedere, Vienna: © akg-images/Erich Lessing: fig. 29
Zurich © 2008 Kunsthaus Zürich. All rights reserved: cats 3, 5, 6, 27, 28, 31

INDEX

NOTE: All academies, galleries, institutions and exhibitions are entered under the town where they are situated.